Monumental *Islamic Calligraphy* from India

A traveling exhibition of estampages and photographs of calligraphic inscriptions on Islamic monuments of the Sultanate and Mughal periods (ca. 1150-1750)

Lent by the Archaeological Survey of India

Sponsored by the Islamic Foundation, Villa Park, Illinois; in conjunction with the School of Art and Art History, The University of Iowa

An Affiliated Event of the FESTIVAL OF INDIA 1985-86

PARTICIPATING MUSEUMS

Sewall Art Gallery, Rice University, Houston
January 24-March 2, 1985

Semitic Museum, Harvard University, Cambridge
 (in cooperation with The Aga Khan Program for Islamic Architecture,
 Harvard University and M.I.T.)
March 18-April 29, 1985

University Gallery of Fine Art, The Ohio State University, Columbus
September 9-29, 1985

Museum of Art, The University of Iowa, Iowa City
November 15, 1985 — January 5, 1986

The University Museum, University of Pennsylvania, Philadelphia
March 18-April 27, 1986

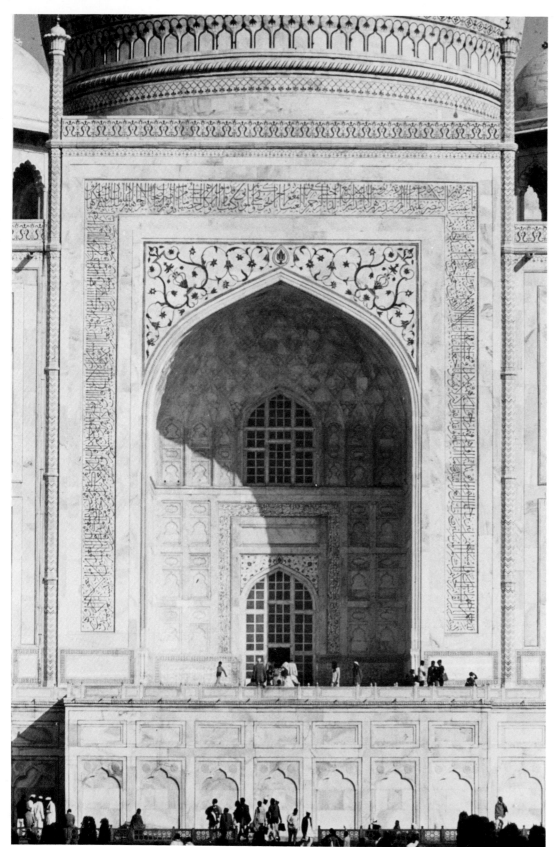

Taj Mahal,
Koranic inscriptions on south facade (No. 59)

Monumental *Islamic Calligraphy* from India

by

W.E. Begley

Professor of Indian and Islamic Art
The University of Iowa

with a Preface by

Z.A. Desai

Former Director (Epigraphy)
The Archaeological Survey of India

Islamic Foundation
Villa Park, Illinois

1985

Patrons of the Exhibition

GRAND PATRONS:

Mr. Ali Habib Ahmed
Dr. Mohammad Ali
Mr. Syed Viqar Ali
Dr. Nasrullah Basha
Dr. Fazlur R. Khan
Dr. and Mrs. Arnold Menezes
Dr. Annemarie Schimmel
Dr. Shaukat Shah
Dr. A. Toor
Islamic Society of North America
Pakistan Physicans Association

PATRONS:

Mrs. Rafiq Abid
Mr. Azeez Ahmad
Dr. Amjad Ali
Mr. Syed Yusuf Ali
Dr. Murthaza Arain
Dr. M.M. Haque
Mr. M.A. Haque
Mr. Manzoor Hussain
Dr. Zia M. Hassan
Dr. Mustaq Khan
Dr. Javed Akthar
Mr. Shakeer Moiuddin
Dr. Syed Rahman
Dr. Mohammad Z. Sait
Dr. Shafi U. Syed
Dr. A. Waliuddin
Agudas Achim Congregation, Iowa City

DONORS:

Dr. Azizuddin Ahmed
Mrs. Farhath Akthar
Dr. Ata Arain
Mr. Shahid Aziz
Dr. and Mrs. Hunter H. Comley
Dr. Waheed Fakhri
Mr. Ghulam Hafiz
Mr. Syed Shamshad Hussain
Dr. and Mrs. Alexander Kern
Dr. and Mrs. Satish Khera
Dr. Rajiv Kohli
Dr. Hamid Mahmood
Dr. Arshad Mirza
Dr. Taj Mohammad

Mr. Khaja Mohuiddin
Mr. Mahmood Mohuiddin
Mr. Mohammad Muniruddin
Mr. C.M. Naim
Dr. and Mrs. S.R. Patil
Mr. Ahmad Qadeer
Dr. and Mrs. Gerard Rushton
Mr. Najmuddin Saleem
Mr. Saleem Shaikh
Dr. Mohammad Shariff
Dr. Vasant L. Tanna
Dr. Wallace J. Tomasini
Dr. and Mrs. Stephen Vlastos
Dr. Arshad Zaheer

Program in Asian Civilization, The University of Iowa

Monumental Islamic Calligraphy from India is the catalogue of a traveling exhibition of estampages and photographs of inscriptions lent from the archives of the Archaeological Survey of India. Sponsored by the Islamic Foundation, 300 W. High Ridge Rd., Villa Park, Illinois 60181; in conjunction with the School of Art and Art History, The University of Iowa, Iowa City, Iowa 52242.

ISBN 0-932815-00-6 17.95 (cloth)
ISBN 0-932815-01-4 10.95 (paper)

LCC 84-29717

بسم الله الرحمن الرحيم

Contents

Acknowledgements

This book is dedicated to the memory of the great calligraphers of India, and to the many scholars of the Archaeological Survey of India who have recorded and interpreted monumental Islamic inscriptions throughout the subcontinent. Among the numerous individuals and organizations that have kindly lent their support to the present traveling exhibition, a primary debt of gratitude is owed to Dr. Z.A. Desai, who generously loaned the estampages catalogued here from the extensive archives of Arabic and Persian architectural inscriptions at Nagpur, in his capacity as then Director (Epigraphy), The Archaeological Survey of India. Through his efforts, the loan was authorized by the office of the Director General of Archaeology in Delhi in August 1982, with the sanction of the Ministry of Education and Culture. My travel to India to negotiate the loan was made possible by a grant from The American Institute of Indian Studies. Others in Nagpur who facilitated my research include Dr. N.M. Ganam, Superintending Epigraphist; Mssrs. M.I. Quddusi and M.Y. Quddusi, Epigraphical Assistants; and Mssrs. P.V. Janardhan, Alauddin, and Abbasi.

As most of the loaned estampages had been published in the scholarly journals *Epigraphia Indo-Moslemica* (EIM) and *Epigraphia Indica, Arabic and Persian Supplement* (EIAPS), Dr. Desai also kindly granted permission to quote or adapt the published translations in the present catalogue. A number of the inscriptions were specially re-edited and re-translated by Dr. Desai himself during July of 1984, when a travel grant awarded by the Office of Fellowships and Grants, The Smithsonian Institution, made it possible for him to visit The University of Iowa for this purpose. Whatever scholarly merit the present catalogue may have is due to Dr. Desai's great erudition in matters of Arabic and Persian epigraphy as reflected by the twenty volumes of *EIAPS* edited by him, and his scores of published articles. Unfortunately his stay in this country was too short to edit the entire catalogue, so I must assume final responsibility for all lapses—both in the text and in the Appendix of Arabic and Persian transcriptions, which are derived mostly from the pages of *EIM* and *EIAPS*. Since complete sets of these important journals are extremely rare in the U.S., I have also appended a complete list of the definitive scholarly articles they contain, in the hope that these may soon be reprinted by the Archaeological Survey of India, for the benefit of scholars.

After Dr. Desai, another major debt of gratitude is owed to the Islamic Foundation of Villa Park, Illinois, for its generous, timely, and indispensable financial support in organizing the exhibition and publishing the Catalogue. A complete list of Patrons and Donors is given above, but here I would like to extend my special thanks to Mr. M. Zia Hassan, Chairman of the Board of Trustees; Dr. N. Basha, Chairman of the Foundation's exhibition committee, and Dr. Habib Ahmed, who acted as coordinator. Other committee members include Mssrs. Khaja Mohuiddin, Saeed Moghal, Waheed Fakhri, M.A. Haque, and Ashraf Toor. Professor C.M. Naim of the University of Chicago was instrumental in establishing initial contact with the Foundation, and he and Professor John Carswell were helpful in other ways as well.

At the University of Iowa, numerous colleagues and friends have been generous with their support. Among them, special thanks are due to Professor Wallace Tomasini, Director of the School of Art and Art History, who has facilitated my work on this project in a number of crucial ways. Some colleagues are included among the list of Patrons and Donors by reason of their financial support; while moral support was also graciously extended by Professors Norval Tucker, Arnold Menezes, John P. Boyle, Helen Goldstein, Ingeborg Solbrig, Sheldon Pollock, Paul Greenough, Steve Burton, Serena Stier, David Arkush, Susan E. Nelson, Steve Arum, and Satish Khera.

Most of the photographs of monuments were taken by myself, but a few were generously lent by colleagues. I am specially grateful to Dr. Catherine Asher for the illustrations of the Adina Mosque at Pandua (pp. 49-50) and the Amin Dargah at Bijapur (p. 125); other photographs were supplied through the courtesy of the Walters Art Gallery, Baltimore (p. 7); The University Museum, Philadelphia (No. 26); American Institute of Indian Studies, Center for Art and Archaeology, Varanasi (pp. 42, 45, 54, 72, 74); and the Asian Art Archives of the University of Michigan (cover and pp. 108-109). For expediting the travel grant made to Dr. Desai, thanks are due to Ms. Gretchen Ellsworth and Ms. Jacki Rand at the Smithsonian Institution.

Numerous graduate students at the University of Iowa worked on mounting and photographing the exhibition, among whom the following should be mentioned: Wing Law, Jeffrey Jenson, John Bowers, Donald Martin, David Heffner, Wayne Barlett, David Richmond, Jeffrey Lewis, John McCarthy, Donald Alvarado and Steve Tatum. In addition, Jeffrey Hughes provided help with checking bibliographic items. For their invaluable assistance in preparing the manuscript, I am indebted to Vimala Begley and Varun Begley.

Finally, I would like to record my appreciation of the participating museums that have scheduled the exhibition, and to all those colleagues who made this possible: Professor Marion Grayson, Director of the Sewall Art Gallery at Rice University; Dr. Carney Gavin, Curator of the Semitic Museum, and Professor Annemarie Schimmel, Harvard University; Professor Yasser Tabaa, Aga Khan Program for Islamic Architecture, M.I.T.; Professor Gregory Possehl, Associate Director, The University Museum, Philadelphia; Professor Howard Crane and Ms. Stephanie Blackwood, University Gallery of Fine Art, The Ohio State University; Richard Remington, Vice-President and Dean of Faculties, Frederick Woodard, Associate Dean of Faculties, and Robert C. Hobbs, Director of the Museum of Art, The University of Iowa. Thanks are also due to the Pakistan Physicians Association and the Islamic Society of North America for scheduling previews of the exhibition at their 1984 annual meetings. Much more effectively than through this Catalogue, the exhibition scheduled at these museums should help to increase public awareness of the beauty and cultural significance of monumental Islamic calligraphy India.

W.E. Begley

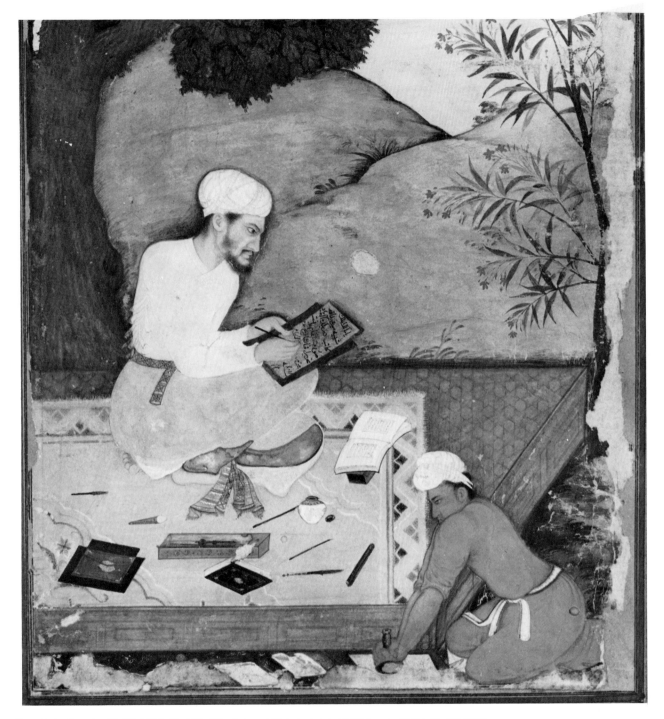

Portrait of calligrapher Mir 'Abd Allah, titled *Mushkin Qalam*, at Allahabad; dated 27 Muharram 1011 (=17 July 1602).
From manuscript of *Diwan* of Amir Hasan Dihlawi *(Walters Art Gallery, Baltimore)*
(see Catalogue No. 52)

Preface

by Dr. Z.A. Desai

former Director (Epigraphy), Archaeological Survey of India

Background of the Study of Arabic and Persian Inscriptions in India

From the late 18th-century on, after the British had become firmly established in India — and more particularly after the founding in 1784 of the Royal Asiatic Society of Bengal in Calcutta — the importance of inscriptions as an indispensable source of ancient Indian history began to be recognized by scholars, both European and Indian. However, since so many Persian histories and other literary sources were available for the medieval period, these were, and unfortunately still are, given greater priority by the majority of scholars.

Among the first works to deal systematically with Arabic and Persian inscriptions on monuments were the *Sair al-Manazil* of Mirza Sangin Baig (composed before 1820, but circulated only in manuscript copies, recently edited by Dr. S.H. Qasimi, Delhi, 1982) and the *Asar al-Sanadid* of the great scholar Sayyid Ahmad Khan (Kanpur, 1846 and subsequent editions) — later to become a founder of Aligarh Muslim University. The first of these works is in the Persian language and the second in Urdu; both deal with the monuments of Delhi and their inscriptions. They also contain fairly accurate facsimiles of inscriptions, and in the case of the *Asar al-Sanadid,* drawings of monuments also.

In 1862, the Archaeological Survey of India was formed under the directorship of Major (later General) Alexander Cunningham, and for the next twenty years, he, H. Cousins, A. Fuhrer, and Edmund Smith and others brought to light large numbers of inscriptions on monuments. They and their colleagues forwarded inked paper estampages of these inscriptions to the Asiatic Society of Bengal, where the distinguished scholar H. Blochmann, successively Assistant Professor and Principal, Calcutta Madrasa, and Philological Secretary to the Asiatic Society, deciphered and published them in the *Journal and Proceedings* of the Society — which may be regarded as a precursor of the specialized epigraphical series *Epigraphia Indica*, started in 1892 by the Government of India. In 1894, two articles on Arabic and Persian inscriptions from Delhi and parts of eastern Punjab were published in the second volume of *Epigraphia Indica,* by the distinguished scholar Dr. Paul Horn of Strasburg University.

Aside from Sayyid Ahmad Khan's Urdu work on Delhi, the first major published study of inscriptions at a particular site was J.H. Ravenshaw's *Gaur: Its Ruins and Inscriptions* (London, 1878). During the next thirty years, many important inscriptions were published in such monographic studies as Sayyid Muhammed Latif's *Lahore: Its History, Architectural Remains and Inscriptions* (Lahore, 1896) and *Agra: Historical and Descriptive* (Calcutta, 1896); Muhammed Akbar Jahan's *Ahsan al-Siyar* (Agra, 1320/1902-3); Razi al-Din Bismil's *Ganj al-Tawarikh* (Budaon, 1319/1901-2); and M. Nur Ahmad Chishti's *Tahiqiqat-i-Chishti* (Lahore, 1329/1906-7).

Apart from the periodical reports of the Archaeological Survey of India, wherein inscriptions were also published form time to time, periodicals like *Asiatic Researches, Journal and Proceedings* of the Asiatic Society of Bengal, *Indian Antiquary,* and the *Journal of the Bihar Research Society* devoted considerable space to the publication of inscriptions. Particular mention may be made to a collection of some fifty-one inscriptions from the Kathiawad or Saurashtra region of Gujarat which was published by the antiquarian department of the erstwhile Bhawnagar state under the title *Corpus Inscriptionum Bhawnagari.* (Bombay, 1889).

With the turn of the century came a greater awareness for and deeper interest in the documentation of activities of the Archaeological Survey. Arabic and Persian inscriptions also received some attention; as a result of this, there emerged a separate medium for the publication of such inscriptions in the form of a new journal called *Epigraphia Indo-Moslemica* (abbreviated *EIM*). Its first issue for 1907-08 was published under the editorship of E. Dennison Ross, then Principal of the Calcutta Madrasa; while the issues for 1909-10 and 1911-12 were edited by Dr. Joseph Horovitz, Professor of Arabic in the Muhammedan and Anglo-Oriental College, Aligarh (later Aligarh Muslim University) and Honorary Government Epigraphist for Muslim inscriptions. In his first issue, Dr. Horovitz published a detailed list of more than one thousand previously published inscriptions, arranged geographically and chronologically, and prefaced by a short but scholarly essay on their historical, linguistic, and paleographic importance.

The first World War interrupted the publication of this journal, but it was resumed with the 1913-1914 and subsequent issues up to 1939, under the editorship of Mr. Ghulam Yazdani, who was originally attached to the Archaeological Survey, and later became Director of the newly established Archaeological Department of the princely state of the Nizam's Dominions, Hyderabad, and the Honorary Muslim Epigraphist to the Government of India. Due to the second World War, the series had a lapse of four issues after the 1939-40 issue. After the 1949-50 issue, the journal was redesignated *Epigraphia Indica, Arabic and Persian Supplement* (abbreviated *EIAPS).*

From its 1951-1952 issue, the new series was edited by Dr. Z.A. Desai, who had joined the Survey in 1953 as Assistant Superintendent for Muslim Epigraphy. He edited in all twenty issues until he retired as Director (Epigraphy) in 1983. The series was converted into an annual publication after its 1959-1960 issue; long in arrears, the most recent issue to come out is that of 1975 (published 1983).

Apart from the regular journal series, the Archaeological Survey also published texts of inscriptions in its periodic reports, like *Revised List of Antiquarian Remains in the Bombay Presidency,* and also in two *Memoirs:* No. 69, *Bijapur Inscriptions* (Calcutta, 1936) by Dr. M. Nazim; and No. 67, *Quranic and Non-*

Historical Inscriptions on the Protected Monuments in Delhi (Calcutta, 1936), by M. Ashraf Husain.

The number of scholars and officials who have contributed to the various issues of *EIM* and *EIAPS* series is not large. The larger contributions to the earlier *EIM* series are — apart from those of the editors, Dr. Horovitz and Dr. Yazdani — by Zafar Hasan, M. Nazim, Shams al-Din Ahmad, Ram Singh Saksena, Khwaja Muhammed Ahmad, and Dr. M.A. Chaghtai; and to the later *EIAPS* series by W.H. Siddiqi, A.A. Kadiri, S.A. Rahim, M.F. Khan, S.S. Hussain, as well as the editor Z.A. Desai.

In more recent times, a few individual scholars have published Arabic and Persian inscriptions in independent monographs, dissertations or periodicals — like *Bulletin of the Deccan College Research Institute,* Poona; *Journal of the University of Bombay;* etc. Foremost among these scholars are M. Bashir al-Din Ahmad, of Hyderabad Civil Service, who published texts of a large number of inscriptions from the Deccan in his *Waqiat-i-Mamlakat-i-Bijapur* (Agra, 1915) and *Waqiat-i-Dar al-Huklemat-i-Delhi* (Agra, 1919); S.A.A. Bilgrami, Acting Director of the Archaeological Department, Hyderabad (1922-24), who brought out a corpus of inscriptions from Golonda and Hyderabad, under the title *Landmarks of the Deccan* in English (Hyderabad, 1927) and *Maathir-i-Dakan* in Urdu (Hyderabad, c. 1925). In 1942, Dr. M.A. Chaghtai, then of the Deccan College, Poona, published *Muslim Monuments of Ahmadabad Through Their Inscriptions,* first in the *Bulletin of the Deccan College Research Institute* and also in a separate monograph form. Other scholars include Prof. S.H. Askari, of Patna, who discovered and published quite a few inscriptions in the *Patna College Magazine;* Professor B.D. Verma, of Poona, whose Ph.D. dissertation on Adil Shahi Epigraphy was accepted by the Bombay University in the early 1960's; and Dr. Qeyam al-Din Ahmad, whose *Corpus of Arabic and Persian Inscriptions of Bihar* was published in 1972. Special mention may also be made to V.S. Bendrey's *A Study of Muslim Inscriptions* (Bombay, 1944), which contains a comprehensive analysis of the inscriptions published in the volumes of *Epigraphia Indo-Moslemica* from 1907 to 1938.

From 1952 on, an attempt was made to systematize the collection and study of important inscriptions from different parts of the country. It was decided that preliminary readings of all inscriptions collected in a particular year would be listed and published in the *Annual Reports on Indian Epigraphy* (abbreviated ARIE) which from the 1952-53 report onwards devoted a separate appendix to Arabic and Persian inscriptions. Over the last three decades, the total number of Arabic and Persian inscriptions that have been collected and listed in the *Annual Report* is well over 8,000, of which only the most important have been analyzed in detail in the journal *EIAPS.* From the first issue of *EIM* to the 1975 issue of EIAPS, the total number of inscriptions published with complete annotation is close to 2,000.

Historical and Cultural Aspects of the Inscriptions

The Indian Islamic inscriptions collected and published so far date only from the middle of the 12th century, although earlier ones are known from Sind in Pakistan, where the first Muslim incursion into the subcontinent occurred in 711. Following the establishment of the first sultanate at Delhi by ca. 1200, Muslim monuments and inscriptions quickly proliferated over most of north India. The earliest inscription that has come to light in the eastern part of India belongs to the first quarter of the 13th century; while in the South, Islamic inscriptions first appear about a century later — with the possible exception of an epitaph of the middle of the 13th century found in Andhra Pradesh, in the city of Visakhapatnam on the eastern coast. Traditional accounts report much earlier inscriptions, particularly on the Malabar coast, but none has actually been found.

The language of the majority of these records is Persian, which it must be remembered was the official court language of the country for more than six hundred years, until the early 19th century, when the British installed English in its place. Many historical inscriptions are also in Arabic, at least until around 1300; and quite a few are in both Arabic and Persian. There are very few in Urdu or Hindustani, which was the "camp" or vernacular tongue spoken from the 14th century onwards by Muslims and Hindus alike. With few exceptions, the Arabic records are in prose, most frequently consisting of quotations from the Koran. The earliest metrical Arabic inscription is from Tribeni in Bengal, and dates to the early 14th century. On the other hand, metrical Persian records occur in the 13th century and are quite common from the 14th century onwards.

Calligraphic inscriptions are found on religious buildings like mosques, seminaries (*madrasa*), and tombs; or on secular edifices like forts, palaces, gateways, tanks, wells, caravanserais, and the like. Inscribed stones have also been used as boundary or direction markers. By and large, religious buildings, particularly mosques and tombs, account for the majority of these records. Next in number come inscriptions on forts — which were of course a necessary kind of structure in the process of military conquest and rule in medieval India. The number of inscriptions commemorating philanthropic or public works like caravansarais, step-wells, dams, roads, and market places is also quite large. There are quite a few records set up for the specific purpose of proclaiming royal edicts or official orders, registering public or private endowments for charitable purposes, or confirming other kinds of bequests.

These inscriptions are usually dated in the Hijra era, which commences with the year 622, in commemoration of the migration of Prophet Muhammad from Mecca to Medina. The year is invariably expressed in words only until about the 15th century, when numerals or chronograms came into use. Chronograms give dates through the system of numerical values assigned to each letter of the Arabic alphabet, as contained in a given word, phrase, or sentence composed specifically for the purpose. The dating in the regnal year of a monarch, used for the first time in the epigraphs of the Gujarat Sultans, was extensively used in the inscriptions of the Mughals. A solar adaptation of the Hijra lunar calendar intitiated toward the middle of the 14th century was also employed occasionally in the 16th-17th century epigraphs of some parts of the Deccan.

The primary importance of these inscriptions lies in the wealth of information they furnish about various

facets of medieval India — including the political, cultural, social and religious history of the period. For example, an early 13th century inscription of Bengal, dated 1221, refers to the construction of a saintly establishment (khangah) for mystics engaged in meditation. The inscriptions are mostly dedicatory in nature, recording the date of construction of the building or event, and the political or social status of the builder — who may have been a local official, provincial governor, or even the reigning monarch. In many instances, the inscriptions give the names of officials or individuals not otherwise known from literary sources; in addition they also furnish a wealth of detail about administrative procedures, and the hierarchy of officialdom. Other inscriptions are extremely valuable for the local history of a village, a town, or district and even large areas far removed from the capital or provincial metropolis.

The large list of builders mentioned in these records furnish an interesting picture of the varied vocations and social status of the patrons of architecture — ranging from king down to lowly workman. Other references in inscriptions reveal glimpses of a vast cross-section of medieval Muslim society with occupations like banner-makers, vegetable-sellers, bangle-makers, tobacco-sellers, weavers, cobblers, barbers, horse-shoe fitters, and the like — apart from saintly personages, merchants, soldiers, courtiers and nobles.

The endowments, which were usually for the upkeep and maintenance of both religious and non-religious establishments, likewise point to a systematic pattern of financial investments that would produce revenue from shops, fruit-gardens, arable land and even wells. These investments must have in turn had a double benefit — not only to the endowed buildings but also to the local agrarian economy. Quite a few inscriptions bear testimony to the high social status and affluence of freed slaves, some of whom even rose to the exalted position of sultan.

Also known from these epigraphs is the existence of bribery and corruption among officials, and the misappropriation of even religious properties, or the rents deriving therefrom. Merchant guilds or merchant-houses are also known to have been operating in

some parts of the country.

A considerable number of funerary and other inscriptions refer to officials, scholars, merchants, sailors, and craftsmen who were foreigners settled in India, and they provide an interesting study of the assimilation of foreign population and culture in various parts of the country at different periods. We come across quite a few records of distinguished visitors who settled in India. In particular, mention may be made of a well-known official, poet and historian of Akbar, Mir Muhammad Ma'sum Nami by name, who has left calligraphed inscriptions of his on a pillar and wall of a palace, a mosque, a tomb, a temple, and numerous hostelries.

Aside from their obvious bearing on the history of Islamic architecture in India, inscriptions also provide useful information for the assessment of the literary contribution made by India to Persian language and literature in both the Sultanate and Mughal periods. While many inscriptions are trite and conventional in their wording, some contain poetry and prose compositions of high quality.

But no less important is the artistic significance of the inscriptions, most of which were designed by skilled calligraphers — of whom only about fifty are so far known in India through their signatures (twenty of these are included in the present exhibition). The calligraphic styles employed on monuments are fewer than those found in manuscripts, but they are frequently more powerful in their effect on the viewer — and not just on account of their large size. As is well known, calligraphic inscriptions constitute the most important decorative element in Indian Islamic architecture. Through their well-defined vertical and horizontal bands and friezes, the calligraphic inscriptions dramatically articulate the building; and in the process, writing took on a profundity and beauty unknown in any other religion or civilization. Calligraphy attained a high level of perfection and dazzling effect in the Qutb Minar and Quwwat al-Islam Mosque at Delhi (Nos. 2 5); the Adina Mosque at Pandua in Bengal (No. 19); the Jami Mosque and other monuments at Ahmadabad in Gujarat (Nos. 22, 60); various buildings at Golconda and Hyderabad in Andhra Pradesh (Nos. 57, 64); Akbar's Tomb at Sikandra (53); and the famed

Taj Mahal at Agra (No. 59). The inscriptions selected for the present exhibition constitute a rich collection of beautifully executed specimens of calligraphic art on stone in diverse scripts in amazing dimension and ingenious ornamentation. In addition to their historical value, the inscriptions are clearly also works of art.

A Note on the Technique of Preparing Estampages

A few words may perhaps be said to explain the technique for copying inscriptions used by the epigraphy branch of the Archaeological Survey of India. Estampages or paper impressions can be prepared only from those stone inscriptions that are carved in raised or incised relief; the pietra-dura inlay work on the Taj Mahal, for example, produces a completely smooth surface, making it impossible to take impressions of its calligraphy.

The instruments used to make impressions are few and simple. These are: a horse-hair brush with curved wooden handle; a padded ink applicator (usually a small wooden box), covered with velvet cloth; large-size paper, preferably hand-made of substantial weight; ink prepared out of black lamp-soot mixed with glue; and some sort of scraper for cleaning, if necessary, stone inscriptions that have become covered with layers of dirt or whitewash.

To make an impression, the inscription is first properly cleaned and dampened with water. Next sheets of paper, cut to the size of the inscription, are stuck to the stone and smoothed with the brush to make them stick to the surface; this is accomplished by wetting the paper sufficiently to make it adhere to the surface, but not to become so wet as not to absorb the ink. When the paper is uniformly pressed by the brush, it will completely stick into the surface of the inscription, which is either inscribed in raised-relief letters or incised with letters cut into the surface. Care is taken to see that the paper completely covers each and every part of the inscription to be copied.

After coating the velvet surface of the dabber with ink, the paper is then uniformly dabbed, replenishing the ink as necessary. When the entire surface of the paper covering the inscription has been dabbed, the estampage or impression is then carefully removed from the stone, and spread out to dry — thus allowing the paper to shrink and return to its normal flat condition. In the case of incised incriptions, the background will be black and the letters white; while in the case of the far more common raised relief inscriptions, the letters are black against a white background — so that the impression thus closely approximates the original ink design that would have been prepared by the calligrapher for the stonecutter's use.

The *Arabic* and *Persian* Alphabet

	No.	Name	Separate Form	Transcription	Combined Forms Final Medial Initial	Numerical Value		No.	Name	Separate Form	Transcription	Combined Forms Final Medial Initial	Numerical Value
	1.	Alif	ا	a,ā,etc.	ـا... ── ──	1		17.	Ṣād	ص	ṣ	ـص...ـصـ...صـ	90
	2.	Bā' (Be)	ب	b	ـب...ـبـ...بـ	2		18.	Ḍād (Ẓād)	ض	ḍ (ż)	ـض...ـضـ...ضـ	800
(P)	3.	(Pe)	پ	p	ـپ...ـپـ...پـ	(2)		19.	Ṭā'	ط	ṭ	ـط...ـطـ...طـ	9
	4.	Tā' (Te)	ت	t	ـت...ـتـ...تـ	400		20.	Ẓā'	ظ	ẓ	ـظ...ـظـ...ظـ	900
	5.	Thā' (Ṣe)	ث	th (s)	ـث...ـثـ...ثـ	500		21.	'Ayn	ع	'	ـع...ـعـ...عـ	70
	6.	Jīm	ج	j	ـج...ـجـ...جـ	3		22.	Ghayn	غ	gh	ـغ...ـغـ...غـ	1000
(P)	7.	(Chīm,Che)	چ	(ch)	ـچ...ـچـ...چـ	(3)		23.	Fā' (Fe)	ف	f	ـف...ـفـ...فـ	80
	8.	Ḥā' (He)	ح	ḥ	ـح...ـحـ...حـ	8		24.	Qāf	ق	q	ـق...ـقـ...قـ	100
	9.	Khā' (Khe)	خ	kh	ـخ...ـخـ...خـ	600		25.	Kāf	ك	k	ـك...ـكـ...كـ	20
	10.	Dāl	د	d	ـد... ── ──	4	(P)	26.	(Gāf)	گ	(g)	ـگ...ـگـ...گـ	(20)
	11.	Dhāl (Ẓal)	ذ	dh (z)	ـذ... ── ──	700		27.	Lām	ل	l	ـل...ـلـ...لـ	30
	12.	Rā' (Re)	ر	r	ـر... ── ──	200		28.	Mīm	م	m	ـم...ـمـ...مـ	40
	13.	Zāy (Ze)	ز	z	ـز... ── ──	7		29.	Nūn	ن	n	ـن...ـنـ...نـ	50
(P)	14.	(Zhe)	ژ	(zh)	ـژ... ── ──	(7)		30.	Hā' (He)	ه	h	ـه...ـهـ...هـ	5
	15.	Sīn	س	s	ـس...ـسـ...سـ	60		31.	Wāw (Vāv)	و	w(v)etc.	ـو... ── ──	6
	16.	Shīn	ش	sh	ـش...ـشـ...شـ	300		32.	Yā' (Ye)	ی	y,ī,etc.	ـی...ـیـ...یـ	10

DIACRITICAL SIGNS

١ ٢ ٣ ٤ ٥ ٦ ٧ ٨ ٩ ٠
1 2 3 4 5 6 7 8 9 0

Fathah (Zabar)	╱	a
Kasrah (Zir)	╱	i (e)
Dammah (Pish)	�9	u (o)

Hamzah	ء	' (glottal stop)	Tanwin - an, etc. (suffix)
Maddah	ٓ	ā (extended alif)	Shaddah (Tashdid)	ّ (doubled consonant)
Waslah	ٱ	(unvocalized alif)	Sukun (Jazm)	٥ (unvocalized consonant)

Introduction
by W. E. Begley

O calligrapher! As long as thy pen continues
 to work miracles,
It is fitting if Form proclaims superiority
 over Meaning!

Each of thy *da'ira* curves causes Heaven's dome
 to declare itself thy slave;
While each *madda* stroke thou mak'st is worth
 the price of Eternity itself!

—Mir 'Ali Harawi (d. 1556)

Islamic Calligraphy as Art

Attributed to one of the most famous Persian calligraphers of the 16th century, these remarkable verses furnish insight into some of the reasons why the Islamic world has long regarded calligraphy as the highest form of artistic expression. In no other world civilization—except for that of China and the regions under its influence—has the art of writing been so exalted, or such extravagant claims made for its enduring aesthetic impact on the viewer.

Actually, the aesthetic stance taken here by the poet is surprisingly close to the formalist theories of Modern Art. In effect, Mir 'Ali claims that the intrinsic meaning, or content, of beautiful writing is secondary in importance to the totally abstract form of its letters considered as an artistic composition. The second verse cites two specific types of strokes that calligraphers spent years in mastering, before winning the critical acclaim of connoisseurs: fully rounded strokes *(da'ira)*; and the long extended strokes *(madda)* used in executing certain letters of the Arabic and Persian alphabet (for examples, see the Nasta'liq exercise model on facing page).

In accordance with literary convention of the time, Mir 'Ali addresses himself as "thou"; so it is his own calligraphic skill that here elicits such vain and grandiose praise. The poetic allusions he employs are both subtle and ingenious. When he speaks of "Heaven's dome" *(falak)* declaring itself a slave

(literally, wearing "the earring of slavery"), the motivation is obviously envy of the even more perfect curves created by the calligrapher; while the second simile suggests that the *extended* strokes *(madda)* of his pen are so enduringly beautiful that their value *extends,* as it were, to the very Day' of Judgement *(muddat-i-ayyam).*

Mir 'Ali's high estimation of the aesthetic merits of calligraphy was shared by numerous connoisseurs of the 16th century, including the great Indian scholar Abu'l-Fazl, author of the voluminous *Akbar Nama,* or history of the reign of the Mughal emperor Akbar (1556-1605). In the *A'in-i-Akbari,* Abu'l Fazl maintains that "pictures are much inferior to the written letter [which is] spiritual geometry emanating from the pen of invention"—thereby adapting the maxim traditionally attributed in Islamic literature to Plato: "Writing is the geometry of the soul." In the same effusive vein, Abu'l-Fazl continues:

Superficial observers see in the letter a sooty figure, but the deepsighted see a lamp of wisdom...A letter is the portrait painter of wisdom...a black cloud pregnant with knowledge...speaking though dumb; stationary, and yet travelling; stretched on the sheet, and yet soaring upwards.

It may well be asked how calligraphy attained such an exalted conceptual status in Islamic civilization. An adequate answer to this question would require several volumes; but briefly stated, the importance of calligraphy derives from its crucial role in three main areas of Islamic civilization—

which might be labelled *religious, political,* and *cultural* (or *aesthetic*).

The sacrosanct character of the written word in Islam stems in large part from its being regarded as copied from a divine prototype, namely the Koran. According to orthodox interpretation, the Koran is eternal both in *content* and *form;* it is in effect the *Logos,* or Word of God embodied in physical form. The Koran itself refers to its own sanctity and uniqueness, and in addition contains numerous metaphors of the calligrapher's pen as a divine instrument. In the Sura "The Clot" (96.4-5), God is praised as *"He Who taught with the Pen, taught man that he which knew not!"*

According to medieval Islamic cosmology, the Pen is also the embodiment of the Primordial Intelligence *('Aql al-Awwal),* which represents the first seemingly differentiated aspect of Divine Unity: in the process of Divine Emanation *(Tajalli),* the Pen thus becomes the actual agent of Creation. Since the words of the Koran are divine both in form and content, it is small wonder that they became the "sacred symbol" of Islam—particularly when the use of icons or figurative images of any kind was totally prohibited on most Islamic monuments. Throughout the Islamic world, mosques are decorated with passages from the Koran inscribed by skilled calligraphers. Like the figurative sculptures adorning medieval Christian churches, the Koranic inscriptions on mosques and tombs convey important religious concepts and values that help us

Exercise Model for Nasta'liq Script (adapted form Ihtram ud-Din Ahmad, *Sahifa-i-Khushnavisan*, Aligarh, 1963)

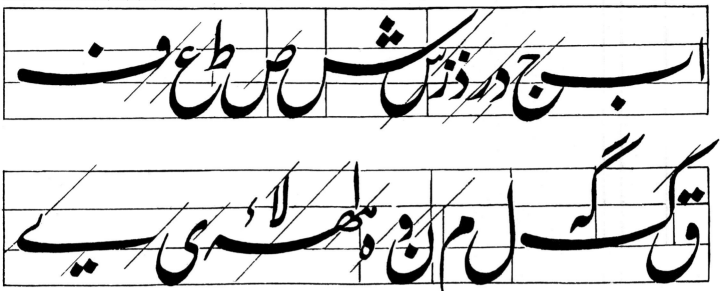

understand the deeper levels of meaning of the architectural monument. In effect, from the time of the Dome of the Rock in Jerusalem, the first Islamic architectural masterpiece, calligraphy on monuments has increasingly served what might be called an "iconographic" function—a function to which Western scholars have only recently begun to pay serious attention.

In addition to the rich aura of religious associations summoned up by specific Koranic passages, even the very letters of the Arabic alphabet came to be imbued with complex symbolism. It is well known that the letters of the Arabic alphabet have assigned numerical values; and these were widely employed to devise chronograms commemorating important events like birth and death dates, as well as the dates of construction of architectural monuments. In the hands of mystical sects like the Hurufiyya (from *huruf,* meaning "letter"), the letters of the alphabet acquired esoteric meanings similar to those associated with the Jewish Kabbalah. The use of Koranic verses as charms or talismans continues even to this day.

The *political* applications of calligraphy are also of crucial importance. The great majority of imposing Islamic monuments were of course constructed by rulers or members of the nobility; hence architec-

tural inscriptions frequently consist of flattering eulogies of these patrons. Even on mosques, much more space is sometimes devoted to praise of both the ruling monarch and the actual patron, than to appropriate quotations from the Koran. Thus on occasion, the religious character of the building becomes obscured by the propagandistic motivation of the inscriptions. As in the case of purely religious inscriptions, the form of the calligraphy—particularly the type of script used—was of great concern to the designers of the political inscriptions. Here also, *words* functioned as if they were *images*—summoning up a mental picture of the builder's rank and prestige, as well as detailing the building's literal and allegorical functions.

As used here, the term *cultural* applies to other kinds of purposes served by calligraphy, besides religious and political. This rubric would of course include perhaps the most important function of the calligrapher in Islamic civilization—namely to transcribe books and therefore aid in the dissemination of knowledge throughout the Islamic world, before the very late adoption of Western printing technology. The copyists of books are usually called scribe *(katib)*, to distinguish them from the great calligraphers, even though the latter probably received most of their remuneration from the same mundane

task of copying. Most skilled calligraphers were also scholars, and many were also capable poets and prose writers as well; hence many architectural inscriptions tell us about both the literary and the artistic abilities of the calligraphers.

In short, writing was an important cultural value in Islam, and its presence on architectural monuments—regardless of whether they were religious or secular—came to be expected by the educated classes, and even by the illiterate members of society as well. In the words of the late distinguished scholar Richard Ettinghausen, writing on buildings was more frequently intended as "symbolic affirmation" rather than mere "communication."

There remains to be briefly considered what might be called the purely "aesthetic" aspects of calligraphy, for these surely played an important role in the exaltation of writing in the Islamic world. Indeed, it could be argued that without the contributions made by early masters to the refinement of the Arabic script, calligraphy would not have developed into the major art form that it did. Originally descended from Aramaic by way of the Nabataean script used in North Arabia, the Arabic alphabet did not evolve most of its present characteristics until the 8th or 9th century, when diacritical signs for

showing vowels were added to the original consonants.

Far more important than these technical improvements was the invention of distinctive calligraphic "styles" by the early master scribes. Unfortunately, there soon developed almost as many "styles" as there were calligraphers; and not until the 10th century did the various "styles" come to be somewhat standardized through the efforts of the great Abbasid calligrapher Ibn Muqlah (d. 940). In the realm of architectural inscriptions, the angular Kufi script continued to dominate until the 12th century; but Ibn Muqlah and others concentrated their energies on perfecting the various cursive styles, which by this time had been reduced to the still standard list of six—Thulth, Naskhi, Muhaqqaq, Rayhani, Riqa' and Tawqi'. An important statesman as well as influential calligrapher, Ibn Muqlah served as vizier to three caliphs, until the last of these had him imprisoned and put to death. Ibn Muqlah's great contribution to calligraphy lay in his devising geometric structures for each letter and a coherent system of proportional relationships for the entire alphabet.

Because calligraphy now possessed a rigorous intellectual foundation, analogous to those of mathematics and musical theory, later master calligraphers came to be respected both as scholars and artists—just as Renaissance painters gained greater respect among intellectuals following the invention of one-point perspective. From the 10th century onward, the reputations of calligraphers and the aesthetic stature of calligraphy steadily increased, eventually making it possible for Mir 'Ali Harawi to write the verses quoted above, praising the superiority of the *form* of his words over their *meaning*.

Monumental Islamic Calligraphy in India

By the time the first permanent Muslim empire in India was established at the end of the 12th century, the tradition of adorning Islamic monuments with large-scale calligraphy was already centuries old.

Before the 12th century, almost all Islamic architectural calligraphy was executed in the dignified angular script called Kufi—after the Mesopotamian city of Kufa, where it had supposedly been invented in the 7th century. The earliest versions of Kufi, found in various manuscripts of the Koran, as well as the inscriptions inside the Dome of the Rock and other early monuments, are rather austere in appearance. As time progressed, however, many ornamental varieties of Kufi evolved; serifs, hooks and foliate forms were added, and complex patterns were created by intertwining the verticals of certain letters—particularly the *lam-alif* combination, and the letters forming the word *Allah*.

The earliest known Kufi inscription inside India dates to 554 Hijri(=1159-60), and occurs on a tomb at the site of Bhadreswar in Gujarat (No. 1). The foliate variety here employed is greatly similar to contemporaneous inscriptions in Afghanistan and Iran as well as Egypt and Syria. By the end of the 12th century in India, a highly sophisticated type of plaited Kuri began to appear certain monuments at Ajmer and Delhi (No. 4), only to disappear almost completely from Indian inscriptions after ca. 1250 (a rare late survival of plaited Kufi appears on No. 15, dated 1333).

The primary reason for the decline of the angular Kufi was that it was replaced in popularity by monumental cursive scripts. Outside India, the use of cursive styles in architectural inscriptions began in the 12th century, which in effect saw the passing of one calligraphic era and the advent of another. The earliest Sultanate monuments in India like the Quwwat-al-Islam mosque and the Qutb Minar (No. 2) either use cursive scripts entirely or else juxtapose them with a few elaborate bands of Kufi—as on the later extensions to the Quwwat mosque (No. 5). There is some confusion in the scholarly literature as to what this monumental cursive should be called; some use the term Naskhi, and others, Thulth. Even within the Arabic and Persian literature on calligraphy, the terms sometimes appear to be interchangeable. In most Indian publications, the term *Naskhi* (which literally means "copyist" or "scribal") is used for the earlier varieties of monumental cursive; while the term *Thulth* (literally, "one-third"—the name supposedly deriving from the ratio between curves and straight lines) is applied to the uniform varieties inscribed on Indian monuments from the 14th century onward. This usage will be followed here even though it differs from the terminology of some writers on Islamic calligraphy outside India. The term *Tughra* refers not to a distinct type of script, but rather to the exaggerated flourishes and convoluted patterns of overlapping found in certain inscriptions.

Whatever terms are used, there are clearly two major categories of bold, monumental cursive calligraphy on Indian monuments. The first of these, here called Naskhi, is characterized by irregularity in the shape of its letters, and by its highly expressionistic, almost frenzied sense of movement. Most of the letters are rather thick, especially the verticals, which sometimes are so widely flaring as to appear like elongated triangles.

In contrast to Naskhi, monumental Thulth is extremely regular in appearance; its letters are always well-proportioned and uniform in thickness.

Major Styles of Calligraphy in Indian Inscriptions:

(a-e) varieties of Kufi;

(f) Naskhi;

(g) Thulth;

(h) Nasta'liq

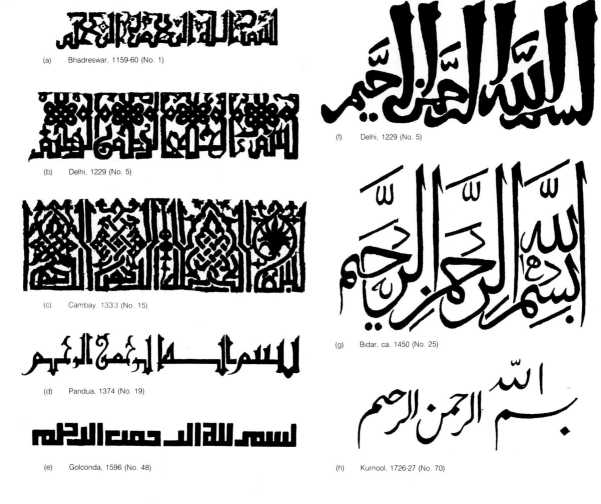

(a) Bhadreswar, 1159-60 (No. 1)

(b) Delhi, 1229 (No. 5)

(c) Cambay, 1333 (No. 15)

(d) Pandua, 1374 (No. 19)

(e) Golconda, 1596 (No. 48)

(f) Delhi, 1229 (No. 5)

(g) Bidar, ca. 1450 (No. 25)

(h) Kurnool, 1726-27 (No. 70)

The sense of movement of Thulth is more stately and dignified—it is much more self-consciously "artistic", and obviously required greater discipline on the part of the calligrapher. Very few Naskhi inscriptions bear the signature of a calligrapher, but it is much more common for Thulth inscriptions to be signed—sometimes in large prominent letters (e.g., Nos. 25, 58, 65; see also the signature of Amanat Khan inside the Taj Mahal, on p. 111).

As in the case of the transition from angular Kufi to cursive Naskhi, there was a fairly long period of chronological overlap, when both irregular Naskhi and standard Thulth were used on Indian monuments. Though Thulth was introduced as early as the 14th century, it did not succeed in ousting the earlier script until around the middle of the 16th century—the last major use of monumental Naskhi with widely flaring verticals was on the tomb of Sher Shah Suri (see No. 35), dating to 1545.

The 16th century also saw the first use on Indian monuments of the very delicate cursive script called Nasta'liq. Supposedly invented around 1400 by the great Persian calligrapher Mir 'Ali Tabrizi, the refinement of Nasta'liq complemented perfectly the subtleties of Persian poetry. It is surely no coincidence that after Nasta'liq started appearing on monuments (No. 33 dated 1515, is the earliest Indian example), more and more dedication inscriptions were composed in Persian verse. Under the Mughal emperors, Nasta'liq was the preferred script for writing everything except passages from the Koran—for which the more traditional Thulth continued to be employed right up to modern times.

As mentioned in the Preface, surprisingly few Indian monuments bear the signatures of the calligraphers who designed them. In all only about fifty names are so far known, and of these, twenty different calligraphers are included in the present exhibition. Despite the high praise of the calligrapher's art contained in both Arabic and Persian literary works, the social standing of Indian calligraphers generally was not high. Mere scribes (katib) were not usually paid much for the manuscripts they copied, but calligraphers of exceptional skill were sometimes lavishly rewarded by their

Serai Amanat Khan (Punjab), view of west gateway

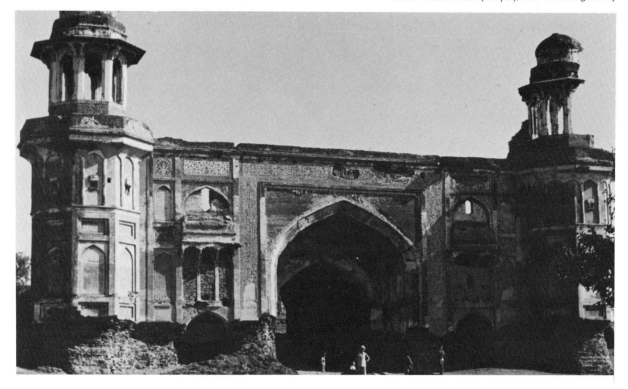

wealthy and noble patrons— particularly in Mughal India, where Persian poets, painters and calligraphers immigrated with the expectation of sharing in the famed largesse of art connoisseurs there.

Like art collectors in our own time, Mughal connoisseurs vied with one another to acquire creations of the great masters—in this case, calligraphy from the pens of famous Persian masters of the distant and immediate past. The work of Mir 'Ali Harawi (whose verses on calligraphy are quoted above) was particularly admired; and numerous examples of his work (not all authentic) adorned the pages of the great albums of calligraphy and painting that were assembled for the Mughal emperors Jahangir and Shah Jahan, as well as some of the great nobles.

Among the living masters resident at the Mughal court, some were specially honored by honorific titles as well as generous stipends. Four calligraphers at the end of the 16th and beginning of the 17th century were further honored by having their portraits included at the ends of manuscripts they had copied—including the portrait of the famed Nasta'liq calligrapher Mir 'Abd Allah, titled *Mushkin Qalam* ("Musky-Pen"), which was painted in 1602 while he was in the employ of Prince Salim at Allahabad (see reproduction on p. 7). The portrait is the only one extant of a calligrapher who is known to have also designed architectural inscriptions. Like many calligraphers, Mir 'Abd Allah was also a poet, and in 1604 he was requested to compose a verse epitaph and design the gravestone for Prince Salim's wife Shah Begum, following her tragic suicide in that year (see Catalogue No. 52).

The most honored calligrapher in Indian history was also the designer of the calligraphy on India's most famous Islamic monument, the Taj Mahal (No. 59). This was the great Persian master 'Abd al-Haqq of Shiraz, the son of a professional scribe named Qasim. He was probably in his thirties, when he immigrated to India around 1608, and entered the employ of the emperor Jahangir. His first major commission apparently was to both compose the Persian eulogy and inscribe the magnificent Thulth and Nasta'liq calligraphy on the gateway of the late emperor Akbar's tomb at Sikandra (see No. 53). Unlike his more famous brother Afzal Khan, who quickly became a high-placed official (he eventually became prime minister under Shah Jahan), 'Abd al-Haqq was content with a scholarly appointment in the royal library, although after Shah Jahan's accession he was also entrusted with periodic diplomatic tasks. About six months after work commenced on the Taj Mahal, 'Abd al-Haqq was appointed to a fairly high level in the Mughal nobility and also awarded the noble title Amanat Khan. Approximately equivalent to knighthood, this distinguished honor had apparently never before been bestowed upon a calligrapher in Mughal India.

But then Amanat Khan was no ordinary calligrapher. Entrusted with designing the Koranic inscriptions on the famed Taj Mahal, he produced monumental calligraphy that must rank as one of the

Detail of dedication inscription designed by the calligrapher Amanat Khan

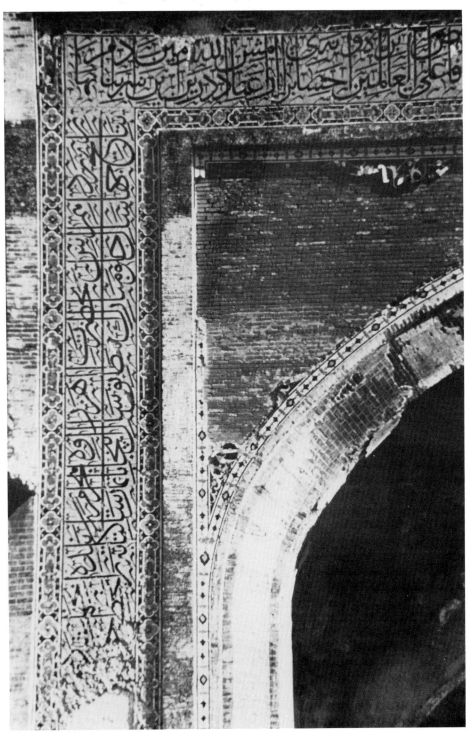

great achievements of world art—as majestic and beautiful as the architecture of the tomb itself.

In addition to Akbar's tomb and the Taj Mahal, two more monuments survive with calligraphic designs by Amanat Khan. One of these, the Madrasa Shahi mosque at Agra is also included in the present exhibition (No. 58). The last known calligraphic work of Amanat Khan was the vast and extravagantly decorated caravanserai he built with his own funds about a day's journey east of Lahore, on the old Mughal highway connecting that city with Delhi and Agra. This was at the place the distinguished calligrapher had retired from public office in 1639, following the death of his brother Afzal Khan, Shah Jahan's highly honored prime minister.

Completed two years later, in 1640-41, the serai's most extraordinary feature is its use of glazed-tile calligraphy to adorn both of its mammoth gateways. No other Indian serai has such large and magnificent inscriptions; the lengthy Persian dedication they contain was both composed and written by the calligrapher himself. Building serais was considered an act of pious religious charity, and the conclusion of Amanat Khan's boldly written inscription on the west gateway confirms this motivation:

...I have founded this serai in this land for the comfort of God's creatures, and having completed it on this date—the fourteenth year of the auspicious accession of His August Majesty (Shah Jahan), corresponding to the Hijri year one-thousand-and-fifty (=1640-41)—(I wrote) this inscription with my own hand by way of a remembrance...

Although Amanat Khan's calligraphy on the Taj Mahal will always be considered his supreme masterpiece, his inscriptions on the serai bearing his name constitute a moving, final aesthetic testament of a great artist nearing the end of his life. Four

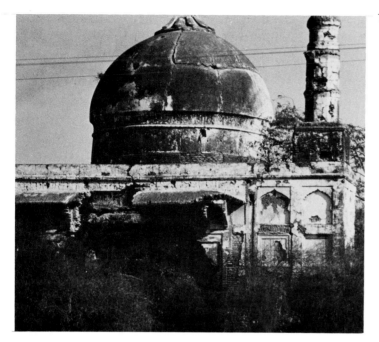

Tomb of Amanat Khan

years later, in the eighteenth year of Shah Jahan's reign (1644-45), Amanat Khan did in fact die, and was buried in a small, presently very dilapidated tomb near his vast caravanserai. One hopes that both the serai and tomb will eventually be preserved and restored by the Archaeological Survey of India—not only as a lasting tribute to Amanat Khan's individual greatness as an artist, but as a symbolic memorial to all those other calligraphers whose work provides a key to the better understanding of an important chapter of India's rich artistic heritage.

Rationale and Scope of the Exhibition

The present exhibition is the first in this country to focus entirely on large-scale calligraphy adorning Indian Islamic monuments. In recent years, some progress has been made in increasing Western awareness of Islamic calligraphy, through a few notable exhibitions like *Calligraphy in the Arts of the Muslim World*, organized by Anthony Welch in 1979 for the Asia House Gallery in New York, which assembled an impressive number of manuscripts and inscribed ceramics, textiles and metalware.

For obvious reasons, original stone inscriptions from monuments are rarely included in art exhibitions; most major examples of Indian architectural calligraphy are either still attached to the original buildings, or else their great size and weight preclude their shipment outside the country. Even for visitors to the original monuments in India, there are obstacles standing in the way of a proper aesthetic evaluation of the calligraphy. The vast size of many of the buildings, their frequently damaged condition and various other distractions sometimes make it difficult to even *see* the calligraphy, much less appreciate its artistry. As a result of these difficulties, a highly significant body of artistic and historical material has passed largely unnoticed by scholars and public alike.

Instead of the original stone inscriptions, the present exhibition consists of full-size inked estampages on paper that have been prepared directly from the monuments (by the procedure mentioned in the Preface). The sixty-four exhibited estampages (supplemented by seven full-size photomurals) have been selected from the extensive archives of the Archaeological Survey of India at

Nagpur, which contains facsimiles of more than 12,000 Arabic and Persian inscriptions taken from Islamic monuments all over India. As pointed out by Dr. Desai in his Preface, these estampages have been systematically collected for almost a century; and since 1907, almost 2,000 have been published in the journals *Epigraphia Indo-Moslemica* and *Epigraphia Indica, Arabic and Persian Supplement*. Occasionally some of the estampages have been lent to scholarly exhibitions within India (such as the Seminar on Medieval Inscriptions held at Aligarh Muslim University in 1970), but never before have they been displayed in the U.S.

As full-size replicas of the stone inscriptions, the inked paper estampages are of course impressive in scale. Surprisingly they are also impressive as works of art. Not only are they carefully executed (the process of preparing an estampage is somewhat analogous to making a monotype print); but they are also, in effect, faithful re-creations of the original ink designs that would have been prepared by the master calligraphers as models for the stonecutter to follow. In fact, by showing the writing as black letters against a white background, the estampages give a better idea of the calligrapher's *original* design than do some of the actual stone reliefs still *in situ*.

As pointed out above, much of the aesthetic appreciation of calligraphy within the Islamic tradition stems from the dramatic visual contrast that exists between the whiteness of the paper and the immutable blackness of the letters inscribed upon it. Hence the transference of the calligrapher's inked design to the medium of stone necessarily modified his original concept, not always to best advantage. On many buildings, it is true, the strong

shadows cast by the Indian sun create a bold contrast between the raised-relief letters and their background, but this effect only temporarily makes the inscriptions as clearly legible as they would have been on the calligrapher's original inked model.

During the 17th century, a new technique of *pietra-dura* inlay was introduced in India which allowed calligraphers to reproduce exactly their inked designs. The most outstanding example of this technique is found on the Taj Mahal (see No. 59), where the letters are inlaid with black stone into the white marble surfaces of the building. The strong resemblance between the Taj's calligraphy and the inked estampages in the present exhibition points up the importance of the latter as a means of re-creating, and thereby better understanding, the calligrapher's original designs.

The task of selecting representative inscriptions was complicated by the vast number of Arabic and Persian estampages in the archives of the Archaeological Survey of India at Nagpur. A preliminary selection was made from among the almost 2,000 published inscriptions, whose translations and scholarly interpretations have formed the basis for the treatment given in the present Catalogue. In order to convey the full range of monumental Islamic calligraphy from India, the selection was not limited to any particular time-period or geographical region. As a result, the seventy-one inscriptions included here span more than 600 years, and come from almost every region of India (inscriptions from Pakistan and Bangla Desh unfortunately could not be included in the present exhibition, so the selection is not fully representative of Islamic calligraphy in the entire subcontinent).

Aside from the obvious criterion of aesthetic excellence, the major motivation in the selection was to achieve some sort of chronological and geographical balance—so that every major type of inscription and calligraphic style would be included. For each century, there are approximately ten inscriptions—although the 12th and 18th centuries have less, and the 16th and 17th centuries more; this allowed all of the major Muslim dynasties in India to be represented (see List on p. 21). The following is the breakdown of inscriptions by state or territory: *Andhra Pradesh:* 11; *Bihar:* 6; *Delhi:* 4; *Gujarat* 12; *Karnataka:* 10; *Madhya Pradesh:* 6; *Maharashtra:* 3; *Punjab:* 1; *Rajasthan:* 4; *West Bengal:* 7; *Uttar Pradesh:* 10.

As for the types of scripts employed, these reflect most of the regional and period varieties that are peculiar to India. Only five inscriptions use Kufi, since this angular monumental script never caught on in medieval India. The bold cursive inscriptions are equally divided between the earlier, thicker and more irregular variety, here called Naskhi; and the thinner and more uniformly proportioned Thulth—together these two scripts account for about four-fifths of all the inscriptions. Of the inscriptions written in Naskhi and Thulth, about fifteen are sufficiently dense and convoluted to be also called Tughra. The latest script to appear in monumental Indian inscriptions was the delicate Nasta'liq, accounting for about one-fifth of the total number of inscriptions. Nasta'liq was introduced in the early 16th century; by the end of the same century it and monumental Thulth had completely replaced the earlier varieties of Naskhi.

The selection is also comprehensive with regard to the types of buildings inscribed, and gives some idea of the priorities of use of monumental calligraphy on Indian Islamic architecture. About half of the inscriptions were originally installed on mosques and one-fourth on tombs and gravestones—corresponding fairly closely to the percentages obtaining in published inscriptions throughout the subcontinent. The remaining one-fourth of the inscriptions derive mostly from secular buildings such as forts, gateways, caravanserais, and other miscellaneous structures.

Many of these inscriptions contain poetry or prose compositions that are typical of literary tastes in the periods they represent. Although the texts of most inscriptions consist primarily of flattering eulogies of the rulers and nobles who caused the buildings to be built, they all provide interesting glimpses into the great cultural heritage of Muslim India. The often obscure historical events and personages mentioned in the inscriptions may be of greatest interest to scholars, but the beauty and majesty of the calligraphy—its *form* if not its *meaning*—should be comprehensible to everyone. In the words of the 16th-century author Qadi Ahmad, "If someone, whether he can read or not, sees good writing, he likes to enjoy the sight of it."

SELECT BIBLIOGRAPHY

For the purposes of this Catalogue, the primary references consulted are those cited in the captions for each inscription, especially the definitive articles published in *Epigraphia Indo-Moslemica* and *Epigraphia Indica, Arabic and Persian Supplement* (complete list given in Appendix I). In addition to the books and articles cited in the Preface and Introduction, the following are also recommended (works marked with an asterisk contain detailed bibliographies relevant to the study of Islamic calligraphy):

* Abbott, Nabia. *The Rise of the North Arabic Script and its Kur'anic Development.* Chicago, 1939.

Ahmad, Nazir. "Shah Khalilullah Khushnawis, The Royal Calligraphist of the 'Adilshahi Court," *Islamic Culture* 44 (1970), 36-55.

* Ahmad, Qadi. *Calligraphers and Painters...* Translated by V. Minorsky, Washington, 1959.

Ahmed, Shamsud-Din. *Inscriptions of Bengal,* vol. 4. Rajshahi, 1960.

* Arts Council of Great Britian. *The Arts of Islam.* London, 1976.

Begley, W.E. "Amanat Khan and the Calligraphy on the Taj Mahal," *Kunst des Orients* 12(1978-79), 5-55.

———. "The Myth of the Taj Mahal and a New Theory of its Symbolic Meaning," *The Art Bulletin* 61 (1979), 7-37.

———. "The Symbolic Role of Calligraphy on Three Imperial Mosques of Shah Jahan," in J. Williams, ed. *Kaladarsana: American Studies in the Art of India.* New Delhi, 1981.

———. "Four Mughal Caravanserais Built during the Reigns of Jahangir and Shah Jahan," *Muqarnas 1* (1983), 166-179.

———. "A Mughal Caravanserai Built and Inscribed by Amanat Khan, Calligrapher of the Taj Mahal," in F.R. Asher and G.S. Gai, eds., *Indian Epigraphy: Its Bearing on Art History* (forthcoming).

Bendrey, V.S. *A Study of Muslim Inscriptions.* Bombay, 1944.

Bilgrami, A.A. *Landmarks of the Deccan.* Hyderabad, 1927.

Chaghtai, M.A. *Muslim Monuments of Ahmadabad Through Their Inscriptions.* Poona, 1942.

———. *Pak wa Hind men Islami Khattati.* Lahore, 1976.

Desai, Z.A. "A 17th Century Iranian Calligrapher of India," *Indo-Iranica* 30(1977), 50-61.

Ettinghausen, Richard. "Arabic Epigraphy: Communication or Symbolic Affirmation," in *Studies in Honor of George C. Miles.* Beirut, 1974.

* Dodd, Erica C. and Khairallah, Shereen. *The Image of the Word, A Study of Quranic Verses in Islamic Architecture,* 2 vols. Beirut, 1981.

Ghafur, M.A. *The Calligraphers of Thatta.* Karachi, 1968.

———. "Fourteen Kufic Inscriptions of Bhambhore," *Pakistan Archaeology,* 3(1966), 65-90.

Grohmann, Adolf. *Arabische Palaographie,* 2 vols. Vienna, 1967-1971.

Ghulam, Muhammad. *The Tadhkira-i-Khushnavisan.* Ed. by H. Hidayet Husain. Calcutta, 1910.

Habibi, Abdul Hayy. *A Short History of Calligraphy and Epigraphy in Afghanistan.* Kabul, 1971.

Huart, Clement. *Les Calligraphes et les Miniaturistes de l'Orient.* Paris, 1908.

Lings, Martin. *The Quranic Art of Calligraphy and Illumination.* London, 1976.

Moritz, Bernhard. *Arabic Palaeography.* Cairo, 1906.

Nath, R. *Calligraphic Art in Mughal Architecture.* Calcutta, 1979.

K.A. Nizami, ed. *Proceedings of the Seminar on Medieval Inscriptions.* Aligarh, 1974.

Pope, Arthur U. and Ackerman, eds. *A Survey of Persian Art,* vol. 2. London, 1939 (section on "Calligraphy and Epigraphy").

* Rahman, Pares I.S.M. *Islamic Calligraphy in Medieval India.* Dacca, 1979.

Safadi, Y.J. *Islamic Calligraphy.* London, 1978.

* Schimmel, Annemarie. *Calligraphy and Islamic Culture.* New York, 1984.

———. *Islamic Calligraphy.* Leiden, 1970.

Soucek, Priscilla P. "The Arts of Calligraphy," in Basil Gray, ed. *The Arts of the Book in Central Asia.* Paris, 1979.

Verma, S.P. "Portraits of the Calligraphers Depicted in the Mughal Miniatures—A Historical Study," *Islamic Culture* 54(1980), 173-180.

* Welch, Anthony. *Calligraphy in the Arts of the Muslim World.* New York and Austin, 1979.

Zafar, Hasan. *Specimens of Calligraphy in the Delhi Museum of Archaeology.* Memoirs of the Archaeological Survey of India, No. 29. Calcutta.

Ziauddin, M. *Moslem Calligraphy.* Calcutta, 1936.

List of *Muslim Dynasties* in India
and Rulers Mentioned in the Inscriptions

North India

South India

DELHI SULTANATES

GHURI:
Muhammad ibn Sam (ca. 1173-1206)

MAMLUK:
Qutb al-Din Aibak (1206-1210)
Iltutmish (1211-1236)
[Mas'ud Shah (1242-1246)]
Mahmud Shah (1246-1266)
[Balban (1266-1287)]

KHALJI:
'Ala al-Din (1296-1316)
Mubarak Shah (1316-1320)

TUGHLUQ:
Muhammad Shah (1325-1351)
Firoz Shah (1351-1388)
[Mahmud Shah (1393-1395 and 1399-1413)]

SAYYID:
[Mubarak Shah (1421-1435)]
['Alam Shah (1446-1451)]

LODI:
[Bahlul (1451-1489)]
[Sikandar Shah (1489-1517)]

SURI:
Sher Shah (1540-1545)
Islam Shah (1545-1554)

BENGAL SULTANS:
Tughril (ca. 1240-1280)

Firoz Shah (1302-1318)
Sikandar Shah (1358-1390)
Mahmud Shah (1437-1460)
Barbak Shah (1460-1474)
Yusuf Shah (1474-1481)
Husain Shah (1484-1519)

SHARQI SULTANS OF JAUNPUR:
Ibrahim (1402-1440)

GUJARAT SULTANS:
Ahmad Shah II (1411-1442)
Mahmud Shah (1458-1511)

KHANZADAS OF NAGAUR:
Firoz Shah II (ca. 1470-1495)

FARUQI SULTANS OF KHANDESH:
Da'ud Shah (1503-1510)

MUGHAL EMPIRE

Akbar (1556-1605)
Jahangir (1605-1627)
Shah Jahan (1628-1658)
Aurangzeb (1658-1707)
Farrukhsiyar (1713-1719)

BAHMANI SULTANS OF DECCAN:
Ahmad Shah II (1436-1458)
Mahmud Shah (1482-1518)

'ADIL SHAHI SULTANS OF BIJAPUR:
['Adil Khan (1510-1534)]
Ibrahim II (1580-1627)
'Ali II (1656-1672)
Sikandar (1672-1686)

BARIDI SULTANS OF BIDAR:
Ibrahim (1580-1587)

QUTB SHAHI SULTANS OF GOLCONDA:
Ibrahim (1550-1580)
Muhammad Quli (1580-1611)
'Abd Allah (1626-1672)
Abu'l-Hasan (1672-1687)

NIZAM SHAHI SULTANS OF AHMADNAGAR:
Murtaza II (1600-1610)

NIZAMS OF HYDERABAD:
[Asaf Jah (1713-1748)]
['Ali Khan (1761-1803)]

NAWABS OF KURNOOL AND CUDDAPAH

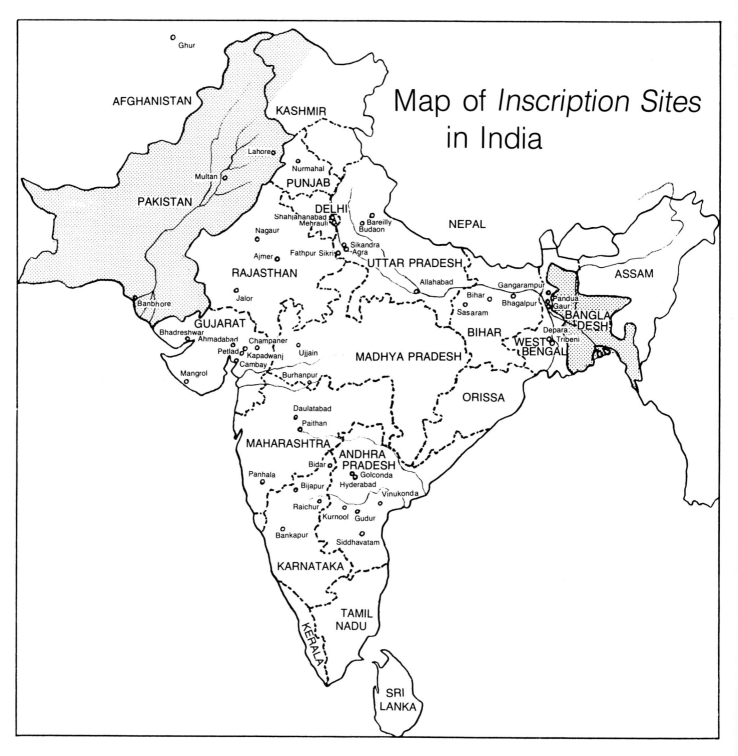

Map of *Inscription Sites* in India

AFGHANISTAN

KASHMIR

Ghur

PAKISTAN

Lahore

Multan

Nurmahal

PUNJAB

DELHI

Shahjahanabad
Mehrauli

Nagaur

Ajmer

Fathpur Sikri

RAJASTHAN

Jalor

Banbhore

GUJARAT

Bhadreshwar

Ahmadabad

Champaner

Petlad

Kapadwanj

Cambay

Mangrol

Ujjain

Burhanpur

Bareilly

Budaon

Sikandra

Agra

UTTAR PRADESH

NEPAL

Allahabad

Bihar

Sasaram

MADHYA PRADESH

Gangarampur

Bhagalpur

Pandua

Gaur

Depara

Tribeni

BANGLA
DESH

ASSAM

BIHAR

WEST
BENGAL

ORISSA

Daulatabad

Paithan

MAHARASHTRA

Bidar

ANDHRA
PRADESH

Panhala

Bijapur

Golconda

Hyderabad

Vinukonda

Raichur

Kurnool

Gudur

Bankapur

Siddhavatam

KARNATAKA

TAMIL
NADU

KERALA

SRI
LANKA

Catalogue

Kufi inscription above north doorway of Tomb of Ibrahim

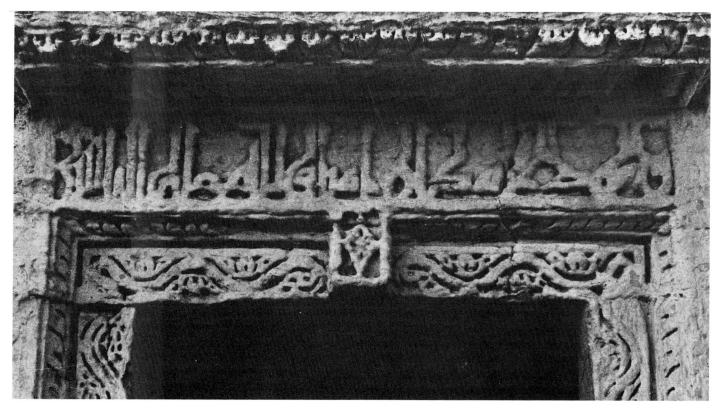

1.

SITE Bhadreswar (Gujarat)

MONUMENT Tomb of Ibrahim, son of 'Abd Allah (locally called tomb of "La'l Shahbaz"); detail of Arabic epitaph invocation inscribed on west wall

DATE month of Dhu'l-Hijja 554/ December-January 1159-60

DYNASTY Chaulukya, reign of Hindu king Kumarapala (1143-1178)

SCRIPT foliated Kufi

SIZE 21x196 cm

PUBLISHED *EIAPS* 1965, pl. I(i) (List No. 187)

This is the earliest known Islamic inscription still *in situ* on a monument inside India, although several much earlier detached inscriptions from Pakistan are now known—including the mosque dedication from the early costal site of Banbhore, which is apparently dated 109/727-28, or shortly after the first Arab conquest of Sind in 711 A.D. At the time the Bhadreswar tomb was inscribed, Gujarat was still ruled by Hindu kings, although Muslim merchants and Sufi saints had long been active in the region. The architectural style of the tomb clearly reflects Hindu antecedents in both structure and ornament—except of course for the imported Kufi style of writing, which is used for the Arabic epitaph. In its many varieties, the angular Kufi script was the only style used for architectural inscriptions throughout the Islamic world until the 12th century, when cursive styles (primarily monumental Naskhi) began to make inroads. Here the geometric rigidity of

the letters is softened by the addition of stylized leaf-motifs to some letters—hence the designation "foliated Kufi."

The entire inscription is quite long, and it is carved in a narrow relief band starting on the cornice of the entrance wall of the tomb, and continuing onto the south, east and north architraves of the projecting porch. Shorter Koranic inscriptions are also found over the two doorways leading to the tomb. The exhibited portion of the epitaph begins with the *Bismillah* invocation, and continues with a traditional prayer of blessing:

In the Name of God, the Merciful, the Compassionate. Blessings of God be upon the Prophet Muhammad and his descendants...

Following this invocation, the inscription next quotes the "Throne Verse" of the Koran (2.255; for translation see catalogue entry No. 12), which

occurs very frequently on funerary monuments. The epitaph concludes with the death date of the deceased, whose name is given as Ibrahim, son of the "steadfast" (Abu'l-'Azam) 'Abd Allah, son of Bakr.

It is unknown how the tomb came to be mistakenly ascribed to the well-known Sufi saint La'l Shahbaz, who actually died later and whose real grave is at Sehwan in Sind. Local legend suggests that some person called "La'l Shahbaz" had died a martyr's death in struggles against the Hindu regime in the region; but there is nothing in the present epitaph to suggest that Ibrahim had anything to do with this unknown saintly hero. In any event, it is noteworthy that professional Hindu artisans must have been responsible for executing the structure and its profuse relief decoration—including the carving of the Kufi epitaph, which marks the beginning of monumental Islamic calligraphy in India.

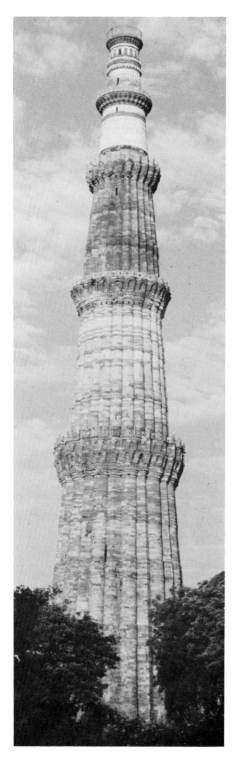

Qutb Minar

2.

SITE Mehrauli (Delhi)

MONUMENT Qutb Minar, basement storey, part of Arabic inscriptions on first and second bands, containing fragments of Koranic verses and eulogy of sultan Muhammad ibn Sam

DATE 595/1199 (=V.S. 1256)

DYNASTY Ghuri sultans of Afghanistan, reign of Muhammad ibn Sam (ca. 1173-1206)

SCRIPT monumental Naskhi

SIZE approx. 366x244 cm (exhibited portion)

PUBLISHED *EIM* 1911-12 (List No. 11); J.A. Page, *An Historical Memoir on the Qutub: Delhi* (Calcutta 1926)

After the Taj Mahal, perhaps the most famous Islamic monument in India is the enormous Qutb Minar tower attached to the Quwwat al-Islam mosque at Delhi—built to commemorate the conquest of the region in 1192, by the general Qutb al-Din Aibak on behalf of his master, the sultan Muhammad ibn Sam of Ghur. The dynasty founded by the victorious Aibak, who became independent after the death of the sultan in 1206, created the first permanent Muslim empire within the borders of India.

The mosque itself was built over the six-year-period 1192-1198; and work apparently began on the ambitious Qutb Minar immediately afterward. In his foundation inscription, the great military commander Aibak—who was the Turkish slave of the Ghuri sultan—informs us that he built the mosque with the spoils of twenty-seven destroyed Hindu temples, after overthrowing the fortress of the city (until then, the capital of the Rajput ruler Prithiviraja III). Elsewhere on the mosque, Aibak records the full name of his master, Sultan Mu'izz al-Din Muhammad ibn Sam, who is described as "the helper of the Prince of the Faithful"—implying that the sultan acknowledged fealty to the Caliph at Baghdad.

Judging from information contained in the inscriptions, only the basement storey of the Qutb Minar had been completed by Aibak at the time of his death in 1210, as a result of an accident while playing polo. That the work had commenced as early as 1199 is indicated by two mason's dates in the Hindu Vikrama era (V.S. 1256= 1199), inscribed beside the main entrance to the tower on the basement storey. This storey contains six bands of inscriptions written in a very bold variety of monumental Naskhi. The order of several of the slabs appears to have been disturbed, especially on the lowest band, making decipherment difficult. The first, third, and fifth-sixth bands contain primarily Koranic passages; while the second and fourth bands are both given over to a lengthy Arabic eulogy of Aibak's overlord. Except for one fragment of his military title, Aibak's name is no longer extant on the basement storey, but it is clear that he was its builder (the upper storeys were eventually completed by his successor, Iltutmish).

The inscribed detail reproduced here shows part of the two bottom bands on the basement storey. On the lowest, only the word *Allah* and a few other letters can be made out (see transcriptions in the Appendix); but the energy and massiveness of the calligraphy help create a rather grandiose effect. Elsewhere on this band, two short Koranic passages have been traced (parts of 11.6 and 13.1)—affirming belief in God as the source of all good, and in the Koran as His divinely revealed word.

The calligraphy on the second band is slightly different in style, with more attenuated verticals and a more stately rhythm to the composition. This may be a deliberate device to emphasize the political content of the inscription, which contains the eulogy of Muhammad ibn Sam—which has been partially restored by Horovitz as follows:

The great Sultan, the most exalted King of Kings, Lord of the necks of the people, Master of the kings of the Arabs and Persians, the most just of the Sultans in the world, the Strengthener of the World and Religion (Mu'izz al-Din), the help of Islam and the Muslims, the splendor of the kings and Sultans, the spreader of justice and kindness, the Shadow of God in East and West, the shepherd of the servants of God, the defender of the countries of God... the upholder of (the ordinances of God)....

It is the final phrase of this excerpt that is exhibited here. But only the word translated as "upholder" (qa'im) is clear; the interpretation of the rest remains problematical. Interestingly enough, the word qa'im means firmness, standing erect, by extension a "pillar"; hence the phrase may also allude to the role of the Qutb Minar itself—to serve as a visible and enduring symbol of the sultan's upholding of the faith in a foreign land.

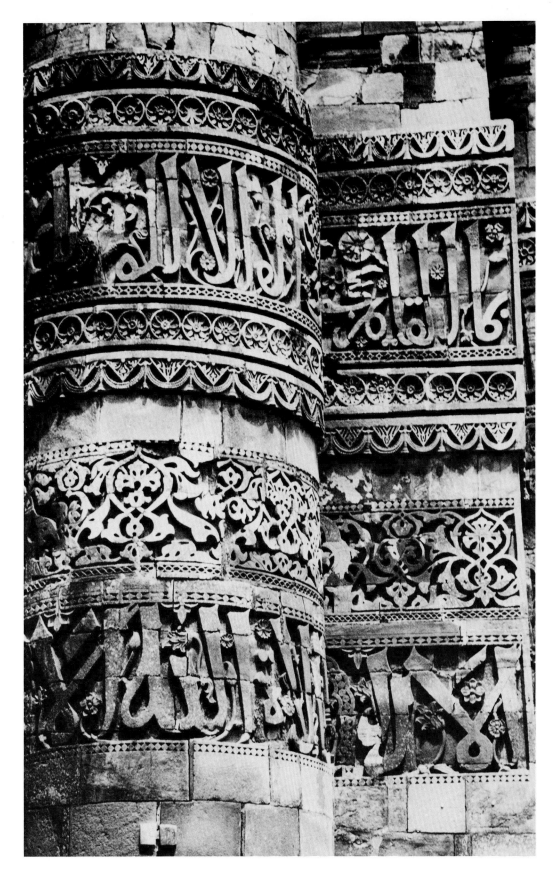

3.

SITE	Budaon (Uttar Pradesh)
MONUMENT	Jami' Masjid, Arabic dedication inscription over the east entrance
DATE	620/1223
DYNASTY	Mamluk, reign of Iltutmish (1211-1236)
SCRIPT	monumental Naskhi
SIZE	46x229 cm
PUBLISHED	*EIM* 1911-12, pl. XXIX (List No. 11)

Though of noble Turkish birth, Iltutmish became the trusted slave, and later son-in-law and chief lieutenant, of the first independent Muslim ruler of Delhi, Qutb al-Din Aibak—the builder of the famed Qutb Minar. After Aibak's death in 1210, his son-in-law Iltutmish quickly outdistanced the other contenders for the throne. Since the new emperor had formerly served as governor of the province around Budaon, he eventually got around to building a great congregational mosque there, which was completed in the twelfth year of his reign. The dedication inscription was carved from a slab of red sandstone and fixed in the massive arched entrance on the east side of the mosque.

The script used by the calligrapher is the same powerful and vigorous Naskhi cursive as that found on the Qutb Minar, which is characterized by thick wedge-shaped vertical letters. Though other mosques built by Iltutmish combine both monumental Naskhi and the more traditional Kufi, the latter script is here conspicuous by its absence. Interspersed through the inscription are several abstract decorative motifs intended to fill the empty spaces above certain letters. Probably derived from Koranic illumination, the motifs may also have functioned as monograms of some sort.

The dedication begins with a brief Koranic quotation (15.46): *"Enter it in peace safely"*—which alludes to the promised Paradise, but may have been chosen here for its appropriateness to the strongly fortified character of this and other mosques of the early sultanate period. The main thrust of the rest of the inscription is to glorify the mosque's builder, by reciting his exalted titles:

The magnificent Sultan, the most exalted King of Kings (Shahinshah), the Lord of the necks of the people, the Sun of the state and religion, the help of Islam and the Muslims, the most just of the kings and sultans, the Victorious Iltutmish, the "Royal Retainer" (al-Sultani), the helper of the Commander of the Faithful (the Caliph at Bagdad), may God perpetuate his kingdom. In the month of the year 620 (=1223).

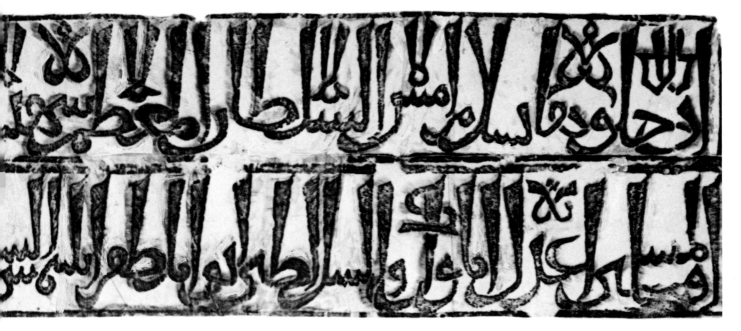

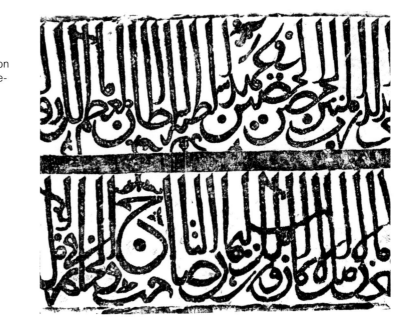

4.

SITE	Budaon (Uttar Pradesh)
MONUMENT	detached and fragmentary Arabic dedication inscription, recording construction of a gateway in the town's fortification wall
DATE	undated, around 620's/1220's(?)
DYNASTY	Mamluk, reign of Iltutmish (1211-1236)
SCRIPT	monumental Naskhi
SIZE	80x107 cm
PUBLISHED	*EIM* 1911-12, pl. XXX (List No. 11)

This fragmentary inscription shows a somewhat different—slightly more rounded—variety of monumental Naskhi script than the preceding one from Budaon. Here the vertical letters are of more uniform thickness and lack the widely flaring tops of those in the mosque inscription. The interspersed decorative motifs are also different, being more recognizably foliate in character. Compared to the deliberate brusqueness of the other Budaon panel, the present inscription strives for a greater elegance and more coordinated design. On the basis of style alone, it would seem later; but as pointed out in the 1911-12 article by Horovitz, the titles of the unnamed ruler are so similar to those in other inscriptions of Iltutmish that he must be the builder of the monument specified.

The extant part of the inscription has been translated as follows:

This strong gate of this fortified stronghold was built in the time of the magnificent Sultan, the Lord of the necks of the people... Who provides safety to the believers, the inheritor of the kingdom of Solomon, the Lord of the Crown, and the Seal in the rule (of the world).

5.

	SITE	Mehrauli (Delhi)
	MONUMENT	Quwwat al-Islam mosque, north extension screen of sultan Iltutmish, part of Koranic passages inscribed on right pier of left arch
	DATE	probably 627/1230
	DYNASTY	Mamluk, reign of Iltutmish (1211-1236)
	SCRIPT	plaited Kufi and monumental Naskhi
	SIZE	approx. 244x184 cm (exhibited portion)
	PUBLISHED	*EIM* 1911-12 (List No. 11); J.A. Page, *An Historical Memoir on the Qutub: Delhi* (Calcutta 1926)

Of the Muslim dynasties to rule parts of North India from their capital at Delhi, the first is called Mamluk (or "Slave"), since its founder Qutb al-Din Aibak had formerly been the royal slave and trusted general of the sultan Muhammad ibn Sam. Even after Aibak became independent in 1206, he and his successors remained proud of their slave heritage, and continued to call themselves *al-Sultani* ("royal slave" or "royal retainer").

The Quwwat al-Islam mosque at Delhi was the most visible architectural symbol of the new Mamluk dynasty's imperial power; hence it is understandable that no expense was spared in making it one of the most grandiose monuments of the entire Islamic world. Moreover, the Muslim population of the capital kept increasing, making it necessary to enlarge the mosque periodically so that it could accommodate the entire population on the day of congregational prayers. During the reign of Aibak's successor, Iltutmish, the mosque's size was more than doubled, through two great extensions to the north and south. Now ruinous, only the stumps of the great piers of the northern *qibla* screen extension still stand; but the surviving areas of ornately carved calligraphy convey some sense of the new mosque's original magnificence.

Apparently Iltutmish brought in skilled calligraphers from Iran, particularly to design the intricate panels of geometric plaited Kufi, shown here in juxtaposition with the traditional cursive Naskhi.

Due to its disciplined and static angularity, the Kufi script forms an effective visual frame for the edge of the pier, just beside the attached pilaster at the left. Separated from the geometric Kufi by an intervening lotus rhizome, the middle and right zones of the base of the pier are ornamented only with the more dynamic Naskhi cursive. Like the Kufi panel, the wide Naskhi band adjacent to it begins with the *Bismillah* invocation, followed by Koranic passages that would originally have continued upward, around the enormous left arch of the *qibla* screen (serving as the orientation toward Mecca).

The Kufi inscription contains the opening words of a Koranic passage (9.18) that is frequently inscribed on Indian mosques, since it conveys the concern of the Muslim community about the sanctity and purpose of a mosque:

In the Name of God, the Merciful, the Compassionate. The mosques of God shall be visited and maintained by such as believe in God and the last Day, (...establish regular prayers, and practice regular charity and fear none except God. It is they only who can be considered among the rightly guided.)

The large Naskhi inscription in the middle of the pier contains a few verses from a passage (55.1-5) urging that Man recognize God's bounty in the harmonious universe He has created:

In the Name of God, the Merciful, the Compassionate. The Merciful God, it is He who hath revealed the Koran. He hath created Man and taught him speech. The sun and the moon follow courses exactly computed...

To the right of these two vertical panels, there is a slightly recessed *mihrab* niche (one of several on the original *qibla* screen), with several inscribed bands. As the right side of the niche is omitted in the exhibit, only the ending portions of the inscribed passages are visible. Across the top of the pointed arch are two rectangular panels with identical quotations of the Muslim "Profession of Faith" *(Kalima)*: *"There is no God but God. Muhammad is the Prophet of God."*

On the narrow strip facing the pointed arch, we read the concluding words of a short Koranic passage (3.18) stressing the unity of God:

(There is no God but He: that is the witness of God, His angels,)...and those endued with knowledge, standing firm on justice. There is no god but He, the exalted in power, the Wise.

The final inscription here occurs on the large rectangular frame surrounding the entire *mihrab* niche; it consists of a few verses (33.42-44), concluding a passage urging constant prayer to God:

(O ye who believe! Celebrate the praises of God and do this often; and glorify Him)...morning and evening. He it is Who sends blessings on you, as do His angels, that He may bring you out from the depths of darkness into light—and He is full of mercy to the believers. Their salutation on the Day they meet Him will be "Peace!"; and He has prepared for them a generous Reward.

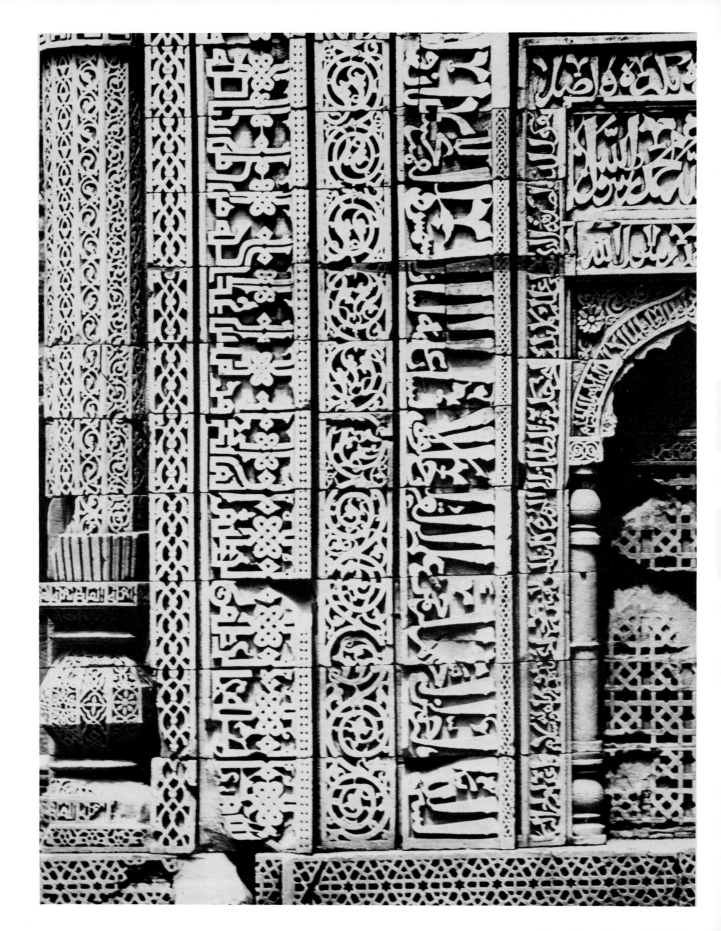

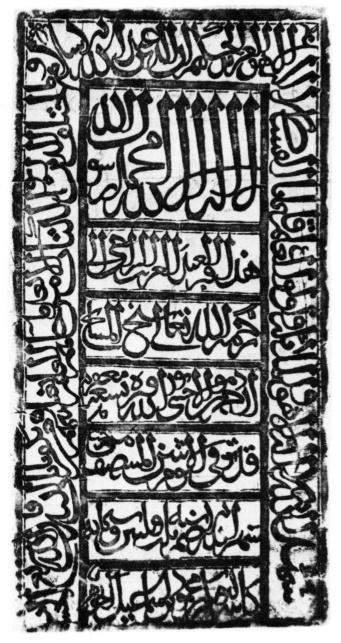

6.

SITE	Petlad (Gujarat)
MONUMENT	gravestone inside tomb of the saint Baba Arjun Shah, containing Arabic epitaph of the deceased
DATE	month of Rajab 633/March 1236
DYNASTY	Vaghelas of Gujarat, reign of Hindu king Viradhavala (1231-1238?); contemporaneous with Mamluk sultan Iltutmish (1211-1236)
SCRIPT	monumental Naskhi
CALLIGRAPHER	Abu Bakr, son of Isma'il al-Jauhari
SIZE	66x34 cm
PUBLISHED	*EIM* 1915-16, pl. XIV (a) (List No. 19)

his Hindu epithet Arjun, it is clear from his father's name given in the epitaph that he was originally a Muslim immigrant to India (a later inscription in the tomb calls him Arjun Ghori, implying that he came from Ghor in Afghanistan). There are many such instances in the subcontinent of Muslim saints who also had large Hindu followings; likewise Hindu holy men were frequently held in high esteem by Muslims.

The calligraphy is of extraordinarily fine quality, typical of funerary inscriptions in Gujarat during this period, and equal to the best inscriptions at Delhi. The cursive Naskhi is seen in the process of becoming more ornamental, with frequent overlaps and prominent hooks attached to the rhythmically disposed verticals. The central portion begins with the Muslim profession of faith:

"There is no god but God, Muhammad is the apostle of God."

Following this is the epitaph proper:

This is the grave of the humble slave, who is expectant of the mercy of God—may He be exalted—the Shaikh of Shaikhs Arjun, son of Damo Akhsi, may God illumine his grave through the plenitude of His mercy! He died on Monday in the middle of the silent month of God (Rajab), in the year 633 (=March 1236). Written by Abu Bakr, son of... Isma'il al-Jauhari.

Beginning at the bottom right, the outer frame contains two verses from the Koran (3.18-19):

There is no god but He: that is the witness of God, his angels, and those endued with knowledge, standing firm on justice. There is no god but He, the Exalted in power, the Wise.

The religion before God is submission to His will (al-Islam); nor did the people of the Book dissent therefrom except through envy of each other, after knowledge had come to them. But if any deny the Signs of God, God is swift in calling to account.

Like the Bhadreswar inscription (No. 1), the present epitaph reflects the presence of a sizable Muslim community in parts of western India that had not yet been conquered by the Delhi sultans. Like the Bhadreswar inscription also, this one is part of a shrine associated with a Sufi saint, known locally as Baba Arjun Shah, but called the "Shaikh of Shaikhs" Arjun on the inscribed marble gravestone. Despite

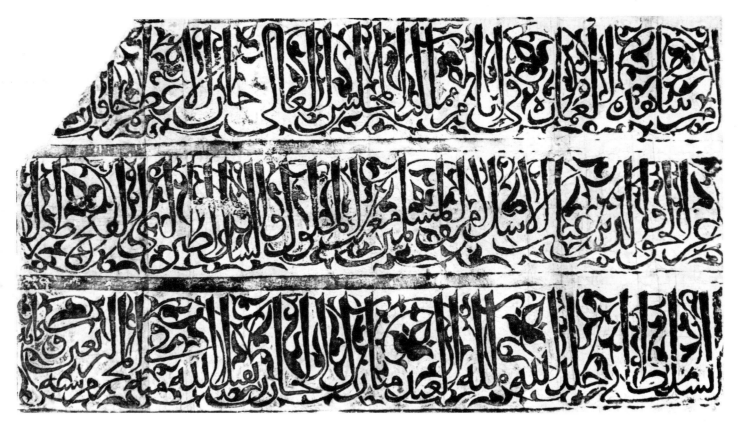

7.

SITE	Bihar Sharif (Bihar)
MONUMENT	detached Arabic inscription inside Bari Dargah, recording dedication of a building by court official Mubarak
DATE	the month of Muharram 640/ July 1242
DYNASTY	reign of Tughril, independent ruler of eastern India (ca. 1240-1280); contemporaneous with Mamluk sultan Mas'ud Shah (1242-1246)
SCRIPT	monumental Naskhi against foliate background
SIZE	66x121 cm
PUBLISHED	*EIM* 1913-14, pl. V. (List No. 15)

One of the most beautifully designed Naskhi inscriptions from the eastern region of North India, the present panel shows how effectively the masters of cursive calligraphy exploited the foliate background motifs that had long been associated with monumental Kufi. The shapes of certain letters are pointed to suggest leaf forms in what must be a deliberate attempt to coordinate the writing with the spiralling foliate pattern. Despite the complexity of the design, the calligrapher brilliantly achieves an overall rich pattern without sacrificing the legibility and harmonic proportions of the letters. Such ornate designs, however, ultimately led to the frequently excessively convoluted Tughra inscriptions produced in Bengal during the 15th century (see Nos. 26, 28).

The patron of the building being dedicated was the state treasurer serving under the former Mamluk governor Tughril, who by 1240 had declared himself independent of the weakened sultanate at Delhi. Like most official endowments, the text mostly enumerates flattering titles of the ruler:

The humble creature, Mubarak, the Treasurer—may God accept his prayers—ordered the construction of this building during the reign of His Highness, the great Khan... the magnificent Khaqan, the glory of Truth and Religion, the succor of Islam and the Muslims, the helper of kings and monarchs, the Victorious Tughril, the "Royal Retainer" (al-Sultani)—may God perpetuate his kingdom! In Muharram of the year 640 (=July 1242).

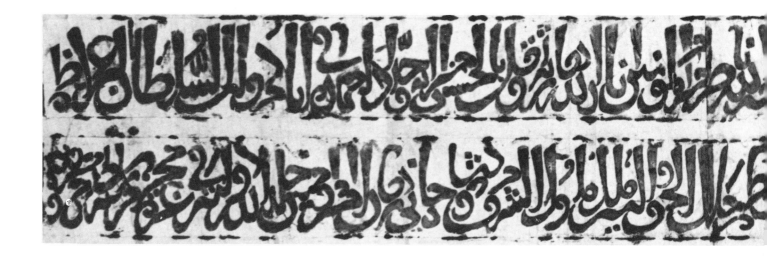

8.

SITE	Gangarampur (West Bengal)
MONUMENT	local mosque, Arabic inscription on back wall, recording renovation of an earlier mosque built by Iltutmish
DATE	1 Muharram 647/16 April 1249
DYNASTY	Mamluk, reign of Mahmud Shah (1246-1266)
SCRIPT	monumental Naskhi, with Tughra tendencies
SIZE	35x222 cm
PUBLISHED	*EIM* 1913-14, pl. VIII(a) (List No. 15)

Like the preceding, the calligraphy of this inscription is of exceptionally high quality, and was undoubtedly designed by a major court scribe. Lacking the floriated background of the Bihar Sharif panel, the letters themselves are more dynamically realized, since they alone create the bold and tumultuous rhythmic effect that appears to be the aesthetic ideal of most of the early Sultanate calligraphers. This effect is accentuated in the present work by the pronounced overlapping and stacking of letters, to the point that there almost seem to be several layers of writing. One result of this visual antiphony—where the continous base line is replaced by alternating layers of phonemic elements—is, of course, reduced legibility. But as the late

Richard Ettinghausen pointed out several years ago, much of Islamic architectural calligraphy is intended as "symbolic affirmation" rather than literal "communication."

To put it another way, the calligrapher has here created a kind of visual equivalent of the Gregorian chant, although what is "chanted" is still largely political propaganda in favor of the governor Mas'ud Shah and of the ruling monarch. The motive for this may not always have been merely to flatter royal vanity. Like the reciting of a new ruler's name and titles in the Friday *khutba* sermon, the inscribed titles constitute, in effect, a visual benediction on him and his regime. This may have been more appropriate in the case of the emperor Mahmud Shah than some of the other Mamluk rulers, since he was renowned as a pious monarch who devoted himself to copying Korans—and therefore was probably especially appreciative of the art of calligraphy.

The full text of the inscription reads as follows:

The magnificent Sultan, Sun of the State and Religion, the Victorious Iltutmish, the "Royal Retainer" *(al-Sultani)*, the Right Hand of the Vicegerant of God, and Helper of the Commander of the Faithful (the Caliph)—may God illumine his argument and may his balance be weighted with good deeds!— gave orders to build this sacred house; and the

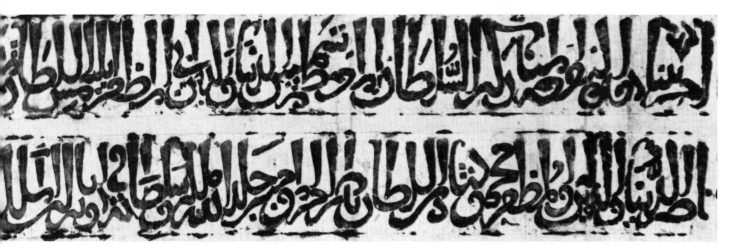

building has been renovated during the reign of the great Sultan, the Helper of the State and Religion (Nasir al-Din), the victorious Mahmud Shah, son of the (late) Sultan, the Helper of the Commander of the Faithful—may God perpetuate his kingdom and majesty!—and during the governorship of the great Lord, the Glory of Truth and Religion (Jalal al-Din) the Lord of lords of the East, Mas'ud Shah Jani, the demonstration of the (glory of the) Commander of the Faithful—may God perpetuate his government! On the 1st of Muharram 647 (=16 April 1249).

9.

SITE	Cambay (Gujarat)
MONUMENT	detached gravestone, with Arabic and Persian epitaph of Sufi mystic Zain al-Din 'Ali, called Salari—with verses composed by him
DATE	23 Dhu'l-Hijja 685/9 February 1287
DYNASTY	Vaghelas of Gujarat, reign of Hindu king Sarangadeva (ca. 1274-1296); contemporaneous with Mamluk sultan Balban (1266-1287)
SCRIPT	monumental Naskhi, with elements of Riqa'
SIZE	74x50 cm
PUBLISHED	*EIPAS* 1961, pl. IV (List No. 166)

Due to the lengthy matter to be inscribed, the calligrapher has devised a framing grid-pattern, like those found in manuscripts, to contain the various sections of the epitaph more coherently. At the top is a cusped arch with hanging-lamp motif, suggestive of the prayer-niche *(mihrab)* found in mosques. Two varieties of cursive script are used: monumental Naskhi with Tughra flourishes for both the epitaph proper (two bottom rows) and the Koranic verses inscribed on the side borders (which originally would have continued around the now broken top of the gravestone); while a second type of cursive, which resembles the elegant epistolary style called Riqa', is employed in the eleven rectangular cartouches that contain mystical Persian verses composed by the deceased himself, as a kind of spiritual testament (it is possible that the designer of the epitaph may simply have transcribed the verses from the author's own autograph manuscript).

The Koranic verses (3.18-19) are the same as those inscribed on the gravestone from Petlad (for translation, see No. 6);these verses succinctly affirm

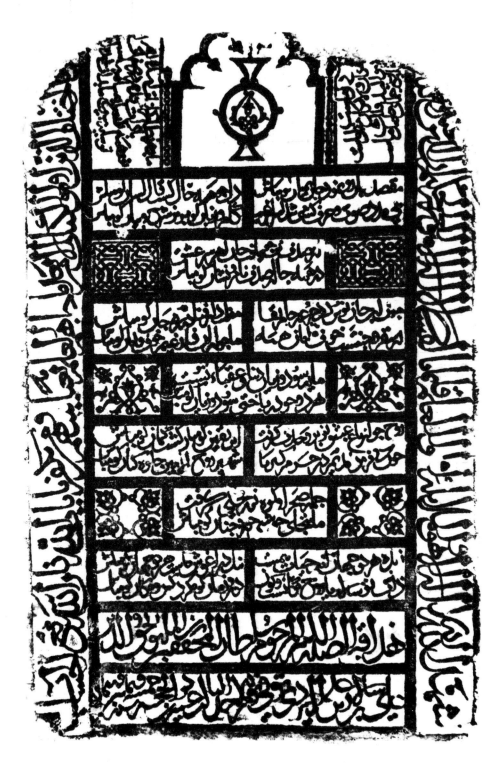

the Muslim's belief in God and Islam, and are frequently carved on funerary monuments (see also No. 10). The epitaph reveals that the deceased was named 'Ali, son of Salar; while the mystical verses he composed give his poetical name as "Salari." The full text of the lower epitaph reads:

This is the grave of the highly honored, one who has been called unto God's mercy, the "Emperor of the Truthful" (i.e., the Sufis), the Ornament of the Religious Fraternity, and of Truth and Religion, (Zain al-Din) 'Ali, son of Salar, son of 'Ali al-Yazdi, who died on Sunday, the 23rd Dhu'l-Hijja, year 685 (= February 9, 1287).

Beginning at the damaged top of the stele, Salari's remarkable Persian verses, which are the earliest metrical epigraphs in that language known from Gujarat, may be translated as follows:

(Ruba'i)

(1) . your heart:

 both this spot and empty space are your abode.

 . the heavenly bodies;

 . these are all your gain.

(2) You have come into existence for the ordering of the universe;

 You have become one with Divine Attributes and the Eternal Essence.

 The Light of all light is the Shadow of your shadow—

 But do not look at the shadow, for you have become the Essence itself.

(Ghazal)

(1) The object of Soul has been achieved; let there be no more soul in this place!

 The Heart has attained the perfect state of ecstasy (*hal*); let the tongue's discourse (*qal*) cease entirely!

(2) Mysteries of the Unseen have been revealed without benefit of sound and word;

 Let the palate and tongue cease to function and there be no more interpretation and explanation!

(3) The soul has acquired the pearl of Love's secret from the shell of the body;

 Let there be no more trace of that shell anywhere!

(4) The lips of Soul have drunk a draught from the cup of Immortality.

Let the stage "Abode of Annihilation" (*Dar-i-Fana*) itself cease to exist!

(5) All fears and hopes stem from concern with Hell and Heaven;

As you are altogether beyond these two, let there be no more fear and hope!

(6) The concept of benefit and loss derives from this world and the next;

When you have staked both of these worlds, let there be no more benefit or loss!

(7) The Spirit has already plucked the fruit of "Divine Unity" (*wahdat*) from the garden of Love;

Let the cloud of certainty stop its downpour, and the sown field of doubt cease to exist!

(8) Now that you have alighted in the holy precinct of Divine Majesty,

Let the wings of the Faithful Spirit (archangel Gabriel) cease beating in display!

(9) The whole of the plains and the hills is bathed in the Light of Divine Emanation (*Tajalli*);

Since this is sufficient, let there be no more Paradise or celestial maidens!

(10) The best of both the worlds is the sole objective of every life;

Since the best is confined within your embrace, let both the worlds cease to exist!

(11) O Salari! Your essence is the Spirit of the world and creation;

Let time and the spheres cease revolving and the world and creation be no more!

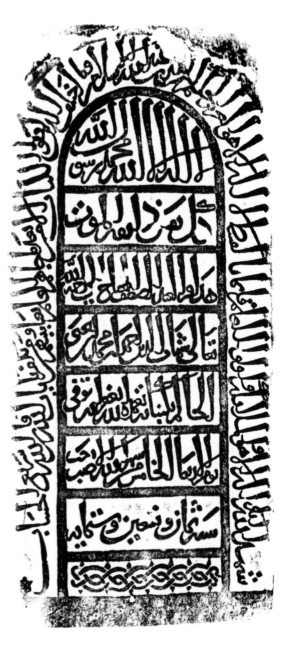

10.

SITE	Cambay (Gujarat)
MONUMENT	detached grave headstone with Arabic epitaph of the court official Shihab al-Din Ahmad (now fixed in north wall of tomb enclosure of Pir Taj al-Din)
DATE	5 Rajab 698 / 8 April 1299
DYNASTY	Khalji, during reign of 'Ala al-Din (1296-1316)
SCRIPT	monumental Naskhi
SIZE	52x26 cm
PUBLISHED	*EIAPS* 1962, pl. I(a) (List No.174)

During the 13th century, there were periodic Muslim incursions into Gujarat, but the final subjugation of the region by the Delhi sultans did not occur until 1297-98, during the reign of 'Ala al-Din Muhammad Shah, the third sultan of the Khalji dynasty. Under this powerful and ambitious ruler, Muslim conquests extended for the first time to South India as well. The present gravestone records the death of the governor *(hakim)* appointed by the emperor to administer the newly conquered city of Cambay—which for centuries had been one of the most important seaports for western India. The new governor died only about one year after being appointed to office. The border of the slab contains the traditional Koranic verses (3.17-18) found on many Gujarat gravestones of this period (see Nos. 6,9). The middle portions of the headstone begin with the *Kalima* profession of faith, followed by a short Koranic quotation, and then the epitaph proper:

There is no god but God, Muhammad is the apostle of God. Every soul shall taste of death. (Koran 29.57 part). This is the grave of the weak creature, dependent on the mercy of God, the exalted, Shihab al-Din Ahmad, son of Muhammad, son of Yahya; the governor at Kambaya (Cambay), may God cover him with His pardon. He died on Wednesday the 5th of the most righteous month of God, Rajab, 698 (=8 April 1299).

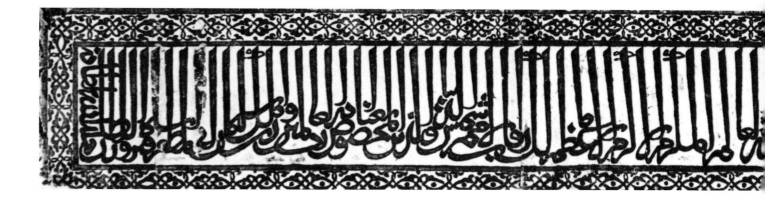

11.

SITE	Tribeni (West Bengal)
MONUMENT	detached Arabic inscription, recording construction of a seminary by the court official Zafar Khan
DATE	1 Muharram 713/ 28 April 1313
DYNASTY	independent Bengal sultan Firoz Shah (1302-1318); contemporaneous with Khalji sultan 'Ala al-Din (1296-1316)
SCRIPT	monumental Naskhi, tending toward convoluted Tughra
SIZE	30x200 cm
PUBLISHED	*EIM* 1917-18, pl. XII(a) (List No. 24)

From the late thirteenth century onwards, Bengal became an independent Muslim kingdom, a development which fostered the emergence of distinctive styles of monumental calligraphy. When compared with the inscription from Gangarampur (No. 8), the present panel reveals the further progress toward the convoluted style called Tughra—which combines intricate clusters of almost illegible letter forms with the stately clarity of uniform verticals arrayed in the background. The textile-like pattern this produces is enhanced by the decorative border—which was probably also designed by the calligrapher. Like other kinds of abstract art, the composition is suggestive of various kinds of interpretations—ranging from seeing the verticals as lush reeds in the Bengal landscape to the upraised spears of a triumphantly advancing army. In a more abstract vein, it seems probable that connoisseurs of calligraphy would have appreciated the design as a visual equivalent of the convoluted rhetoric of the text itself.

The seminary *(madrasa)* endowed by the court official Zafar Khan is no longer extant, but it is appropriate that the dedication inscription was preserved and incorporated at a later date in the north side of his tomb—as a tribute to the philanthropy of Zafar Khan, and perhaps to the calligraphic excellence of the inscription itself. The complete inscription is carved on two panels identical in size and designed by the same calligrapher; the text of the first panel reads:

Praise be to Him to whom praise is due! This school, which is called *Dar al-Khairat* (House of Benevolence), was built during the reign of the lord of benevolence, the master of the crown and the seal, the shadow of God in the world, the benevolent, the generous, the great, the lord of the necks of the nations, Sun of the State and Religion, who is distinguished by the grace of the Lord of the universe, the inheritor of the Kingdom of Solomon, the Victorious Firoz Shah, the Sultan—may God perpetuate his sovreignty!

The text of the second panel—which is not included in the exhibition—continues as follows:

And by the order of the great Khan, the liberal, the exalted, who is generous in gifts and worthy of praise, the supporter of Islam and the helper of mankind, the Meteor of Truth and Religion *(Shihab al-Din)*, the aider of kings and monarchs, the patron of believers, the Khan of the World (Khan Jahan), Zafar Khan, may God make him victorious over his enemies and kind to his friends! On the 1st of Muharram 713 (=28 April 1313).

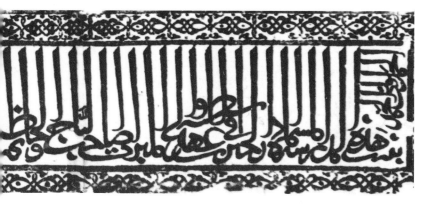

12.

SITE	Cambay (Gujarat)
MONUMENT	detached gravestone, with Arabic epitaph of the royal admiral Ikhtiyar al-Din
DATE	17 Jumada II 716/ 6 September 1316
DYNASTY	Khalji, reign of Mubarak Shah (1316-1320)
SCRIPT	monumental Naskhi
SIZE	129x49 cm
PUBLISHED	*EIM* 1917-18, pl. III(c) (List No. 24)

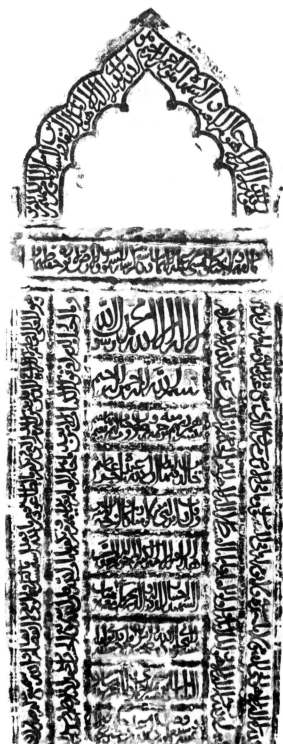

The repressive measures taken by some of the Khalji governors of Gujarat led to numerous disorders, including the one in 1316, that resulted in the death in battle of the Royal Admiral *(Bahr Bek)*, Ikhtiyar al-Din. The monumental Naskhi script used on his gravestone had by then become quite traditional, and the calligrapher has handled it competently yet conservatively—in keeping with the somber nature of funerary inscriptions. The epitaph proper is inscribed in the middle portion, on the bottom five rows:

This is the grave of the great Amir, whom God has taken into His mercy, and whose sins have been pardoned, the fortunate, the martyr, the Approbation of the State and Religion: Ikhtiyar al-Din, Royal Admiral in the city of Khambayat (Cambay), called Alp Khani (Retainer of Alp Khan, governor of Gujarat)...may God cool his resting place and alleviate his solitude! He died on the night of Tuesday, 17 Jumada II, year 716 (=6 September 1316). And may God's blessings be upon the best of creation, Muhammad and his descendants!

The Koranic quotations in the inscription are more numerous than those already noticed on other Cambay gravestones. Beginning on the top arch with Koran 59.22-23, then proceeding to the outer

<table>
</table>

13.

SITE	Jalor (Rajasthan)
MONUMENT	'Idgah, Persian dedication inscription over north *mihrab*, recording endowment by the court official Malik Hoshang
DATE	5 Muharram 718/ 9 March 1318
DYNASTY	Khalji, reign of Mubarak Shah (1316-1320)
SCRIPT	monumental Naskhi/ convoluted Tughra
CALLIGRAPHER	Muhammad-i-Lachin al-Qashmari al-Shams
SIZE	46x206 cm
PUBLISHED	*EIAPS* 1972, pl. II(b) (List No. 238)

vertical band with 2.255 (the well-known "Throne Verse"), and 2.256, we read as follows:

God is He, than Whom there is no other god—Who knoweth both secret and open; He is the Merciful, the Compassionate. God is He, than whom there is no other god—the King, the Holy, the Peaceful, the Guardian, the Preserver, the Exalted...

God! there is no god but He—the Living, the Self-subsisting, the Eternal. No slumber can seize Him nor sleep. His are all things in the heavens and on earth. Who can intercede in His presence except as He permit? He knoweth what is before or after or behind them. Nor shall they compass aught of His knowledge except as He will. His Throne doth extend over the heavens and the earth, and He feeleth no fatigue in guarding and preserving them. For He is the Most High, the Supreme in glory.

Let there be no compulsion in religion: truth stands out clear from error. Whoever rejects evil and believes in God hath grasped the most trustworthy handhold that never breaks. And God heareth and knoweth all things.

The inner vertical band contains the frequently quoted passage 3.18-19 (for translation, see No. 6); while the five upper rows of the middle portion contain the *Kalima* profession of faith, the *Bismillah* invocation, and Koranic verses 9.21-22 and 23.29:

Their Lord doth give them glad tidings of a mercy from Himself, of His good pleasure, and of a Garden for them, wherein are delights that endure. They will dwell therein forever; Verily in God's presence is the greatest reward.

And say: "O my Lord! Enable me to disembark with thy blessing, for Thou are the best to enable us to disembark."

Though damaged and somewhat imperfectly executed by the stonecutter, the present inscription is a calligraphic *tour de force*, designed by an accomplished master proud of his versatility and artistic skill. The convoluted Tughra design of the piled-up letters along the bottom bears a strong resemblance to contemporaneous designs from Bengal (compare No. 11), but the greater delicacy of the present inscription suggests that it was designed by a calligrapher more accustomed to the intimate scale of manuscripts. This is one of the earliest decorative Tughra inscriptions known from western India, but the style apparently originated in eastern India where it remained in fashion well into the 16th century.

This unusual calligraphic style has been designated "bow-and-arrow" variety by some writers, which is unfortunate since it seems highly unlikely that the connecting chevrons, or zigzag lines, across the tops of the varyingly spaced verticals were intended to convey any such allusion. Rather the calligrapher seems to consciously evoke the traditional abstract patterning of older Kufi inscriptions—

though that script was hardly used for monumental calligraphy in India after the reign of Iltutmish.

As argued by Z.A. Desai, the calligrapher may have been the brother of the famous poet Amir Khusrau (1253-1325), whose father Lachin al-Qashmari al-Shamsi had migrated from Balkh to India where he attained a noble title from the Mamluk emperor Iltutmish. Amir Khusrau enjoyed the lavish patronage of the earlier Khalji rulers, and his calligrapher brother apparently rose to a position of esteem under the powerful noble and general, Malik Hoshang, who endowed the Idgah at Jalor. At Delhi, however, the weak young emperor Mubarak Shah quickly lost interest in patronizing poets and lapsed into a life of debauchery under the influence of his favorite Khusrau Khan—a converted Hindu youth from Gujarat, who in 1320 murdered his master, briefly usurped the throne and thereby brought about the downfall of the entire Khalji dynasty.

The full text of the inscription reads as follows:

The construction of this auspicious "place of prayer" (*Namazgah* or *'Idgah)* was in the time of the government of the kingdom, and during the period

of the sovereignty, of the Sultan of Sultans, the ruler on the surface of the earth, the Shadow of God in the worlds, the Second Alexander and "Twin-horned" *(Dhu'l-Qarnain)* of the age, the Pillar of State and Religion, Qutb al-Din, the victorious Mubarak Shah the Sultan, son of the Sultan, the co-inheritor of the Commander of the Faithful (the Caliph), may God perpetuate his kingdom and sovereignty and elevate his affairs and dignity, may he always be firmly fixed for a limitless span of years in the foundations of kingship and administration of the affairs of sovereignty, and may the Friends of the State be victorious and the enemies of the court be vanquished, through the blessings of the unlettered Prophet and his holy descendants, all of them!

The builder of this auspicious abode is the Prince among the Nobles, the Crown of the State and Religion, the Champion of the time, the Commander of the world, Hoshang, son of Mahmud, son of Muhammad, son of 'Umar Kabuli, popularly known as Gurg, may God perpetuate his authority, and may He keep him lasting and steadfast in the war against the infidels, (grant him) eternal bounty and...

And the architect and supervisor of this blessed edifice is the humble creature Nusrat, son of Rustam, son of Mahmud al-Ghori; and its writer is Muhammad-i-Lachin al-Qashmari (?) al-Shamsi. On the 5th of Muharram 718 (=9 March 1318).

Jami Masjid at Cambay

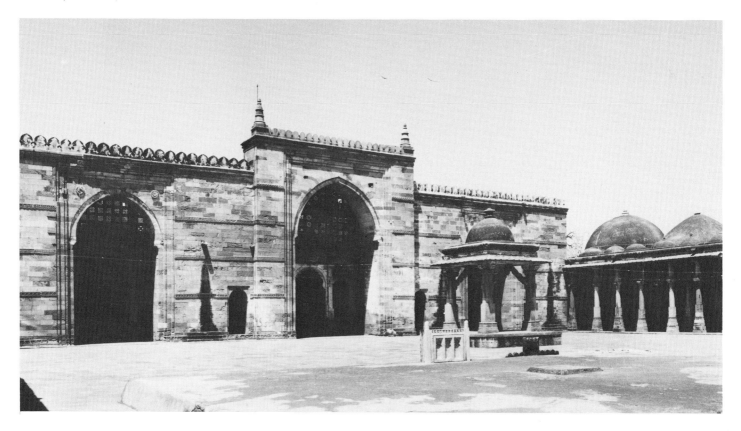

14.

SITE	Cambay (Gujarat)
MONUMENT	Jami Masjid, Arabic inscription over east gateway, recording construction by the noble Daulat Shah Muhammad
DATE	18 Muharram 725/ 4 January 1325
DYNASTY	Tughluq, reign of Muhammad Shah (1325-1351)
SCRIPT	monumental overlapping Naskhi
SIZE	35x274 cm
PUBLISHED	*EIAPS* 1957, pl. IX(a) (List No. 156)

The power and dignity of this inscription effectively epitomize the grandiose aspirations of the new Tughluq dynasty, particularly those of the despotic emperor Muhammad Shah, who attempted to consolidate Muslim control of the entire Indian subcontinent by shifting the capital in 1327 from Delhi to Daulatabad in South India—an ill-fated experiment that lasted only a few years. The donor of the vast new congregational mosque at Cambay was the powerful noble Daultat Shah Muhammad, who was a trusted general and confidant of both of the first two Tughluq emperors. In his foundation inscription, he proudly boasts that the mosque was constructed entirely from his own funds, rather than those of the state. It was probably Daulat Shah Muhammad who succeeded in quelling the various insurrections that had broken out in Gujarat in the later years of the preceding dynasty, and bringing the region solidly into the Tughluq empire for a time.

Although majestic in both conception and execution, the calligraphy is nonetheless fairly conservative in style, to the extent that it has been consciously modelled on the stately monumentality of earlier Mamluk inscriptions. At the same time, the calligrapher also reflects the current fashion for overlapping letters in the Tughra manner; in fact, there are so many of these that they almost constitute a second row at times (compare the earlier and more brilliantly conceived inscription No. 8 from Gangarampur). All in all, however, there is a certain sober quality to the calligraphy that makes it complement perfectly the rather austere yet imposing character of the main facade of the mosque.

The full text translates as follows:

In the Name of God, the Merciful, the Compassionate.

Verily the mosques are for God alone; invoke not therein anyone else with God (Koran 72.18). And says the Prophet, peace be upon him, "Whoever builds a mosque for God, though it be as small as a sparrow's nest, for him will God build a house in paradise." This is by one who has been rightly guided and helped by Him.

This auspicious congregational mosque and its buildings were constructed wholly and completely out of his own money from what God had given him through His grace and benevolence, merely for the sake of God the Exalted, during the reign of the learned and just emperor Muhammad Shah, son of Tughluq Shah the king—may God perpetuate his kingdom and sovereignty—by the feeble servant, expectant of the mercy of God, the exalted Daulat Shah Muhammad al-Butahari. May God enable him to achieve his object. And this took place on the 18th of Muharram 725 (=4 January 1325).

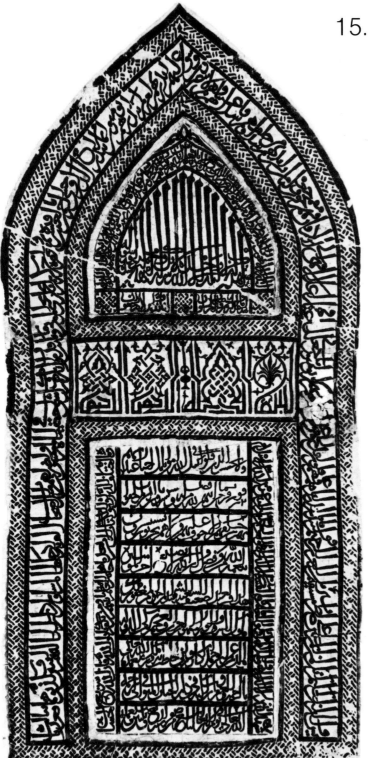

15.

SITE	Cambay (Gujarat)
MONUMENT	Cenotaph inside south entrance of Jami Masjid, with Arabic epitaph recording death of the governor Zaki al-Din 'Umar, al-Kaza-runi, entitled Malik Parviz
DATE	9 Safar 734 / 22 October 1333
DYNASTY	Tughluq, reign of Muhammad Shah (1325-1351)
SCRIPT	monumental Naskhi and plaited foliated Kufi
SIZE	143x69 cm
PUBLISHED	*EIAPS* 1971, pl. X(b) (List No. 232)

This magnificently designed inscription achieves a new monumentality and coherence among Gujarat gravetones, through its bold geometric divisions and its hierarchical ordering of different script sizes and styles. Noteworthy is the prominent use of plaited and foliated Kufi for the *Bismillah* invocation inscribed across the large middle band, since this type of script had virtually disappeared from India from around the first quarter of the 13th century. The elaborate, symmetrical plaiting of the letters in the word *Allah* is especially impressive and imparts an almost iconic quality to the name of God.

The renown of the deceased is attested to by his mention in the accounts of the famed traveler Ibn Battuta of Morocco, who visited India in the early 14th century and described the house of Zaki al-Din 'Umar as one of the great mansions of Cambay. Apparently he had been assigned Cambay as a fief by the Tughluq emperor, and met a martyr's death on his way to Delhi, where he was promised to be appointed vizier (according to Ibn Battuta, the murder was instigated by the jealous vizier he was to replace). Originally from Kazarun in Iran, the deceased is described in the epitaph as "one who is celebrated in Arabia and other Islamic countries." The epitaph proper is inscribed on the last five rows of the middle portion:

This is the grave of the weak creature, the forunate, the martyr, the one taken into God's mercy, the pardoned, the Prince among the princes and ministers of the East, one who is celebrated in Arabia and other Islamic countries, the Just in matters of State and Religion, Zaki al-Din 'Umar, son of Ahmad al-Kazaruni, entitled Parviz Malik, may God the Exalted cover him with His mercy and pardon and settle him in the abode of Paradise, he returned to the mercy of the Exalted God on Wednesday, the ninth of Safar 734 (=22 October 1333).

Cenotaph of Zaki al-Din 'Umar, inside Jami Masjid at Cambay

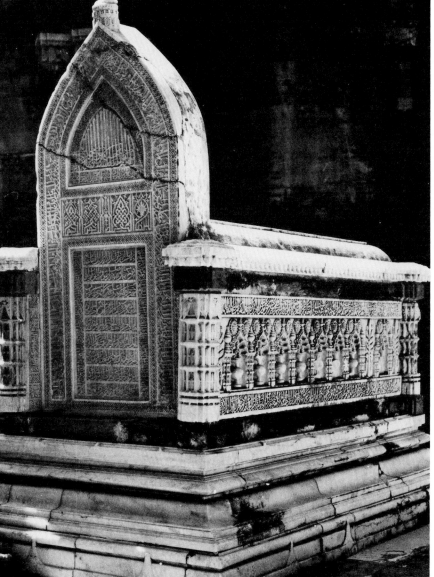

The Koranic quotations are extensive and include some noted on other Cambay gravestones. The outer border of the arch contains the beginning of the *Ya Sin* chapter (36.1-13, part of 14), one of the most profound chapters of the entire Koran and one which is traditionally recited at the time of death:

Ya Sin ("O Man")! Consider the Koran full of wisdom. Most surely you are one of the apostles on the right way. It is a revelation of the Almighty, the Merciful, that thou mayest admonish a people whose fathers were never warned, and who therefore remained heedless. Already the word has proved true for most of them, for they do not believe. We have put bands around their necks up to their chins, so that their heads are forced up; and We have put a barrier in front of them and a barrier behind them—and further, We have covered them up so that they cannot see. And it is the same to them, whether you warn them or not, for they will not believe. You can only warn him who follows the reminder and fears the Merciful unseen. To such a one announce forgiveness and a generous reward. Verily, it is We who shall bring the dead to life, and record that which they have sent before and that which they leave behind—of all things have We taken account in a Clear Register. And set out to them the parable of the people of the city, when there came messengers to it: when we had sent them two, they rejected them both, but we have strenghtened them with a third...

The large words inside the arched portion quote the second Profession of Faith *(Shahada)*:

I bear witness that there is no god but God, who is One and who has no partner; and I bear witness that Muhammad is His creature and apostle.

Around this arch an inscription in much smaller letters quotes the "Throne Verse" (2.255; for translation, see No. 12); while the narrow band below the arch contains two short Koranic passages (36.52 part; 2.156 part):

This is what the Merciful promised and the apostles told the truth....Surely we are God's and to Him we shall surely return.

Framing the nine horizontal rows in the lower half of the panel is the Koranic passage most frequently found on Gujarat gravestones (3.18-19; for translation, see No. 6); while the first four of these row (just above the epitaph proper) quote Koran 3.169-71, a passage obviously chosen for its relevance to the martyrdom of the deceased:

And reckon not those who are killed in God's way as dead, Nay, there are alive and are provided sustenance from their Lord—rejoicing in what God has given them out of His grace; and they rejoice for the sake of those left behind them, who have not yet joined them, that they shall have no fear, nor shall they grieve. They rejoice on account of favor from God and His grace, and that God shall not waste the reward of the believers.

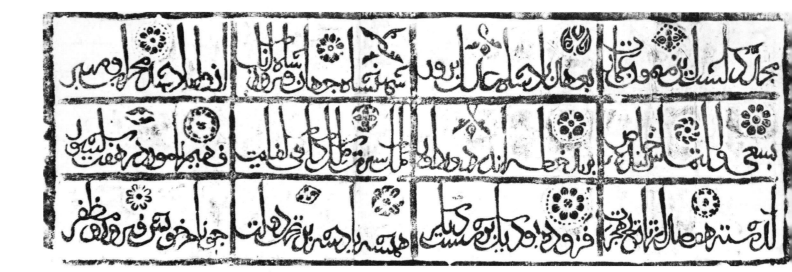

16.

SITE	Bihar Sharif (Bihar)	
MONUMENT	detached inscription, with Persian verses recording the renovation of a building by the royal official Malik Fahim	
DATE	761 / 1359-60	
DYNASTY	Tughluq, reign of Firoz Shah (1351-1388)	
SCRIPT	monumental Naskhi, tending toward convoluted Tughra	
SIZE	52x152 cm	
PUBLISHED	*EIAPS* 1961, pl. VII(a) (List No. 167)	

The Tughluq rulers were great builders, as attested to by the five entirely new capital cities founded by them at Delhi and Daulatabad—not to mention the scores of new constructions and renovations of existing buildings all across their unmanageable empire. Historians of Firoz Shah's reign credit him with "four mosques, thirty palaces, two hundred caravanserais, five reservoirs, five hospitals, a hundred tombs, ten baths, ten monumental pillars, and a hundred bridges"—and this may not include such no longer extant buildings as the one renovated by one of the royal officials of the region of Bihar, which had once again temporarily passed under imperial control.

The royal official was apparently named Malik Fahim, and his position was Royal Recorder, which may have been something like the office of district commissioner. The renovated building may have been one originally built fifty years earlier, in 709/1309, by the independent Bengal ruler Shams al-Din Firoz Shah. That is the date and name recorded on the *back* of the present inscribed slab, indicating that it was common practice to re-use older inscribed stones.

The calligraphy is typical of the convoluted Naskhi/Tughra type preferred in eastern India, but it seems less ornate—despite the added circular medallions—since the division into twelve separate panels imparts a certain structural coherence to the design. The layout accomodates the six inscribed Persian couplets, two to each horizontal row, and these have been translated as follows:

(1) This auspicious building was renovated
In the reign of the justice-establishing monarch,

(2) The emperor of the world Firoz Shah—
Under whom prayer-niches and pulpits flourished—

(3) Through the efforts and the instance of the favorite servant,
The Reporter of the province in the period of the just king:

(4) The angel-natured Malik of perfect competency, Fahim,
Illustrious throughout the seven climes.

(5) Seven hundred from the date of the Hijra had passed,
And besides, one added to sixty (761/1359-60).

(6) May the king remain on the throne of good fortune forever,
As victorious and successful as his name.

17.

SITE	Bihar Sharif (Bihar)
MONUMENT	detached inscription (now in Indian Museum, Calcutta), with Persian verses mentioning the local governor Khanzada Sulaiman
DATE	30 Muharram 767 / 17 October 1365
DYNASTY	Tughluq, reign of Firoz Shah (1351-1388)
SCRIPT	monumental Naskhi / convoluted Tughra
SIZE	44x95 cm
PUBLISHED	*EIAPS* 1955-56, pl. II(b) (List No. 136)

By the middle of the 14th century, the monumental Tughra style had evolved into a very self-conscious art form, especially in the hands of a great calligrapher like the designer of the present fragmentary inscription. As pointed out by Z.A. Desai, the epigraph combines "boldness of execution as well as graceful symmetry;" moreover the calligrapher "also seems to have indulged in a few intricate devices by which he had made one letter serve the purpose of two." The "graceful symmetry" here alluded to, is achieved by clustering them with an elegant curve bridging the open space between. Above these extended curves are placed small circles inscribed with the name *Allah*—one in each cartouche.

Aside from mentioning the name of the reigning monarch, the inscription also gives the name of the local ruler or governor, Khanzada Sulaiman, son of Ulugh Da'ud Khan—who presumably endowed the religious monument to which the slab was once attached.

(1) .
. Firoz Shah, the mainstay of the Universe.

(2) During the regime of Khanzada Sulaiman, son of Ulugh Da'ud Khan—
Who is the pride of the men of the sword, and a leopard indulging in wars—

(3) .
. for the sake of the Creator.

(4) Seven hundred and sixty-seven years had passed from the date of the Hijra;
Again, count the reckoning of thirty days in the month of Muharram (=17 October 1365).

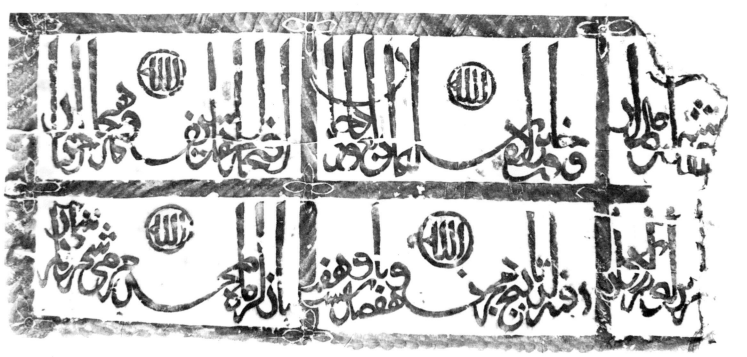

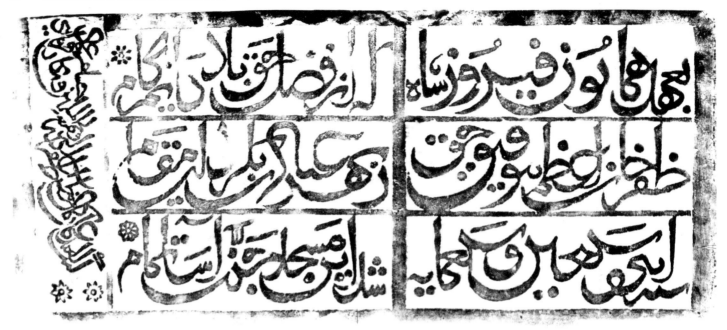

18.

SITE	Kapadwanj (Gujarat)
MONUMENT	Jami Masjid, Persian metrical inscription over main entrance, recording construction by the governor Zafar Khan
DATE	772/ 1370-71
DYNASTY	Tughluq, reign of Firoz Shah (1351-1388)
SCRIPT	variety of monumental Naskhi, resembling manuscript Bihari
CALLIGRAPHER	'Uthman, son of Kamal the calligrapher *(khattat)*
SIZE	38x86 cm
PUBLISHED	*EIAPS* 1962, pl. V(a) (List No. 174)

The present inscription of the emperor Firoz Shah documents his control over Gujarat and western India, then under the able governorship of the great Zafar Khan. Only a few years after the date of the Kapadwanj mosque, however, there began a gradual decline in the stability of the region. By the beginning of the 15th century, the Gujarat governors had become completely independent of the declining Tughluq empire—and remained so until the assimilation of the region into the Mughal empire in the late 16th century.

The calligraphy of the dedication panel is strikingly original in style, although it bears some resemblance to the so-called "Bihari" manuscript style found in a fair number of 14th and 15th-century Korans. A chief characteristic of the Bihari style is the thickened terminal endings of certain extended letters; but here, though thickened, the endings display pronounced curvatures instead of being more nearly horizontal. Since the script also has affinities with the more standard monumental Naskhi, it appears to represent the calligrapher's own synthesis of various contemporaneous styles. Obviously aware of his skills, the calligrapher includes a prominent signature in the vertical panel at the left end of the inscribed Persian verses, which reveals that his father was also a professional calligrapher (the colophon also gives the name of the supervisor of the mosque's construction). The entire text reads as follows:

(1) In the blessed reign of Firoz Shah—

May he always be successful through the bounty of God—

(2) Zafar Khan the great, through divine guidance,

Constructed this place intended for prayers.

(3) In the year seven hundred and seventy-two (772/1370-71),

This paradise-like mosque was completed.

Written by the creature Uthman, son of Kamal the calligrapher *(khattat)*—may God forgive him and all the Muslims!—and supervised by Husam, son of 'Imad.

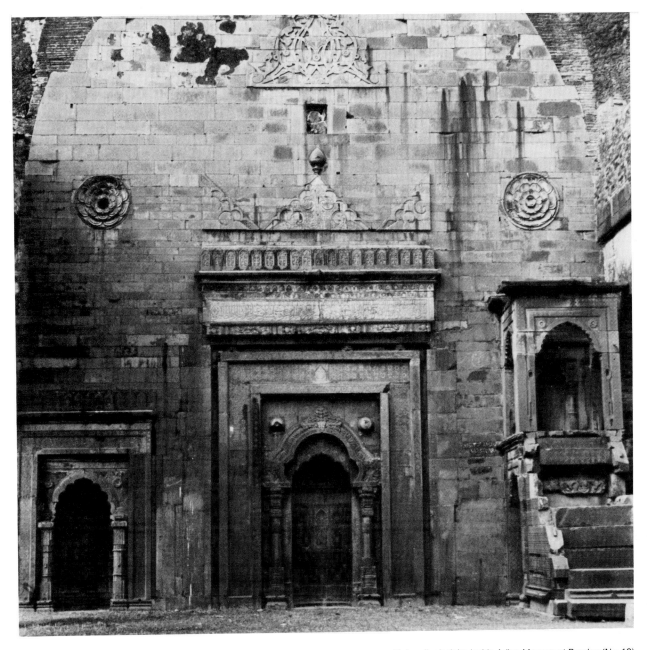

Main *mihrab* niche inside Adina Mosque at Pandua (No. 19)

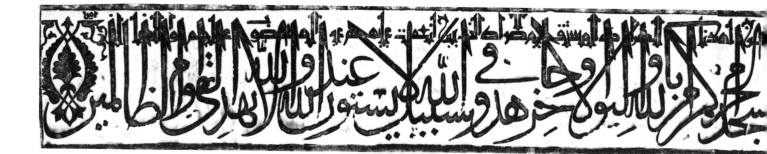

Koranic inscription above main *mihrab* of Adina Mosque

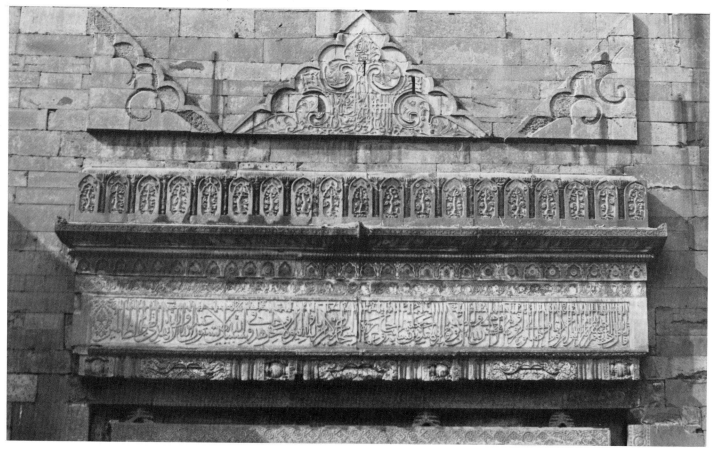

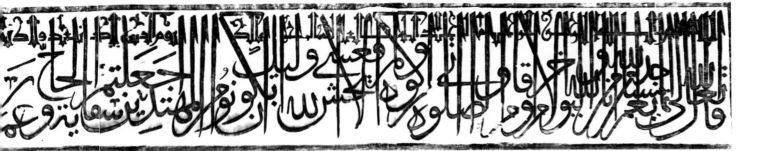

19.

SITE	Pandua (West Bengal)
MONUMENT	Adina mosque, Koranic inscription fixed above central *mihrab*
DATE	undated, mosque completed month of Rajab 776/ December 1374
DYNASTY	Sultans of Bengal, reign of Sikandar Shah (1358-1390); contemporaneous with Tughluq emperor Firoz Shah (1351-1388)
SCRIPT	monumental overlapping Thulth, and narrow band of foliated Kufi
SIZE	36x375 cm
PUBLISHED	J. H. Ravenshaw, *Gaur, Its Ruins and Inscriptions* (London, 1878), pl. XLV; *ARIE* 1969-70, No. D-24

Pandua was the new capital founded by the independent Bengal sultan Sikandar Shah; it is situated less than twenty miles northeast from the ancient city of Gaur—which was from 1202 the chief administrative center of Muslim rule in Bengal, second only to Delhi in importance. The crowning glory of the new capital was the Adina mosque, one of the largest in the Islamic world (about equal in area to the great mosque at Damascus). Though partly in ruins, its vast scale still makes it an awe-inspiring if rather austere structure. The great vaulted transcept hall in front of the central prayer-niche *(mihrab)* constitutes the most imposing area of the mosque, and it is there that the present inscribed slab is fixed-high up on the west wall, above the richly carved mihrab arch.

Like Sikandar Shah's foundation inscription outside the mosque (which was probably designed by the same calligrapher), the style of writing here is monumental overlapping Thulth—the earliest pure example of this magnificent script in the present exhibition. The large size of Thulth letters, their clarity and harmonious proportions go together to make this perhaps the most beautiful and eloquent script used on Indian Islamic monuments.

The decorative richness of the Adina calligraphic design is achieved entirely by abstract means, through the graceful and fortuitous overlappings of perfectly executed and perfectly balanced letter forms. By comparison with the tumultuous rhythms and almost impenetrable density of the earlier varieties of monumental Naskhi, the present design conveys a more stately movement, and seems more open and spacious despite its intricate overlapping.

Complex patterns of overlapping letters like those in the Adina inscription apparently first became the fashion in Iranian monuments built during the 14th century, as did also the practice of superimposing a narrow band of foliated Kufi across the top of the large Thulth letters. In the Adina mosque the constrained angularity of the narrow Kufi band was obviously intended by the calligrapher to serve as a contrapuntal foil to the expansive curvilinear sweep of the larger Thulth letters.

Appropriate to its location above the mosque's prayer-niche, the inscription cites only Koranic verses. The narrow Kufi band contains a few scribal errors which suggests that the calligrapher was not overly familiar with this archaic script; indeed this is one of the very few Kufi inscriptions of any kind known from eastern India. The passage transcribed in the narrow band is the *Fatiha* or opening chapter of the Koran, the recitation of which traditionally precedes all prayers (1.1-7):

In the name of God, the Merciful the Compassionate. Praise be to God, the Cherisher and Sustainer of the worlds, the Merciful, the Compassionate, Master of the Day of Judgment; Thee do we worship and Thine aid we seek. Show us the straight way, the way of those on whom Thou hast bestowed Thy grace, those whose portion is not wrath, and who go not astray.

At the end of this passage there occurs the benediction *Amin*, inscribed in very small Kufi letters just above the large decorative palmette motif at the far left. The large Thulth letters inscribed below contain a short Koranic passage frequently inscribed on Indian mosques (9.18-19; the Arabic text given on the stone contains a few errors and omissions, probably due to slips by the stonecutter rather than scribal error):

Thus says God the exalted: *The mosques of God shall be visited and maintained by such as believe in God and the Last Day, establish regular prayers, and practice regular charity, and fear none except God. It is they only who can be considered among the rightly guided. Do ye make the giving of drink to pilgrims, or the maintenance of the Sacred Mosque, equal to (the faith) of those who believe in God and the Last Day, and strive with all their might in the cause of God? They are not comparable in the sight of God—and God guides not those who do wrong.*

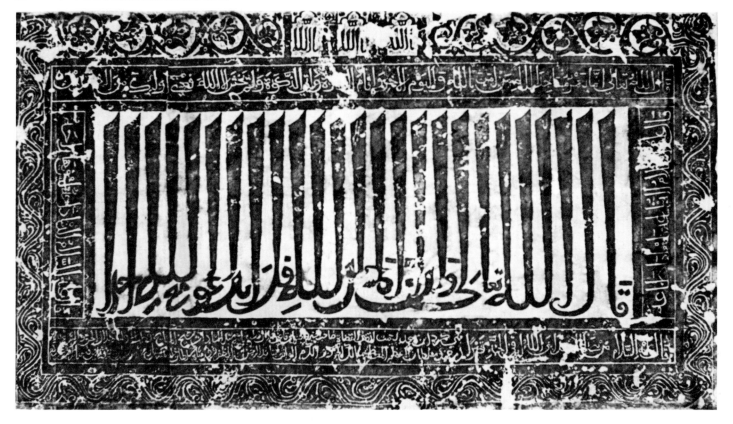

20.

SITE	Mangrol (Gujarat)
MONUMENT	Rahmat mosque, Arabic inscription over central *mihrab*, recording construction by the chief judge, Qadi Jalal, in the name of the saint Jalal al-Haq
DATE	784 / 1382-83
DYNASTY	Tughluq, reign of Firoz Shah (1351-1388)
SCRIPT	monumental Naskhi
CALLIGRAPHER	Sheikh 'Umar, son of Adam
SIZE	52x93 cm
PUBLISHED	*EIAPS* 1962, pl. VII(b) (List No. 174)

Essentially conservative in its calligraphic style, the design is nonetheless quite unusual and effective in its contrast between the bold row of flared vertical letters in the center, and the more delicate and unusual incised passages in the surrounding frame (Indian Islamic inscriptions are almost always in raised relief, rather than incised). The dedication was made by an otherwise unknown judge or *Qadi,* to honor a Sufi saint called Jalal al-Haq—who is probably to be identified as the illustrious Makhdum Jahaniyan, who was later on buried at Uchch in the province of Sind.

The central panel contains a Koranic passage (72.18) frequently inscribed on Indian mosques:

Thus says God the Exalted: *Verily the mosques are for God alone: hence invoke not therein any one else with God.*

On the top of the surrounding frame are incised the words *O God,* repeated three times; then one of the same Koranic verses previously cited at Pandua (9.18; for translation see No. 19). On the right and left sides, in thin vertical panels, are two Traditions *(Hadith)* of the Prophet:

(The Prophet), peace be upon him, has said: "The world is for a moment only; utilize it in devotion." (The Prophet), peace be upon him, has said: "The world is a mere bauble; there is no rest therein."

The bottom border contains the epitaph proper; preceded by another Hadith:

(The Prophet), peace be upon him, has said: "Whoever builds a mosque for God, for him will God build a mansion in Paradise." This Rahmat mosque was constructed by the chief of the judges, the master of bounty and good actions, Qadi Jalal, son of Qutb, in the name of the chief of the descendents of the Prophet, the Shaikh of Shaikhs, the Pillar of the saints, Jalal al-Haq, the Glory of the Law and Religion *(Jalal al-Din),* in the reign of the illustrious monarch, the lord of munificence and generosity, who relies upon the support of the Compassionate, the victorious Firoz Shah, the Sultan, may God perpetuate his kingdom, in the days of the month of the year 784 (=1382-83). Written by Shaikh 'Umar, son of Adam.

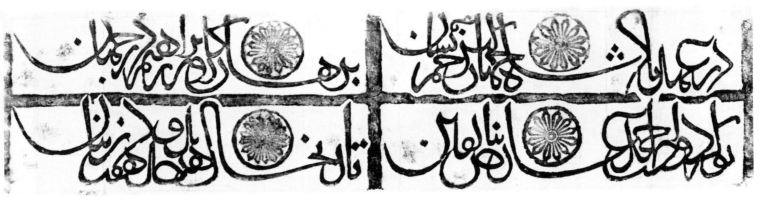

21.

SITE	Bihar Sharif (Bihar)
MONUMENT	detached Persian metrical inscription recording renovation of a building by the court official Qutb bin Ahmad
DATE	807 / 1404-05
DYNASTY	Sharqi sultans of Jaunpur, reign of Ibrahim (1402-1440); contemporaneous with Tughluq sultan Mahmud Shah (1393-1395 and 1399-1413)
SCRIPT	monumental Naskhi / convoluted Tughra
SIZE	25x106 cm
PUBLISHED	*EIAPS* 1962, pl. XII(a) (List No. 175)

Following the death of the great Tughluq emperor Firoz Shah, the region of Bihar and eastern Uttar Pradesh proclaimed its independence and established a dynasty that lasted for about 130 years — but was ultimately reabsorbed by the Lodi sultanate at Delhi. For that brief period, the Sharqi sultans made important cultural contributions primarily through the outstanding architectural monuments patronized by them at their capital of Jaunpur. In Bihar Sharif, the present inscription records the renovation of a building by a state official named Qutb, son of Ahmad, who seems to have held the position of military paymaster (*'arid),* when Sharqi power had temporarily extended that far east.

Although very similar in style to the Bihar Sharif inscription already discussed (see No. 17), the present design is even more professional and assured in execution, as well as more abstract and difficult to decipher. Its idiosyncrasies notwithstanding, it ranks as one of the most artistically brillant of all the works in the present exhibition.

The text consists of two Persian couplets, which translate as follows:

(1) During the reign of the world-conquering monarch of Jamshid insignia,

Ibrahim, who is the proof of the Age in the world,

(2) Verily Qutb, son of Ahmad the Paymaster, renovated the structure,

When the date of the year was eight hundred and seven (807/1404-05).

22.

SITE	Ahmadabad (Gujarat)
MONUMENT	Jami Masjid, Arabic inscription over east gateway, recording construction by sultan Ahmad Shah
DATE	1 Safar 827 / 4 January 1424
DYNASTY	Sultans of Gujarat, reign of Ahmad Shah (1411-1442); contemporaneous with Sayyid sultan Mubarak Shah (1421-1435)
SCRIPT	monumental Naskhi / Thulth
SIZE	45x102 cm
PUBLISHED	M. A. Chaghtai, *Muslim Monuments of Ahmadabad through their Inscriptions* (Poona 1942), 44, pl. X(a); *ARIE* 1967-68, No. D-128

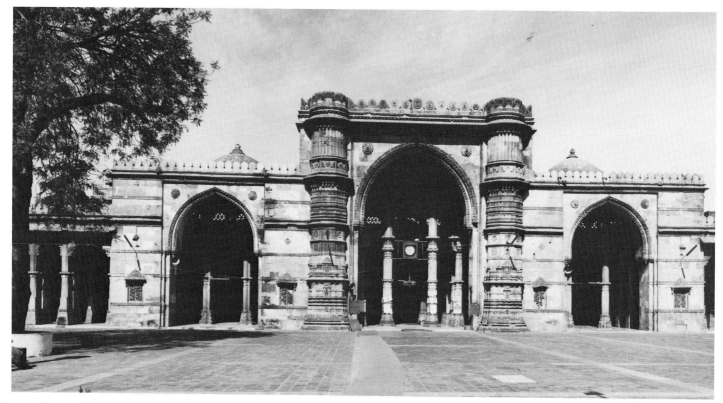

Jami Masjid at Ahmadabad

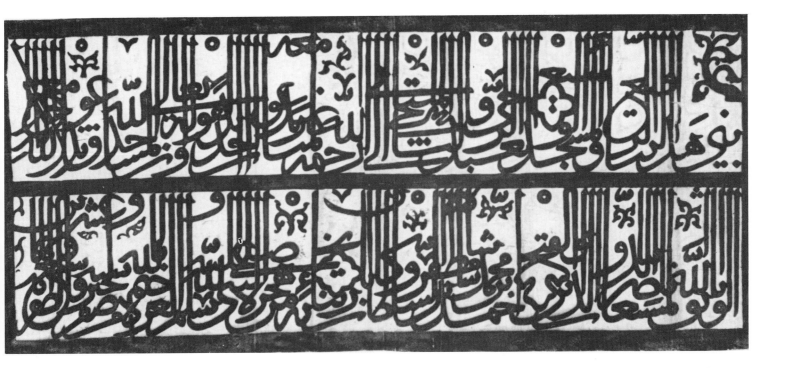

As with the Sharqi sultans of Jaunpur, the provincial governors of Gujarat asserted their independence almost immediately following the death of the last great Tughluq emperor Firoz Shah. Ahmad Shah was the second ruler of the independent dynasty of Gujarat sultans, and gave his name to the new capital of Ahmadabad which he founded in 1411. The crowing architectural achievement of his reign was the large congregational mosque, of which the present inscription records the dedication. Compared to the rather austere mosque at Cambay discussed above (see No. 14), the Ahmadabad mosque is much more ornate and eclectic in style—particularly in its treatment of the great triple arches leading to the interior pillared prayer hall.

The calligraphic style of the foundation inscription is a fitting match to the mosque's architectural ornateness and eclectic character. Designed by a superb calligrapher, the inscription combines certain qualities of both the traditional Naskhi and the more recently introduced overlapping Thulth. Essentially the calligraphic style is Thulth, but the crowded density of the composition recalls the convolutions of the Tughra variety of monumental Naskhi. This is particularly evident in the regularly spaced clusters of vertical letters, which when viewed from a distance, create the effect of a decorative grilled screen. The bold linear script seems to echo the thin linear ornamentation on the attached towers on the mosque's main facade. All in all, both architect and calligrapher appear to have been striving for similar effects of dignity and richness—qualities that would reflect favorably on the builder of this royal mosque.

The full text of the inscription, divided into two bands, is as follows:

This lofty edifice and spacious mosque was built by the humble servant, who hopes and praises, trusting to the mercy of the All-merciful God—along with Whom, no one else is to be invoked, in accordance with His, the Exalted God's word: *"Verily, the mosques are for God alone; hence invoke not therein anyone else with God"* (72.18) —

One who is reliant on God, whose aid is sought, namely the Helper of the State and Religion *(Nasir al-Din),* the Victorious Ahmad Shah, son of Muhammad Shah, son of Muzaffar Shah. And the date of its construction from the Hijra of the Prophet—may God's salutations and peace be upon him—was the 1st of Safar (may God end it with bounty and victory), year 827 (=4 January 1424).

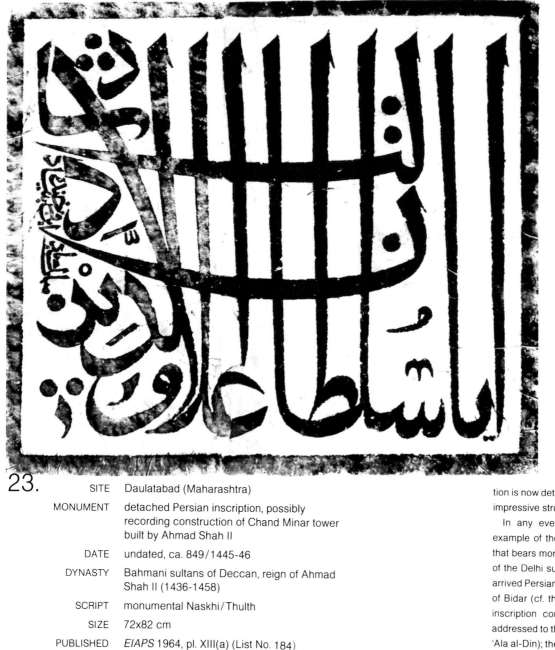

23.

SITE	Daulatabad (Maharashtra)	
MONUMENT	detached Persian inscription, possibly recording construction of Chand Minar tower built by Ahmad Shah II	
DATE	undated, ca. 849/1445-46	
DYNASTY	Bahmani sultans of Deccan, reign of Ahmad Shah II (1436-1458)	
SCRIPT	monumental Naskhi/Thulth	
SIZE	72x82 cm	
PUBLISHED	*EIAPS* 1964, pl. XIII(a) (List No. 184)	

Daulatabad had briefly served as the capital of the Tughluq empire during the reign of the despotic Muhammad Shah, but the entire Deccan became independent of Delhi when the Bahmani dynasty was established in the middle of the 14th century.

Although the major Bahmani monuments are situated in their capitals at Gulbarga and Bidar, the lofty Chand Minar tower at Daulatabad was constructed by Ahmad Shah II in 1445-46, during the second decade of his reign. Although the present inscrip-

tion is now detached, it perhaps also pertains to this impressive structure.

In any event, the calligraphy is an imposing example of the monumental Naskhi/Thulth script, that bears more resemblance to earlier inscriptions of the Delhi sultans than those produced by newly arrived Persian calligraphers at the Bahmani capital of Bidar (cf. the design in No. 25). The text of the inscription consists of a single Persian couplet addressed to the sultan Ahmad Shah II (here called 'Ala al-Din); the first line is written in boldly overlapping letters almost filling the entire panel, while the second is inscribed in tiny vertical letters at the left side:

> O sultan 'Ala al-Din! May your heart be pleased!
> May this blessed building be auspicious!

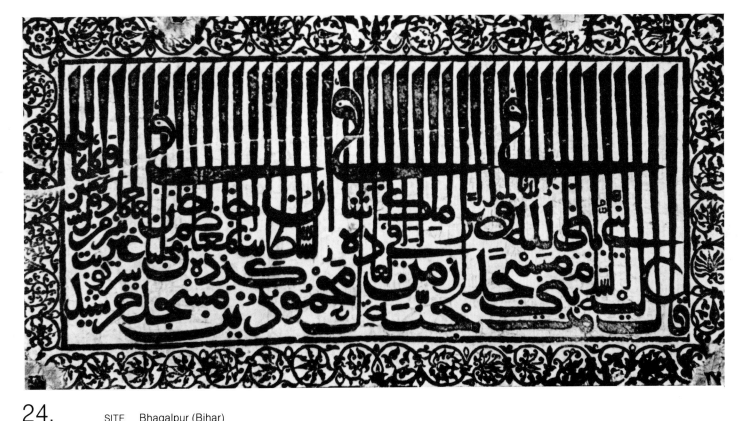

24.

SITE	Bhagalpur (Bihar)
MONUMENT	detached Arabic and Persian inscription, recording construction of a mosque by the noble Khurshid Khan
DATE	10 Jumada II 850/3 August 1446
DYNASTY	independent Bengal sultans, reign of Mahmud Shah (1437-1460); contemporaneous with Sayyid sultan 'Alam Shah (1446-1451)
SCRIPT	monumental Naskhi, tending toward convoluted Tughra
SIZE	46x89 cm
PUBLISHED	*Epigraphia Indica* 2 (1894): 280; *ARIE* 1962-63, No. D-18

In eastern India, monumental calligraphy developed along rather indiocyncratic lines, since a high premium was placed on the purely decorative aspects of the inscriptions—often at the expense of legibility. Many earlier inscriptions employ the same device of extending the vertical letters to form a row of regularly placed strokes across the top of the panel. Similarly, piling up letters into convoluted Tughra patterns had long been the practice in Bengal. Here, however, the calligrapher goes one step further and converts the abstract arrangement of letters into a surprisingly representational scene—in which three repeated words at the top (reading *fi* or "in") are made to resemble ducks floating against a background of reeds; and the jumbled array of words at the bottom, floating plants.

Although the present example might be criticized as excessively anecdotal, abandonment of the traditional method of organizing texts into parallel rows of writing opened up new possibilities for calligraphers to treat their designs as purely abstract compositions (cf. the magnificent panel in No. 28). Difficulty in reading the inscriptions was obviously not a concern to either patron or calligrapher, since the texts of most such dedication panels were usually familiar formulas, as here. Thus the inscription begins with the well-known Tradition about the heavenly reward for building mosques; then succinctly identifies the builder as the noble Murshid Khan, who seems to have been in charge of military security at the capital:

The Prophet—may God's peace be upon him!—says: "He who builds a mosque in this world, God will build for him a palace in Paradise."

During the reign of the just king Mahmud Shah, this mosque was built by the exalted noble Khurshid Khan, chief of the guardians outside the palace, on the 10th of Jumada I, year 850 (=3 August 1446).

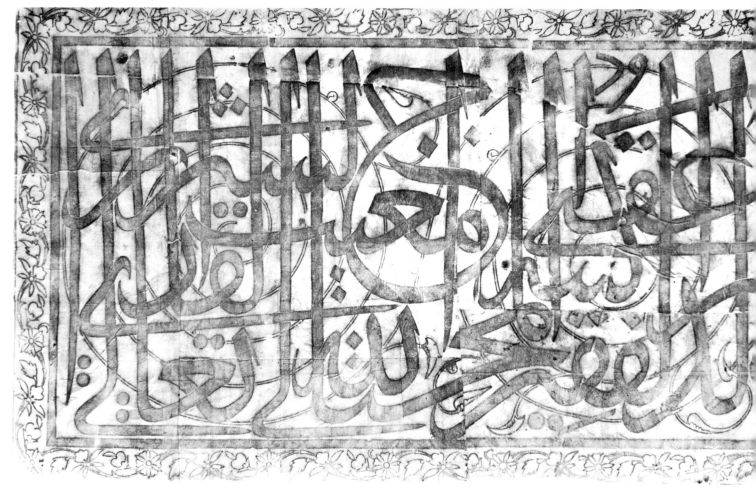

25.

SITE	Bidar (Karnataka)
MONUMENT	Tomb of Sufi saint Khalil Allah, part of Koranic inscription over south doorway
DATE	undated, ca. 854/1450
DYNASTY	Bahmani sultans of Deccan, reign of Ahmad Shah II (1436-1458)
SCRIPT	overlapping Thulth, against foliate background
CALLIGRAPHER	Mughith al-Qari al-Shirazi
SIZE	74x248 (two sections combined)
PUBLISHED	*EIM* 1927-28, pl. VIII (List No. 54)

This majestic and powerful design should rank as one of the great masterpieces of monumental Islamic calligraphy in India. The original is incised on several slabs of fine-grained black basalt, set into a long frieze panel over the recessed south doorway to the tomb of the renowned Sufi saint Khalil Allah. Both saint and calligrapher had immigrated from Iran to the newly established capital of the Bahmani kings at Bidar. The saint, who acted as spiritual guide to two successive rulers (Ahmad Shah I and II), had been invited to court in 1431, after the death of his father, the even more illustrious saint Ni'mat Allah of Kirman. As a result of Khalil Allah's influence on the later Bahmani kings, Shiism was given an important impetus toward becoming a major

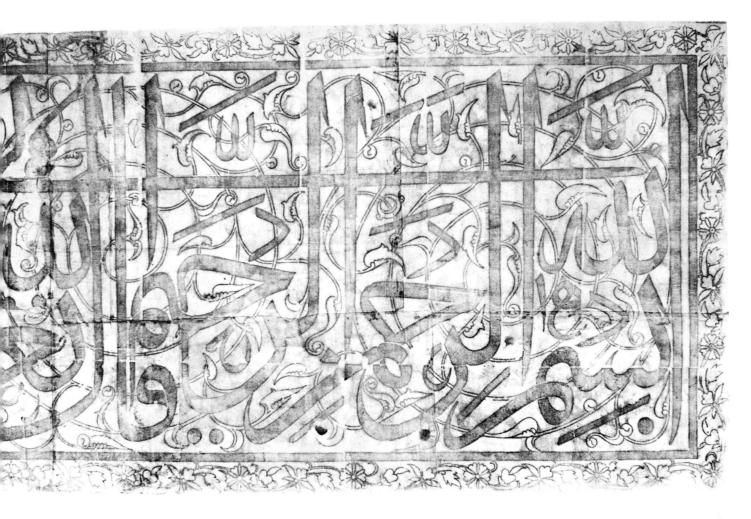

religious force in the Deccan—enjoying a considerable amount of prestige from the 15th century onwards.

Unfortunately, Khalil Allah's beautiful octagonal tomb (locally called *Chaukhandi*) is undated; but it appears that it was constructed sometime during the reign of Ahmad Shah II (1436-1458). Though there is a literary tradition that the saint had died around, 1460, this seems doubtful since he was not present at the great accession ceremonies of 1458, when Ahmad Shah II's son Humayun became king. Moreover, the politically unstable situation that obtained for several years after 1458 makes it much more likely that the tomb dates to about 1450, or perhaps earlier.

In contrast to the saint, the calligrapher, Mughith al-Qari of Shiraz, brought with him to India consummate mastery of the Thulth script, which he here superimposes against an elegant foliate background—in accordance with the prevailing Persian fashion for large architectural inscriptions (especially in mosaic tile-work, which technique Persian artisans imported to Bidar after the middle of the 15th century). Only the beginning and end of the long frieze inscription are shown here: the first panel, containing the opening *Bismillah* invocation of the inscribed Koranic verses (13.23-24); and the end panel, containing the calligrapher's imposing signature. The brief Koranic passage is most appropriate for a tomb, since it alludes to the gardens of

Paradise promised to the righteous; moreover as the octagonal tomb form itself is metaphorically suggestive of the mansions of Paradise, the calligraphy was clearly intended to reinforce the implied symbolism of the saint's final resting place:

In the Name of God the Merciful the Compassionate.

God the Exalted said: (...Gardens of Eden shall they enter there, as well as the righteous among their fathers, their spouses, and their offspring; and angels shall enter unto them from every gate, saying: "Peace unto you for that ye persevered in patience! Now how excellent is the...) final home!

Written by the humble creature (*faqir*), dependent upon the Exalted God, Mughith al-Qari al-Shirazi.

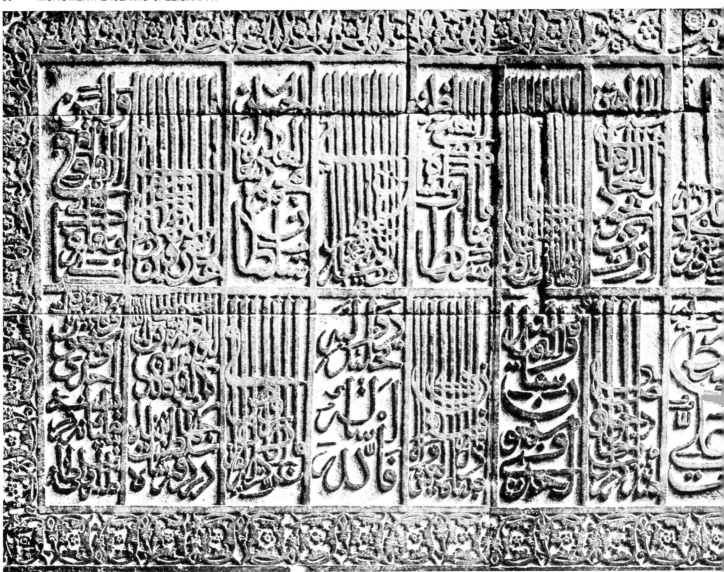

26.

SITE	Gaur (West Bengal)
MONUMENT	detached Arabic inscription (now in The University Museum, Philadelphia), recording construction of a citadel gateway by the ruler Barbak Shah
DATE	871/1466-67
DYNASTY	Bengal sultans, reign of Barbak Shah (1460-1474); contemporaneous with Lodi sultan Bahlul (1451-1489)
SCRIPT	overlapping Naskhi/convoluted Tughra
SIZE	90x244 cm
PUBLISHED	N.A. Faris and G.C. Miles, "An Inscription of Barbak Shah of Bengal," *Ars Islamica* 7 (1940)

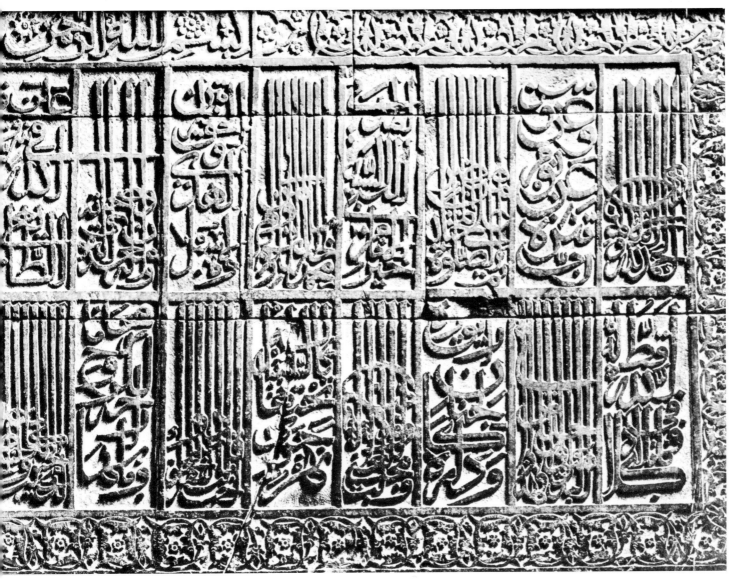

This is perhaps the finest example of monumental Islamic calligraphy from India now in an American collection. Originally set up over a gateway in the medieval city of Gaur in Bengal, the black basalt panel was removed from the site sometime after 1810, and thereafter entered the collection of Thomas Hope, an early 19th century English collector of antiquities. The inscription was acquired by the dealer H. Kevorkian at auction in 1917 and subsequently purchased by the University of Pennsylvania Museum in 1924.

The purpose of the inscription is to glorify the ruler Barbak Shah, and the magnificence of his many constructions in the citadel of his capital at Gaur, specifically the "Middle Gate" (*Miyana Dar*), above which the panel was originally installed. That the inscription was easily legible is extremely doubtful, since the calligraphy is a particularly dense variety of Naskhi script composed in the highly convoluted Tughra manner. The text consists of fifteen Arabic verses and a colophon, inscribed within thirty-two compartments arranged in two horizontal rows—the whole surrounded by a frame with foliate pattern. From minor errors in the transcription it appears that the calligrapher was not an expert in Arabic.

The text begins with the traditional *Bismillah* invocation, inscribed in the top center of the foliate frame. Each of the Arabic verses occupies two adjoining compartments, within which two slightly different styles of calligraphy are used in alternation. Thus half of the compartments are crowded with dense Tughra compositions, with elongated

27.

SITE	Pandua (West Bengal)
MONUMENT	detached Arabic inscription, recording construction of a mosque by the noble Majlis A'zam
DATE	1 Muharram 882/ 15 March 1477
DYNASTY	Bengal sultans, reign of Yusuf Shah (1474-1481) contemporaneous with Lodi sultan Bahlul (1451-1489)
SCRIPT	convoluted Naskhi/Tughra
PUBLISHED	*Archaeological Survey of India Report* 15 (1879-80): 125-126; *ARIE* 1955-56, No. D-29

verticals filling the entire area; while the other half display lettering arranged with more open spacing. For some reason, the calligrapher forgot to allow sufficient space at the end, so the colophon had to be crowded into the last two compartments.

The full text of the inscription was published by Faris and Miles in 1940, and their translation is as follows:

In the Name of God the Merciful the Compassionate

(1) Praise be to God, the source of munificence and grace,
A Lord who transcends slumber and sleep.

(2) Then may the blessings of God be upon the elect of Mudar,
The best of creation, the illustrious Prophet of Medina:

(3) Muhammad, the seal of the noble prophets,
Without whom the paths of righteousness and truth would not have become known;

(4) And upon his family, the fountainhead of piety, and upon his companions,
Who are obedient unto God in private and in public.

(5) Then I sing the praise of one whose generosity
Surpasses the beneficience of clouds heavily laden with moisture;

(6) The King Sultan The Pillar of the World and Religion,
Our Sultan Barbak Shah, the sublime, the wise;

(7) The son of him whose fame has spread throughout the lands—
Sultan Mahmud Shah, the just and fair.

(8) Is there in the two Iraqs a sultan as generous
As Barbak Shah, yea in Syria and in al-Yaman?

(9) No! There is not unto him in all God's land
An equal in generosity, for he is unique, unparalleled in his time.

(10) His abode is like unto a garden, tranquil and pleasing;
It gathers joy and dispels sorrow.

(11) A watercourse flows beneath it, resembling the waters of Paradise,
With pearl-like ripples, which do away with poverty and pain.

(12) Its gate provides refuge, like fragrant basil to the soul,
To friends; while to foes it is forbidden and remote.

(13) A sublime gate, refreshing and cheerful, called The Middle Gate (*Miyana Dar*) was set apart as a special entrance,

(14) In the year eight-hundred and seventy-one—
An abode of life and hope and rest.

(15) I therefore ask God to perpetuate his dominion
As long as birds on tree tops alight and sing.

During the reign of the king, the refuge of the universe, The Pillar of the World and Religion, the victorious sultan Barbak Shah—may God prolong his power and dominion—the building of the Middle Gate was accomplished in the year eight-hundred and seventy-one (=1466-67).

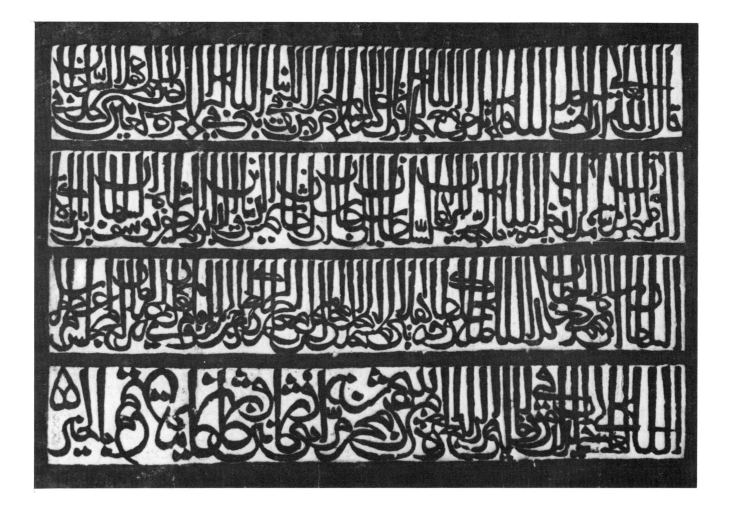

Inscribed on the back of a re-used sculpture of the Hindu deity Surya, the slab's arrangement of the text into horizontal rows follows the more conservative format of earlier Bengal inscriptions, but the use of convoluted Tughra script reflects current fashion. Examples of florid Tughra such as these strongly suggest that the calligraphers who prepared designs for stone inscriptions were the same ones who wrote the official documents in the royal chancellery. Certainly the tumultuous rhythms of the script here make it more akin to bold handwriting than to the disciplined styles practiced by artist-calligraphers—as for example the majestic Thulth inscription from Pandua discussed earlier (No. 19).

Here again, the inscription starts with a well-known Koranic verse (72.18) and Tradition—both of which are frequently inscribed on Indian mosques; these are followed by a eulogy of the reigning king Yusuf Shah and the mosque's builder, the noble Majlis A'zam:

God the Exalted said: *"Verily the mosques are for God alone; hence invoke not therein anyone else with God."* And the Prophet—peace be upon him—has said: "He who builds a mosque in this world, for him will God build seventy palaces in the Hereafter."

This mosque was constructed during the reign of the sultan of the age, one who is backed by the support of the Supreme Judge, the vicegerent of God, by argument and proof, the Sultan, son of a sultan, who was the son of a sultan: the Sun of the State and Religion (*Shams al-Din*), the Victorious sultan Yusuf Shah, son of sultan Barbak Shah, son of sultan Mahmud Shah—may God perpetuate his kingdom and sovereignty!

And it was built by the most privileged noble, the magnificent and respected Majlis, lord of the sword and pen, the champion of the age and the time, the great Majlis, A'zam—may the Exalted God protect him in both worlds!

Written on Wednesday, the 1st of the month of Muharram, year 882 (=15 April 1477); And end it well!

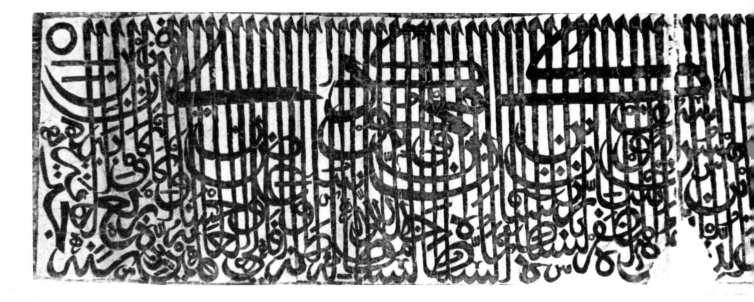

28.

SITE	Gaur (West Bengal)
MONUMENT	detached Arabic inscription (now in Indian Museum, Calcutta), recording construction of a mosque by sultan Yusuf Shah
DATE	884/1479-80
DYNASTY	Bengal sultans, reign of Yusuf Shah (1474-1481) contemporaneous with Lodi sultan Bahlul (1451-1489)
SCRIPT	convoluted Tughra
SIZE	60 x 334 cm
PUBLISHED	*EIAPS* 1955-56, pl. IV(b) (List No. 136)

As the official dedication of a royal mosque near the capital at Gaur, the present inscription is especially large and imposing. Moreover it is a calligraphic *tour de force* of the convoluted Tughra style preferred in eastern India during the 15th century and later. Like the smaller and slightly earlier panel from Bhagalpur (No. 24), the present inscription sacrifices legibility for abstract form. Indeed the closest visual parallel in modern art would be

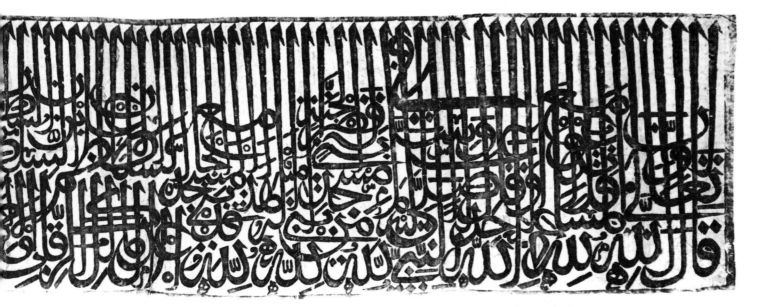

abstract expressionism, particularly the dense calligraphic paintings of artists like Jackson Pollock, Mark Tobey or Ulfert Wilke.

Like such work, the present inscription only creates the illusion of uncontrolled energy and chaos. On closer inspection, it is clear that the design is coherent in structure and ordered in its rhythms. As in inscriptions discussed earlier, a strong sense of architectonic structure is created by the regular repetition of extended verticals; while recurring motifs, like the undulating curves of the letters of the word *Allah* (inscribed six times in quick succession across the bottom of the right side), create a regular rhythmic movement that culminates in a final crescendo at the left.

Unfortunately, like so many other imperial structures in and near the ruined city of Gaur, the mosque mentioned in the dedication no longer survives. Since the mosque's builder, Yusuf Shah, was the son of Barbak Shah, it is instructive to compare the present inscription with the earlier one from Gaur endowed by the latter king (No. 26). Although the script type is the same, it is obvious that dispensing with the geometric compartments used to divide the sections of the text constituted an extremely radical step—but one which facilitated the movement toward even greater freedom in the calligrapher's manipulation of the abstract elements of his art.

With some difficulty, the text of the inscription can be deciphered as follows:

God the Exalted said: *"Verily the mosques are for God alone; hence invoke not therein anyone else with God"* (72.18). And the Prophet—may the blessings and peace of God be upon him—has said: "He who builds a mosque for God, for him will God built a palace like it in Paradise.

This congregational mosque was constructed by the just sultan, master of the necks of peoples and of nations, the Sultan, son of a sultan who was son of a sultan, the Sun of the State and Religion *(Shams al-Din)*, the Victorious sultan Yusuf Shah, son of sultan Barbak Shah, son of sultan Mahmud Shah—may God perpetuate his kingdom and sovereignty, and make his bounty and gift universal—in the Hijri year 884 (=1479-80).

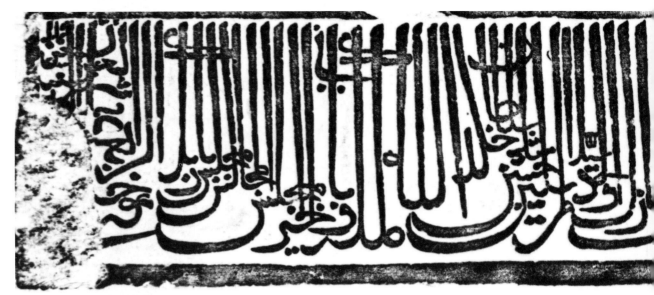

29.

SITE	Depara (West Bengal)
MONUMENT	detached Arabic inscription (now in Indian Museum, Calcutta), recording construction of a mosque by the noble Majlis Barbak
DATE	Jumada II 899/ March 1494
DYNASTY	Bengal sultans, reign of Husain Shah (1494-1519); contemporaneous with Lodi Sultan Sikandar Shah (1489-1517)
SCRIPT	Naskhi/Tughra
SIZE	20x96 cm
PUBLISHED	*EIAPS* 1965, pl. IX(b) (List No. 191)

Written in an elegant and extremely fine variety of Naskhi/Tughra script, the present inscription is historically important as the earliest known epigraph of the important Bengal ruler Husain Shah. His was a long and extremely enlightened reign, characterized by such a high degree of religious toleration, that some Hindu contemporaries referred to him as an incarnation of Krishna.

The delicacy of calligraphic touch seen here stands in marked contrast to the bold and tumultuous styles that flourished in the regions north of the Ganga river. In fact, the architectural usage of the present style was probably limited to a small geographic area; although it bears some resemblance to the so-callled "Bihari" script employed in a fair number of 15th-century Indian manuscripts of the Koran.

The founder of the mosque was the otherwise unknown noble called Majlis Barbak; the text of the inscription includes the standard Tradition about the merits of building mosques, and the standard eulogy of the ruler:

The Prophet—may God's blessings and peace be upon him—has said: He who builds a mosque in this world, for him the Exalted God will build seventy palaces in Paradise."

The mosque was constructed in the time of the just and liberal sultan, a descendant of the chief among the prophets, Husain Shah the Sultan—may God perpetuate his kingdom!—and the founder of this good work is the chief among the nobles, Majlis Barbak. Dated ... of the month of Jumada II, year 899 (=March 1494).

30.

SITE	Nagaur (Rajasthan)
MONUMENT	mosque in Pir Sahib shrine complex, Persian dedication inscription above *mihrab*, recording construction by noble Dada Kila(?)
DATE	12 Rajab 900/ 8 April 1495
DYNASTY	Khanzada chiefs of Nagaur, reign of Firuz Khan II (c.1470-1495); contemporaneous with Lodi sultan Sikandar Shah (1489-1517)
SCRIPT	convoluted Tughra
SIZE	34x83 cm
PUBLISHED	*EIAPS* 1970, pl. VI(b) (List No. 229)

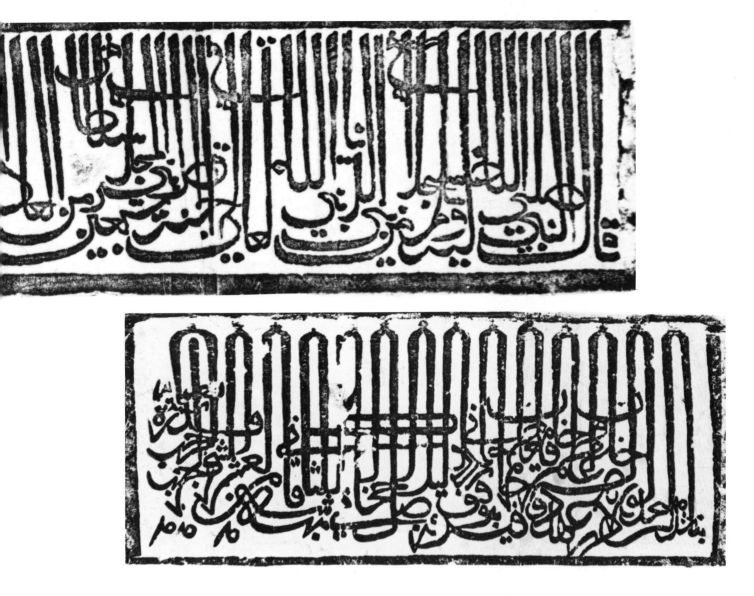

The calligraphy here bears a strong resemblance to another inscription from Rajasthan discussed earlier (No. 13), though the latter is almost two centuries earlier. The history of architectural calligraphy in India includes several such instances of close borrowing from older models; here it appears to indicate an inherent conservatism on the part of the Khanzada chiefs who ruled the region of Nagaur in the 15th century, independently of the Lodi sultanate at Delhi. As in the earlier model, the writing here combines a row of joined verticals across the top with a confused array of superimposed letters below.

The text has been deciphered as follows:

This splendid mosque was constructed during the reign of the great Khan and magnificent Khaqan, Firuz Khan, through the grace of the Merciful God, by Dada Kila(?), retainer of Salal Khan—for the king, on the 12th of the month of Rajab, may its dignity increase. Year 900 (=8 April 1495).

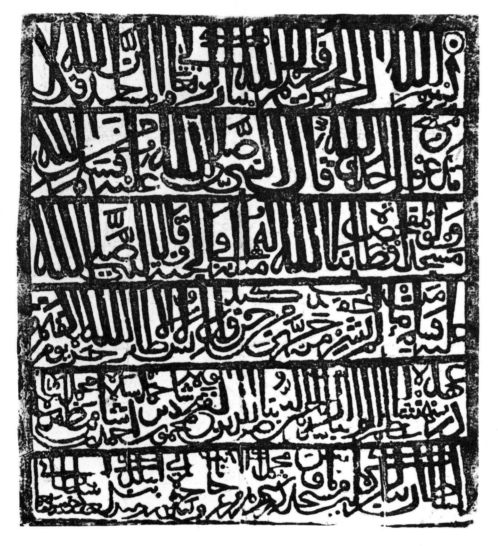

31.

SITE	Champaner (Gujarat)
MONUMENT	detached Persian inscription (now fixed inside a mosque at Godhra), recording construction of a mosque and step-well by the noble Malik Sandal
DATE	905/1499-1500
DYNASTY	Gujarat sultans, reign of Mahmud Shah (1458-1511); contemporaneous with Lodi sultan Sikandar Shah (1489-1517)
SCRIPT	monumental Naskhi
SIZE	58x55 cm
PUBLISHED	*EIAPS* 1974, pl. VI(b) (List No. 253)

Though its calligraphy is not of high quality, the panel is an interesting late specimen of the bold Naskhi script that was widely used in North India for more than three hundred years—from about 1200 to 1550 (see No. 35), after which it disappeared forever from architectural inscriptions. Aside from its dynamic sense of movement, the chief visual characteristic of this script is its use of thick verticals with flared tops. Curiously, bold verticals occur here only in the upper four rows of the panel, and are particularly noticeable in the various repetitions of the word *Allah.*

The text is also of some interest, since it records the donation of both a mosque and another kind of important architectural construction, namely a stepwell—of which hundreds dating to the medieval period still survive. The inscription itself, however, was at some point removed from its original location at Champaner and taken to the town of Godhra, where it was installed on the main gate of a mosque. The translation is as follows:

In the Name of God the Merciful the Compassionate.

God the Blessed and Exalted said: *Verily the mosques are for God alone; hence invoke not therein anyone else with God* (72.18). And the Prophet—may God's blessings and peace be upon him—has said: "He who builds a mosque for God, even if it be as modest as a sparrow's nest, for him God will build the like in Paradise." And the Prophet—may God's blessings and peace be upon him—has said: "He who excavates a well, from which the thirsty among the genii, mankind and birds cannot quench their thirst, God will render him thirsty on the Day of Resurrection."

In the reign of the great king, the reliant on the support of the Compassionate, the Helper of the State and Religion, the Victorious Mahmud Shah—son of Muhammad Shah, son of Ahmad Shah, son of Muhammad Shah, son of Muzaffar Shah—the Sultan, this mosque and step-well were built in the illustrious city of Muhammadabad, called Champaner, by the humble creature of Divine Majesty, Malik Sandal, son of 'Ud, year 905 (=1499-1500).

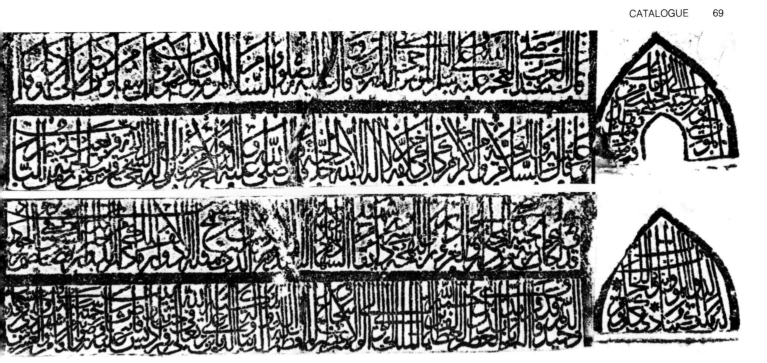

32.

SITE	Burhanpur (Madhya Pradesh)
MONUMENT	grave of the noble Amir Yar 'Ali, Arabic epitaph on sides and ends of cenotaph
DATE	28 Dhi'l-Qa'da 909/ 18 January 1504
DYNASTY	Faruqi sultans of Khandesh, reign of Da'ud Khan (1503-1510); contemporaneous with Lodi sultan Sikandar Shah (1489-1517)
SCRIPT	monumental Thulth
SIZE	66x162 cm (combined sections)
PUBLISHED	*EIAPS* 1962, pl. XXII (List No. 177)

Arabic epitaphs on cenotaphs and sarcophagi constitute another important category of monumental calligraphy in funerary contexts—in addition to the structural tombs and inscribed headstones already discussed. The present inscription decorates the arched ends and curved sides of a stone cenotaph atop the grave of the highly placed noble Amir Yar 'Ali. The deceased had died supporting the cause of the new sultan Da'ud Khan, a member of the Faruqi dynasty which ruled the region of Khandesh in Central India for more than two hundred years, from around 1370 on.

Not only is the densely designed Thulth calligraphy of very high quality, but the Arabic epitaph was obviously composed by someone who was expert in that language—which is unusual for Indian monuments. There are two main divisions to the text: the short inscription at the head and foot of the cenotaph (north and south ends), and the long prose epitaph beginning on the east side and continuing onto the west.

The slightly larger arch on the head-end contains these lines:

Death is a bridge linking friend to friend.
For one who dies, verily comes the Day of Judgment.

Similarly at the foot, the arch bears this verse:

God has an angel whose duty each day is to proclaim:
"Be born to die, and build for eventual destruction."

The full epitaph, divided into two lines on both sides, reads:

The Chief of Arabia and other countries—may God's blessings and peace be upon him and his descendants—has said: "A true believer is alive in both the worlds." And he—peace be upon him— has also said: "The true believers do not die; nay they but move from one abode to another." And he—salutations, blessings and respect be upon him—has said: "He whose last words are *'There is no god but God'* shall enter Paradise." And he— may God's blessings be upon him and his descendants and may He not deprive us of his generous favors—has also said: "A generous man is near to God and Paradise, and far from Hell."

Verily, he answered the call of his Lord's executor, and happily accepted death and passed from the abode of toil and deceit to the abode of peace and joy; the martyr who tested martydom, obtaining the status of martyr; the generous and great Amir, the like of whom is rare in these revolving times and so long as the heavens themselves revolve; one who excelled above all others in generosity in this field of existence; the unique of the age, the phoenix among human beings, the incomparable one of the age for bestowing bounty, the receiver of the mercy of God—Who is the King, the Lord, the Friend— the great and magnificent Amir, the Hero of the State and Religion *(Shuja' al-Din)* Yar 'Ali—may the Exalted God grant him place in the gardens of His Paradise and pour upon him the rains of His mercy and pleasure—on the 28th of the month of Dhi'l-Qa'da, the year 909 (=18 January 1504).

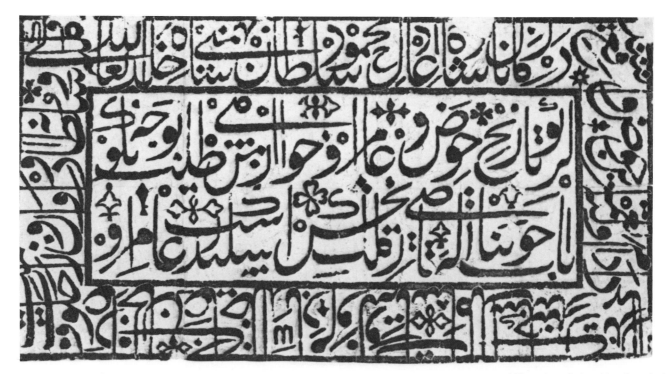

33.

SITE	Panhala (Maharashtra)
MONUMENT	detached Persian inscription (now in Kolhapur Museum), recording construction of a gateway and reservoir by the noble Malik Iskandar
DATE	917/1511-12
DYNASTY	Bahmani sultans of Deccan, reign of Mahmud Shah (1482-1518); contemporaneous with Isma'il 'Adil Khan of Bijapur (1510-1534)
SCRIPT	Nasta'liq
SIZE	44x84 cm
PUBLISHED	*EIAPS* 1964, pl. XIV(c) (List No. 184)

The beautiful and delicate Nasta'liq script was the last to make its appearance in Indian architectural inscriptions, although by the early 16th century it had already become the favored style of Persian calligraphers for writing most kinds of manuscripts (except for Korans, which even today continue to be transcribed in Thulth). Because delicate curves predominate in Nasta'liq, it was relatively easy for calligraphers to create elegant and coherent patterns of decoration, as here. In addition, the characteristic thinness of the letters makes them seem crisper and more distinct than the heavier Thulth script, thereby enhancing legibility even when the letters overlap in complex patterns.

The present detached inscription, which was originally placed above the gateway to a large reservoir or cistern, appears to be the earliest Indian example of Nasta'liq on a building. It is moreover the earliest Muslim inscription from Panhala, one of the strongholds of the Bahmani dynasty from the end of the 14th century. As is evident from the inscription, the region was then under the governorship of the powerful 'Adil Khan of Bijapur, whose successor established an independent kingdom after the final downfall of the Bahmani dynasty in 1538.

There are two parts to the inscription: the prose dedication of the gateway and reservoir in the outer border, and the two Persian verses in the central panel. The second verse contains a chronogram giving the date of the reservoir—according to which the numerical value of the letters in the phrase *"The gate of the reservoir of Panhala"* give the total 917 (=1511-12):

In the reign of the just king Sultan Mahmud Shah Bahmani—may the Exalted God perpetuate his kingdom and sovereignty—and in the time of the ministership and governorship of 'Adil Khan the champion of the faith—may the days of his government last forever—and at the instance of the chief officer of the district *(thanedar)*, Malik Iskandar Haidari—may his administration endure—the construction of this reservoir took place.

(1) If thou wishest to know the reservoir's date and builder,
Put the question in a proper manner.

(2) Its date is: *"The gate of the reservoir of Panhala";*
And its builder is Malik Iskandar.

34.

SITE	Raichur (Karnataka)
MONUMENT	detached Arabic inscription (now in Hyderabad museum), recording construction of a bastion tower by the noble Nizam al-Din Ahmad
DATE	921/1515 (916 Shuhur era)
DYNASTY	Bahmani sultans of Deccan, reign of Mahmud Shah (1482-1518); contemporaneous with Isma'il 'Adil Khan of Bijapur (1510-1534)
SCRIPT	monumental overlapping Thulth
CALLIGRAPHER	Husain, son of Yusuf of Yazd
SIZE	159x83 cm
PUBLISHED	*EIM* 1939-40, pl. VI(a) (List No. 108)

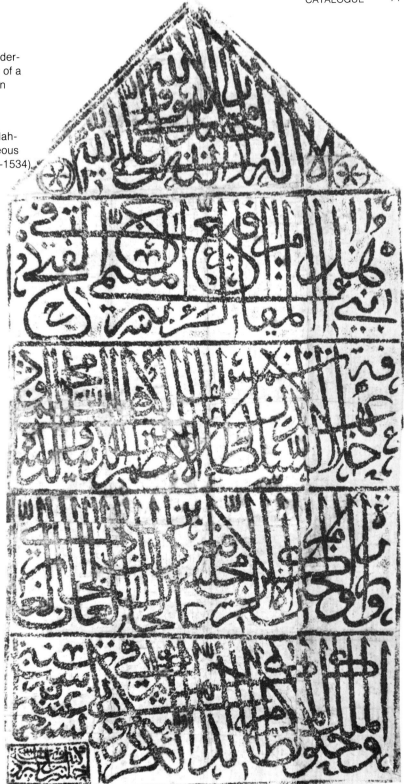

Like the preceding inscription, the present one also comes from the territories administered by the powerful 'Adil Khan "governors" of Bijapur, who refrained from assuming the title of royalty until the last Bahmani king was deposed. Now in the Hyderabad museum, the inscription originally comes from Raichur, and records the construction of a bastion, callled the "Bastion of Victory" *(Burj al-Fath),* that apparently formed part of the fortification wall surrounding the city. Written in skillfully executed Thulth script, the calligrapher has signed his name in the small cartouche at the bottom left.

Beginning with the Shiite Profession of Faith at the top, the entire inscription reads as follows:

There is no god but God. Muhammad is the Prophet of God. 'Ali is the Friend of God.

This lofty building, styled "Bastion of Victory", has been constructed during the regime of the great sultan, the Sun of the State and Religion *(Shams al-Din)* Mahmud Shah Bahmani; and under the ministership of the most generous Khan, the lofty noble *(Majlis-i-Rafi')* 'Adil Khan, son of 'Adil Khan, the champion of the faith; and during administration of the respected noble Nizam al-Din Ahmad al-Kirmani, in the *Shuhur* year 916 (=921/1515).

This has been inscribed by Husain, son of Yusuf of Yazd.

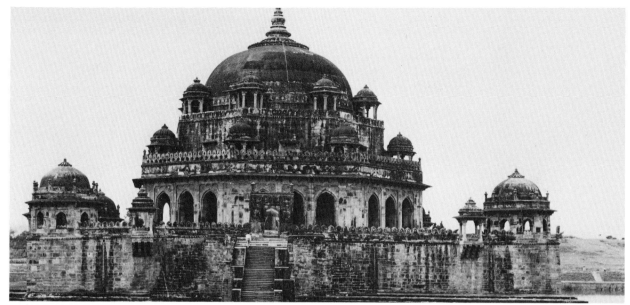

Tomb of Sher Shah at Sasaram

35.

SITE	Sasaram (Bihar)	
MONUMENT	tomb of sultan Sher Shah Suri, part of Arabic inscription around *mihrab* on west wall, recording construction of the building by Islam Shah, son of the deceased	
DATE	7 Jumada II 952/ 16 August 1545	
DYNASTY	Suri, reign of Islam Shah (1545-1554)	
SCRIPT	monumental Naskhi	
SIZE	120x118 cm	
PUBLISHED	*EIM* 1923, pl. XII (List No. 39)	

The magnificent domed, octagonal tomb of the founder of the Suri dynasty, Sher Shah Sur, at Sasaram, was started by him and completed a few months after his death (on 13 May 1545) by his son and successor Islam Shah. Though sometimes viewed as a mere interlude during the early phase of the Mughal empire, the fifteen-year period of Suri rule in North India (1540-1555) was one of great political and cultural achievement. Like the architecture of Sher Shah's tomb itself, the bold Naskhi calligraphy of the present inscription evokes the majestic dignity of earlier Sultanate styles. After the restablishment of Mughal power, however, calligraphers stopped using the traditional Naskhi, preferring instead either the stately perfection of Thulth or the delicate elegance of Nasta'liq—the latter having been first introduced in Indian epigraphs shortly after the beginning of the 16th century.

In keeping with the sumptuous grandeur of the entire Sasaram complex, the enormous *mihrab* on the inside west wall of the tomb is covered with rich tapesty of Koranic inscriptions, only a tiny portion of which is shown here. In fact, the exhibited detail includes just the inscribed arch frame at the bottom of the recessed *mihrab*—containing a single Koranic passage on the outer border; and a brief historical inscription on the inner border, recording completion of the tomb under the ruler Islam Shah. The Koranic passage consists of the entire Sura, "The Sun" (91.1-15), and begins at the bottom right corner. With its powerful opening adjurations and references to the destruction of the Thamud people, the Sura is clearly apocalyptic in tone; since it also implicitly affirms the inevitability of the Judgment, it occurs in funerary contexts with a fair degree of frequency.

In the Name of God the Merciful the Compassionate.

By the sun and its splendor! By the moon which followeth after! By the day which revealeth the splendor! By the night which concealeth! By the heaven and Him who made it! By the earth and Him who spread it forth! By the soul and Him who shaped it, and enlightened it as to its wickedness and piety!—Truly prosperous is he who hath purified it and failed is he who hath corrupted it! The Thamud rejected the message of the Lord out of excessive impiety, when behold, the most wicked among them was delegated; then the messenger of God said unto them: "It is the camel of God, wherefore hinder her not from drinking." But they rejected him, and they hamstrung her; so their Lord crushed them for their sin, and levelled them—and for Him is there no fear of the consequence!

Like the Koranic passage, the historical epigraph also begins with the *Bismillah* invocation (note that the final words of the epigraph are omitted in the estampage, but are visible in the photograph of the *mihrab*, at the bottom center of the recessed arch):

In the Name of God the Merciful the Compassionate. There is no god but God. Muhammad is the Prophet of God.

During the reign of the helper of the faith and the Muslims, the destroyer of heretics and the reviver of faith, one supported by Heaven, the victorious over enemies, Islam Shah the sultan—may God perpetuate his kingdom and sovereignty, and elevate his rank and dignity—in the year 952 on the 7th (...day of the month of Jumada II) (=16 August 1545).

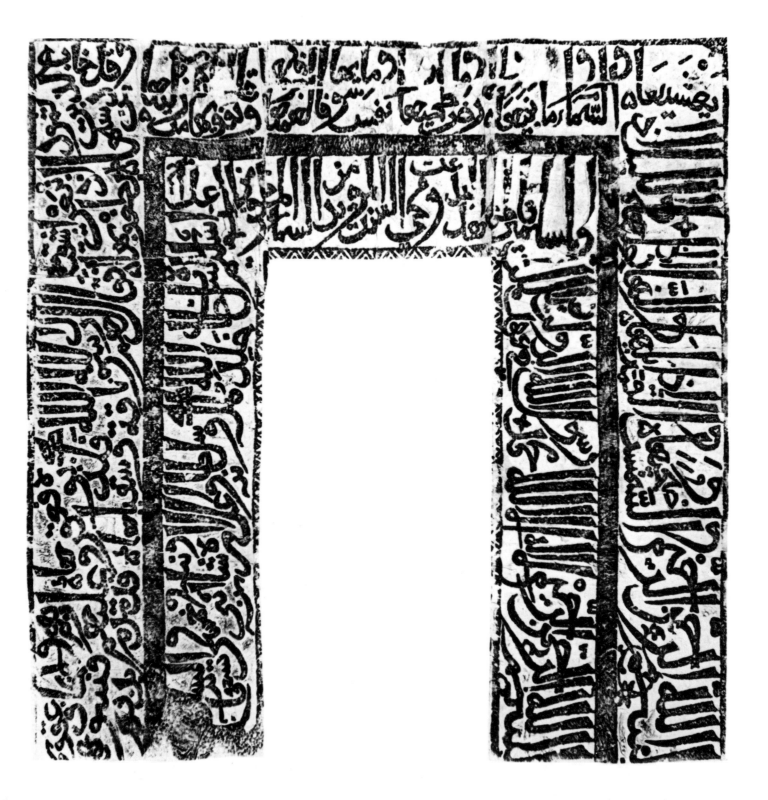

Detail of *mihrab* niche inside Tomb of Sher Shah (No. 35)

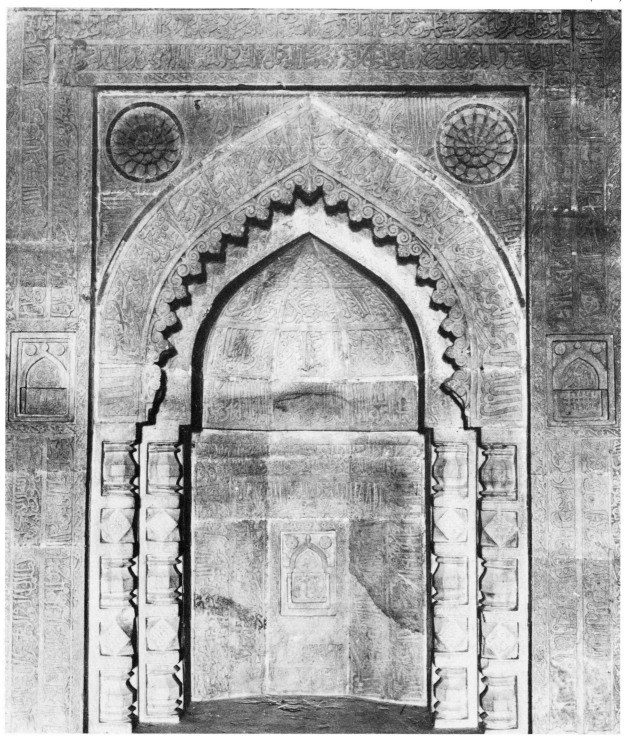

36.

SITE	Mehrauli (Delhi)
MONUMENT	detached stucco medallion with Arabic inscription, probably from early Mughal mosque (now in Red Fort Museum)
DATE	undated, ca. 965-70/1557-62
DYNASTY	Mughal, reign of Akbar (1556-1605)
SCRIPT	monumental Naskhi
SIZE	49 cm (diameter)
PUBLISHED	*EIAPS* 1959-60, pl. VI(c) (List No. 158)

The exact provenance of this beautiful inscribed medallion is unknown, but it reportedly came from Mehrauli near Delhi, where the famed Qutb Minar and Quwwat al-Islam mosque are located. There are various early Mughal structures in the area, like the tomb of Adham Khan, built in 1562; and the medallion could have been removed from one of them. The use of traditional bold Naskhi would point to a relatively early date in Akbar's reign (in fact the calligraphy bears some stylistic resemblance to that on Sher Shah's mosque inside the Purana Qila); but the elegance of the foliate border does not necessarily corroborate this assessment.

The text of the inscription consists of the frequently quoted phrase *"Kingdom belongs to God alone"*—found throughout India on both tombs and mosques.

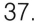

37.

SITE	Golconda (Andhra Pradesh)
MONUMENT	Golconda Fort, Arabic inscription over Makki gate, recording supervision of construction by the general Mustafa Khan
DATE	967/1559
DYNASTY	Qutb Shahi sultans of Golconda, reign of Ibrahim Shah (1550-1580)
SCRIPT	monumental overlapping Thulth
CALLIGRAPHER	Muhammad of Isfahan
SIZE	45x1400 cm
PUBLISHED	*EIM* 1913-14, pl. XIX(a) (List No. 16)

Although the rough granite slabs used for the inscription made the task of transcribing difficult for the stonecutter, the estampage clearly reveals the calligrapher's complete mastery of the majestic Thulth script—seen here to better advantage than on the site itself. Carved in a long ribbon band above the Makki gate of the great citadel of Golconda, the inscription records that the gate's construction had been supervised by the high-ranking noble Mustafa Khan—whose real name was Kamal al-Din Husain. Like their counterparts in Bijapur, the Shiite Qutb Shahi rulers of Golconda had declared their independence following the downfall of the Bahmani sultans, and proceeded to establish a rich and powerful kingdom that lasted until 1687, when it was finally absorbed into the Mughal empire. From literary sources it appears that Mustafa Khan, on behalf of the sultan Ibrahim Shah, was responsible for the entire 8,000 yard circuit of battlements and gates surrounding the fort, which were completed in the incredibly short space of nine months.

Appropriate to the rank and dignity of Mustafa Khan, the gateway inscription is composed in high literary Arabic, perhaps authored by the talented calligrapher himself, Muhammad of Isfahan—who was evidently a recent immigrant to the Deccan from his native Iran. Both text and calligraphy are characterized by similar rhetorical effects: stately cadences, repeated phrases and flourishes, and an overall aura of rationality and sophistication.

The translation of the entire inscription, which is strongly Shiite in its imagery, is as follows:

In the name of God, who made the word of His Unity an impregnable fort, the gates of which have been opened to us through His mercy: *"and whosoever entereth therein shall be safe."* And blessings be upon the Chosen One *(Mustafa),* in whose person the forts and defenses of Prophethood have been brought to completion—for *"he is the City of Knowledge and 'Ali is the Gate";* and blessings also upon his descendants, through whom the towers of Friendship with God and Leadership (of the Imams) have been raised to great height; and upon his companions, the custodians of the qualities of truth and integrity.

And after this: Verily this gate of Fortune of the fortress of Felicity was built during the reign of the greatest of sultans and the noblest of monarchs—who is the champion of sea and land; the opener of the gates of benevolence to all creatures; the constructor of the edifice of Law, prescribed by the Chief of Prophets; the architect of the State and Religion; the Shadow of God in the worlds; the namesake of the "Friend of God" *(Khalil Allah,* that is: Ibrahim)—the greatly auspicious Qutb Shah (may the forts of his sovereignty remain safe from the earthquake of disturbance, and the towers of his kingdom be ever protected from clefts of change and alteration!).

By the noble efforts of the pillar of his mighty empire, and the prop of his bright kingdom; the collector of books and the disperser of armies; whose lineage can be traced through his ancestors and personal qualities to 'Ali, the *"manifestation of wonders among mankind";* who is named among people Kamal al-Din Husain and entitled Mustafa Khan on account of his high rank—may God acknowledge his efforts and ease his burdens! In the months of the year 967 (=1559-60). Written by Muhammad of Isfahan.

Detail of inscription above Makki Gateway at Golconda

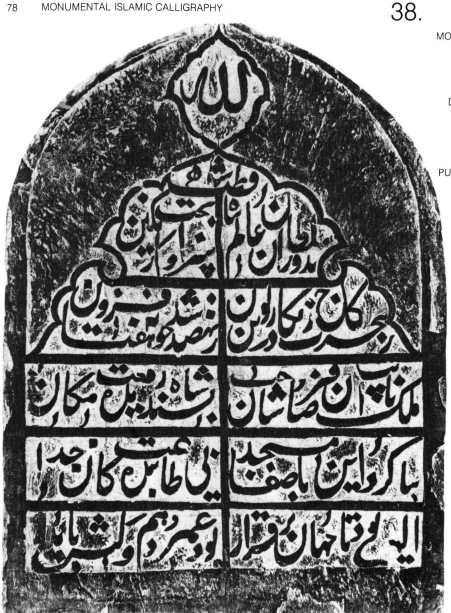

38.

SITE	Gudur (Andhra Pradesh)
MONUMENT	detached Persian metrical inscription, recording construction of a mosque by the noble Rif'at Khan Lari
DATE	970/1562
DYNASTY	Qutb Shahi sultans of Golconda, reign of Ibrahim Quli (1550-1580)
SCRIPT	Nasta'liq
SIZE	97x77 cm
PUBLISHED	*EIM* 1921-22, pl. XIV(a) (List No. 34)

The reign of the sultan Ibrahim Quli saw the consolidation of an extensive kingdom, through the efforts of two notable generals: Mustafa Khan (supervisor of construction of the Makki gate at Golconda, discussed in the preceding entry) and Rif'at Khan Lari, the builder of the mosque mentioned in the present inscription. Executed in beautiful Nasta'liq script, the shape of the inscribed panel is suggestive of a crown—perhaps intended as a conscious evocation of Qutb Shahi overlordship over the recently conquered territory around Gudur.

In the inscription, which consists of five Persian couplets, the general is referred to only by his designation Lord Deputy *(Malik Nayab).* The full translation is as follows:

God!

(1) During the reign of the sultan, refuge of the world,
Worthy of Throne and Seal, Qutb Shah,

(2) In this azure-roofed mansion, when from the Hijra,
Seventy had been added to nine hundred,

(3) The Lord Deputy, master of pomp and glory,
Chosen one of the exalted king,

(4) Built this pure mosque
For the servants of God to worship therein;

(5) May, O God, so long as this world lasts,
His life and glory endure!

39.

SITE	Nagaur (Rajasthan)
MONUMENT	Akbari Masjid, Persian verses inscribed on wall to right of central *mihrab,* recording construction by the general Husain Quli Khan
DATE	972/1564-65
DYNASTY	Mughal, reign of Akbar (1556-1605)
SCRIPT	Nasta'liq
CALLIGRAPHER	Muhammad al-Hajji, called Ramzi
SIZE	142x59 cm
PUBLISHED	*EIM* 1949-50, pl. XVII(b) (List No. 119)

Founded in 1526 by Babur, the early Mughal empire reached its greatest extent during the long and eventful reign of Akbar—an exact contemporary of Elizabeth I of England, and of equal importance in world history. Though the Akbari mosque at Nagaur is a provincial monument, the calligraphy on the dedication stele is of the highest quality and reveals the artistic sophistication that prevailed throughout the kingdom. Almost as if to signal that a new era had dawned, the inscription is written in flawless Nasta'liq—which by then had superceded the monumental Naskhi of earlier Sultanate monuments (Thulth, however, was still retained for Koranic inscriptions and other conservative uses).

Aside from the intrinsic beauty of Nasta'liq, the script's lyrical qualities provide a perfect vehicle for the subtle Persian verses that were now invariably composed to serve as dedication inscriptions for all kinds of monuments—from mosques and tombs to palaces, towers and caravanserais. The present inscription furnishes the names of both the calligrapher and the poet; the latter gives his *nom de plume* as Wisali in the verses, but his real name was Mir 'Ala al-Din of Khorasan, who died in 998/1589-90.

The builder of the mosque was the important noble Husain Quli Khan who waged a victorious campaign in Rajasthan, subsequently became governer of Punjab, and was awarded the exalted title of *Khan Jahan* ("Khan of the World"). The date of construction is given as a chronogram in the last verse, while the calligrapher's signature is inscribed in smaller letters across the bottom:

(1) During the reign of the lord, ruler of the age,
 Akbar Shah, a king united with God,

(2) Husain Quli Khan, a favorite of all,
 Like unto whom there is none in popular esteem,

(3) Built a mosque like unto the Ka'ba,
 Serving as the *qibla* to this and future generations.

(4) It is an abode for those of firm faith,
 And all the pious congregate within.

(5) Seeking its date, the poet Wisali said:
 It is the *"Abode of the God-fearing"* in the Tradition of the Prophet. (=927/1564-65)

Written by the sinful creature, hopeful (of Divine mercy), the dervish Muhammad al-Hajji, called Ramzi.

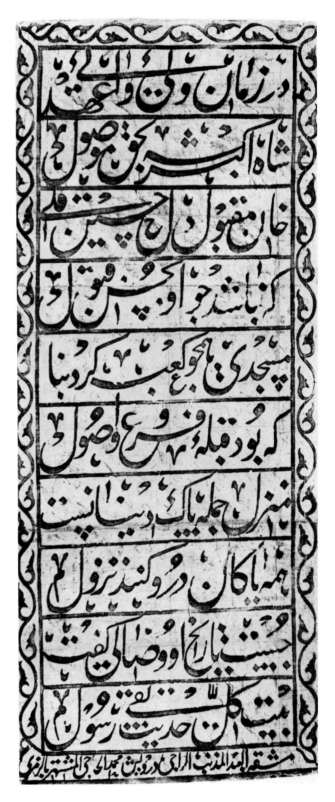

40.

SITE	Budaon (Uttar Pradesh)
MONUMENT	detached Arabic inscription, recording renovation of some building by Mirza Muhammad
DATE	981/1573-74
DYNASTY	Mughal, reign of Akbar (1556-1605)
SCRIPT	monumental Thulth
CALLIGRAPHER	Husain Khan
SIZE	36x72 cm
PUBLISHED	*EIAPS* 1969, pl. XXI(c) (List No. 225)

Written in a handsome but highly unusual variety of monumental Thulth, this detached inscription appears to record repairs and additions made to an already existing building and garden. The building is called "Shamsi," which would indicate that it had been built by the 13th-century Mamluk sultan Iltutmish, called Shams al-Din. What building the inscription refers to is uncertain (the slab is now fixed in the arcade of the tomb of the Sufi saint Badr al-Din Shah Wilayat at Budaon), but its present location is near that of the 'Idgah built by Iltutmish. Since the inscription was meant to be fixed onto a much older building, this may explain why the calligraphy has a slightly archaic quality—as if the designer was consciously emulating and adapting the thick and powerful lettering used in earlier Naskhi inscriptions of the first Delhi sultanate (for inscriptions of Iltutmish, see Nos. 3-5).

Unfortunately, nothing further is known about either the calligrapher or the supervisor of construction; the full text is as follows:

In the reign of the just king, the Glory of Religion (Jalal al-Din), the Emperor Akbar, Champion of the Faith, the Shamsi building and the garden were beautified by Mirza Muhammad, son of Wali Shah. Written by Husain Khan, year 981 (=1573-74).

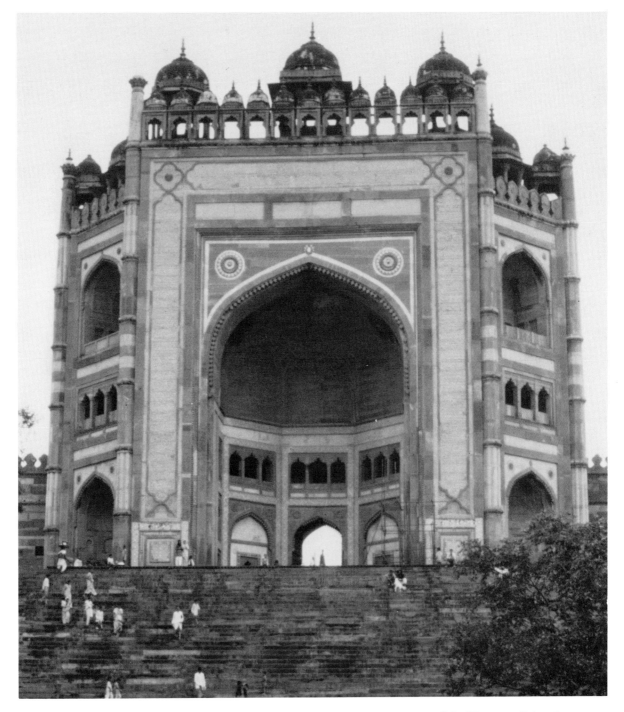

Buland Darwaza at Fathpur Sikri (No. 41)

41.

SITE	Fathpur Sikri (Uttar Pradesh)
MONUMENT	Buland Darwaza inside Jami Masjid, calligrapher's colophon and part of Koranic inscription framing the west facade
DATE	undated, ca. 983/1575-76
DYNASTY	Mughal reign of Akbar (1556-1605)
SCRIPT	monumental Thulth
CALLIGRAPHER	Husain, son of Ahmad Chishti
SIZE	366x244 cm (exhibited portion)
PUBLISHED	E. W. Smith, *The Moghul Architecture of Fatehpur Sikri,* Part III (Allahabad 1897); cf. S. A. Rizvi and V. J. Flynn, *Fathpur-Sikri* (Bombay, 1974)

Akbar's new capital at Fathpur Sikri was surely the outstanding architectural project of his long reign; and within the city, the most imposing monument is the vast congregational mosque, with its enormous ceremonial gateway, the Buland Darwaza. Completed in 1572, the mosque also contains the tomb of the renowned Sufi saint Shaikh Salim Chishti, who died in the same year. In effect the entire city was built by Akbar as a means of honoring the saint in gratitude for the blessing that preceded the birth of a royal heir, Prince Salim—later to become the emperor Jahangir.

Although undated, the disproportionate size of lofty Buland Darwaza suggests that it was a later addition, probably to commemorate Akbar's great victory over the sultans of Gujarat in 1573; in fact literary evidence in the form of a contemporary chronogram suggests a completion date of 983/1575-76 (the chronogram's use of the word *buland,* or "lofty," is probably the origin of the gateway's current designation).

Because of its enormous size, the gateway overpowers the viewer and serves as a compelling symbol of royal power and authority. The content of the Koranic passages inscribed on the west facade seems to furnish corroboration of this interpretation (the passages include 39.73-75; 41.53-54; and 41.30-31). Appropriate to the dignity and profundity of the verses, the calligraphy is large, majestic Thulth, carved in very low relief in three elongated cartouches on the sides and top of the great framing arch. In the exhibited portion, only the opening words of the right cartouche are visible, but the entire passage reads as follows (39.73-75):

In the Name of God the Merciful the Compassionate.

And those who feared their Lord (...shall be led unto Paradise in troops; and behold, when they arrive, the gates thereof shall be opened, and its keepers shall say: "Peace be unto you! Well have ye performed; wherefore enter ye here to dwell forever!"

And they shall say: "Praise be unto God, Who hath truly fulfilled His promise unto us, and hath made us inherit the land, so that we may dwell in Paradise wheresoever we please—so excellent is the reward of those who labor!"

And thou shalt see the angels encircling about the Divine Throne, celebrating the praises of their Lord; and Judgment shall be pronounced upon them with justice, and they shall say: "Praise be unto God, the Lord of the Worlds!")

Apparently this and other passages were not chosen merely for their religious significance within the Koranic context; the verses may also be interpreted as an allegorical allusion to Akbar's recent military triumph in Gujarat, which further strengthened and expanded the empire—" *...so that we may dwell in Paradise wheresoever we please"* (compare the opening words of the passage inscribed across the top of the gateway (41.53-54): *"Soon shall We show them Our signs in the farthest regions...").*

It is unknown who would have selected the verses to be inscribed, but it may well have been the calligrapher himself, who was a disciple of Shaikh Salim; his signature is inscribed at the base of the right side of the arch in the small rectangular cartouche beneath the opening words of the first Koranic passage:

"This inscription was written by Husain bin Ahmad Chishti."

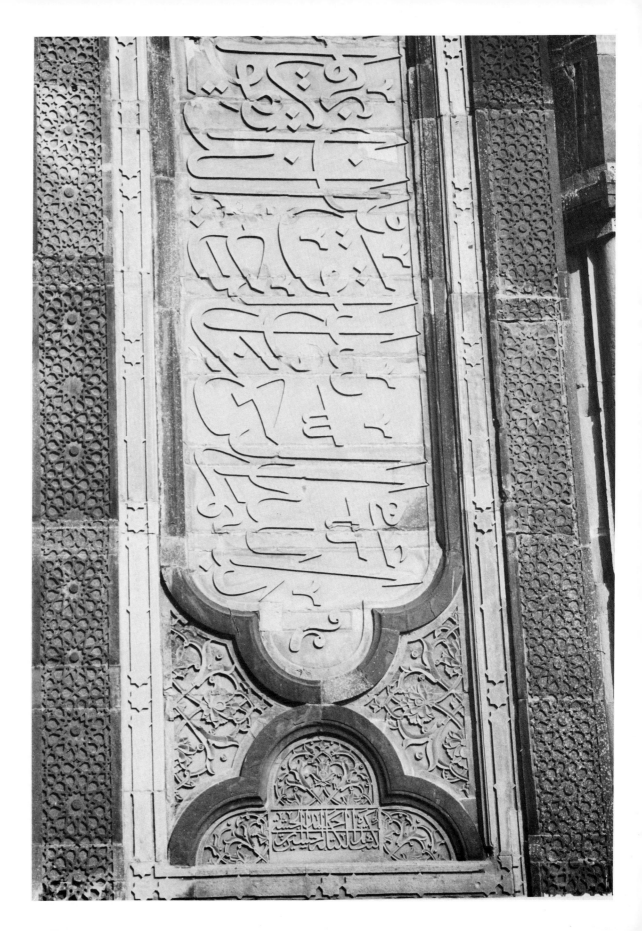

42.

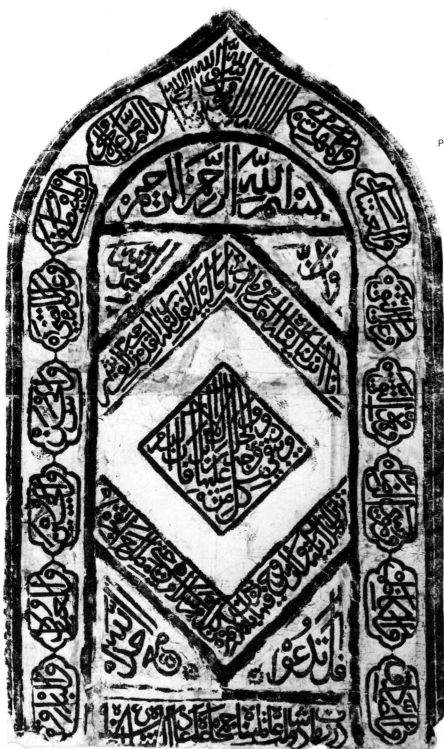

SITE	Raichur (Karnataka)
MONUMENT	Jami' Masjid inside Fort, Arabic and Persian inscription fixed in the right *mihrab*, quoting Shiite Prayer and recording construction during reign of 'Ali 'Adil Shah
DATE	985/1577-78
DYNASTY	'Adil Shahi sultans of Bijapur, reign of 'Ali (1558-1580)
SCRIPT	monumental Thulth
SIZE	145x91 cm
PUBLISHED	*EIAPS* 1963, pl. XXI(b) (List No. 182)

The bold geometric patterning of this mosque inscription is suggestive of a carpet design. The heavy Thulth calligraphy contributes to this decorative effect, despite its rather provincial coarseness. The content of the inscriptions reveals the mosque's Shiite affiliation, attesting to the wide popularity of Shiism in the Deccan kingdoms, particularly under patrons like the Bijapur sultan 'Ali 'Adil Shah-to whom reference is made at the very bottom of the stele: "During the reign of the king, the refuge of the world, possessing the dignity of Jamshid, 'Ali 'Adil Shah, year 985 (=1577-78).

The religious text begins with the Shiite "Profession of Faith," inscribed at the pointed top of the stele: *"There is no god but God, Muhammad is the Prophet of God, 'Ali is the Friend of God."* The rest of the border contains fourteen cartouches bearing the Shiite *Durud*, or "Prayer," calling for God's blessings on the Twelve Imams:

O God! Bestow blessing on Muhammad the Chosen, and 'Ali the Approved, and Hasan and Husain, and al-'Ibad (Zain al-'Abidin), and Baqir, and Sadiq, and Kazim, and Musa al-Riza, and Muhammad Taqi, and 'Ali Naqi, and 'Askari, and Mahdi.

Inside the rounded arch, the *Bismillah* invocation is inscribed; while the four corners outside the two inscribed chevrons contain the well-known verse about mosques being for God alone (72.18; for translation see No. 14).

The chevron shapes themselves contain the entire Sura "The Night of Power" (97.1-5):

We have indeed revealed this message in the Night of Power. And what will explain to thee what the Night of Power is? The Night of Power is better than a thousand months. Therein come down the angels and the Spirit by God's permission, with all decrees. Peace! until the rising of the dawn.

Finally, in the exact center of the panel, the inscribed diamond bears two verses frequently contemplated by mystics (55.26-27):

All that is on earth will perish. But there will abide forever the Face of thy Lord—full of Majesty, bounty and honor.

43.

SITE	Ujjain (Madhya Pradesh)
MONUMENT	detached Arabic and Persian inscription (now in State Museum of Antiquity, Ujjain), recording construction of a caravanserai by the court official Shah Fakhr al-Din
DATE	986/1578-79
DYNASTY	Mughal, reign of Akbar (1556-1605)
SCRIPT	monumental Thulth and Nasta'liq
SIZE	84x59 cm
PUBLISHED	*EIAPS* 1968, pl. IX(a) (List No. 217)

Throughout the Islamic world, it had long been considered an act of religious charity to endow serais, wells and other structures that served the public benefit. Although the major caravanserais were the responsibility of the ruler, the royal example was frequently emulated by the great nobles, court officials and wealthy merchants. The present inscription records the construction of a serai at Ujjain by Shah Fakhr al-Din, a descendant of the Prophet, who immigrated from Mashhad to India in 1554, and was subsequently appointed to a government post under the emperor Akbar.

Skillfully written in ten rows of elegant Nasta'liq script, framed by a border of bolder Thulth, the inscription consists of five Persian couplets and a single Koranic passage. By the 16th century, Indian calligraphers invariably used Thulth for Koranic inscriptions; as a result it came to acquire almost sacred connotations, while the elegant Nasta'liq was viewed as the most appropriate vehicle for courtly poetry and prose.

The Koranic passage on the border consists of the well-known "Throne Verse" (2.255; for translation see No. 12). The translation of the Persian couplets is as follows (the fourth and fifth verses contain chronograms of commencement and completion of the serai):

(1) During the reign of the Glory of Religion Muhammad Akbar, Champion of the Faith:
 Who, through God-given good fortune, has conquered the world—

(2) The "Mendicant" (Shah) of pure nature, Shah Fakhr al-Din, the magnanimous,
 Who perpetually captures the hearts of the people through his bounty,

(3) Constructed a serai for the comfort of the populace,
 Of such strength that even the Heavens term it the "Fort of Steel."

(4) Since he implored Divine help at the time of its construction,

Wisdom found the date in the word *"Succor"* 982 (=1574-75).

(5) And if thou desirest the completion date of this edifice,
 Discover it in: *"Holy Edifice"* 986; and *"Work of its Master"* 986 (1578-79).

44.

SITE	Bareilly (Uttar Pradesh)
MONUMENT	Mirza'i Masjid, Persian inscription on facade, recording construction by the court physician and noble Hakim 'Ain al-Mulk
DATE	987/1579-80
DYNASTY	Mughal, reign of Akbar (1556-1605)
SCRIPT	Nasta'liq
SIZE	39x104 cm
PUBLISHED	*EIAPS* 1969, pl. XXI(b) (List No. 225)

Like the majority of Persian metrical inscriptions inscribed in the graceful Nasta'liq script, the present one places the different halves of the verses into separate, elegantly designed cartouches. The writing is so carefully coordinated with the decorative cartouches that it seems probable the calligrapher designed both.

As the earliest extant Muslim epigraph from Bareilly, the inscription is historically as well as artistically important. It records the construction of a mosque by the noble 'Ain al-Mulk, a learned physician who was appointed to various important posts during the reign of Akbar, including that of com-

mander (*Faujdar*) of the fort at Bareilly. The mosque mentioned in the inscription was erected during his two-year tenure at Bareilly, after which he was appointed chief judge (*Sadr*) of Bengal.

As a scholar and poet, Hakim 'Ain al-Mulk may also be the author of the two verses inscribed over the entrance to his mosque (note chronogram in second verse).

(1) The striver of this act of bounty, 'Ain al-Mulk, Constructed the mosque by the order of Akbar Shah.

(2) The year of completion is in the instructions to the faithful:
"Prostrate yourself only before God!" Year 987 (=1579-80).

45.

SITE	Bidar (Karnataka)
MONUMENT	tomb of Sufi saint Shah 'Ali Sahib, Persian inscription above east doorway, recording date of construction
DATE	992/1584
DYNASTY	Baridi sultans of Bidar, reign of Ibrahim (1580-1587)
SCRIPT	monumental Thulth
SIZE	82x160 cm
PUBLISHED	*EIM* 1927-28, pl. XIII (List No. 54)

Although written in dignified Thulth, this beautifully designed inscription captures the delicacy and elegance of Nasta'liq; so much so that the entire arched panel functions visually like a filigree screen-set above the entrance to this impressive Sufi tomb. Instead of cartouches, thin vertical and horizontal lines (the middle one created by extended letters) divide the panel into five compartments—the lower four containing two Persian couplets giving the date of construction.

The Sufi Shah 'Ali Sahib, who belonged to the Chishti order, was descended from an even more revered saint, his grandfather, Shah Abu'l-Faiz, (d. 1474), who is buried in a larger tomb nearby. The shrine complexes (called *Dargah*) of Sufi saints attracted disciples in death as well as life; and the precincts of many of the shrines became crowded burial grounds where nobles and even princes and kings chose to be interred.

Beginning at the top arch, the complete translation of the text of the inscription is as follows:

The date of the building of this auspicious dome (*gunbad*): Nine hundred and ninety-two.

(1) How excellent is this high dome wherein is resting

The king of heavenly abode, Shah 'Ali, Guide of Religion!

(2) I enquired of Wisdom about the year of its construction;

The voice from the unseen replied: "*The dome of highest heaven has been built*" (=992/1584).

46.

SITE	Bankapur (Karnataka)
MONUMENT	detached Persian inscription, recording construction of a bastion tower (*burj*) by the noble Najafi Khan
DATE	999/1590-91
DYNASTY	'Adil Shahi sultans of Bijapur, reign of Ibrahim II (1580-1627)
SCRIPT	Nasta'liq
SIZE	45x134 cm
PUBLISHED	*EIAPS* 1968, pl. VI(b) (List No. 216)

Written in an attenuated and somewhat mannered hand of Nasta'liq, the detached inscription records the construction of a bastion tower, probably in the defense wall of the fortress at Bankapur, one of the most strategically important in Karnataka during the medieval period. Unfortunately, nothing is known about the builder Najafi Khan, although it would seem likely that he held an official post under the 'Adil Shahi sultans, perhaps governor or commander of the fort.

As had become the rule with Persian metrical inscriptions of the 16th century, the slab is divided into four identical cartouches with cusped ends, each containing one line of the two inscribed couplets. The second verse contains the customary chronogram, which flatteringly incorporates the name of the patron—thereby increasing the likelihood that the poet would be well rewarded.

(1) Behold this bastion of lofty dignity
 Raised in height to the very sphere of Mars!

(2) For the date of its completion, Wisdom said:
 The date is in the words: "*Bastion of Najafi Khan*" (=999/1590-91).

47.

SITE	Fathpur Sikri (Uttar Pradesh)
MONUMENT	*Jama'at Khana* inside Jami Masjid, Persian verses inscribed over veranda doorway, recording death of Sufi mystic Shaikh Haji Husain
DATE	1000/1591-92
DYNASTY	Mughal, reign of Akbar (1556-1605)
SCRIPT	Nasta'liq
SIZE	67x154 cm
PUBLISHED	E.W. Smith, *The Moghul Architecture of Fatehpur Sikri,* Part III (Allahabad 1897), pl. XLVIII; *ARIE* 1965-66, No. D-524

This beautiful inscription, written in flawless Nasta'liq script against a delicate foliate background, ranks as one of the finest examples of architectural calligraphy during the reign of Akbar. Nasta'liq is deceptively simple in appearance, but extremely difficult to master. Few calligraphers have achieved the perfect balance demonstrated here: a balance in which letters appear both to float independently in empty space, and to be firmly fixed and coordinated to each other at the same time.

The cartouches with lobed ends are very similar to those on the Buland Darwaza at Fathpur Sikri (see No. 41), but unfortunately, here we do not know the identity of the master calligrapher. The purpose of the inscription is clear: it consists of three Persian verses (two on the upper cartouche and one on the lower), carved above one of the veranda doorways to a structure called the *Jama'at Khana* (or "Assembly Hall"), and serving as a poetical epitaph for the Sufi mystic Shaikh Haji Husain, who is buried inside.

Originally used as a place for religious exercises, the *Jama'at Khana* (also known, wrongly, as the tomb of Islam Khan) was gradually converted into a place of burial for several distinguished disciples of the renowned saint Shaikh Salim Chishti, who had died in 1572. Haji Husain was the first disciple to be honored by burial here following his death in 1591-92, at which time the present inscription was installed.

As indicated in the epitaph, the Shaikh had performed the pilgrimage to Mecca on several occasions, hence his designation Haji Husain. His circumambulation of the Ka'ba became the inspiration for the poetical chronogram of his death contained in the third verse:

(1) The Shaikh, Leader of the pilgrim caravan, Haji Husain, was one
Who always took delight in the *Haj* and the *'Umra* pilgrimages.

(2) When, in the *Safa* and *Marva* stations of his life, no running remained,
Divine Mercy pulled him toward the Ultimate Goal.

(3) The date of his final Union was transcribed by the other pilgrims,
"He proceeded for circumambulation of the Ka'ba with all his soul!" (=1000/1591-92).

48.

SITE Golconda (Andhra Pradesh)

MONUMENT Tomb of sultan Ibrahim Qutb Shah, grave of
Muhammad Amin, Koranic inscription on top
of cenotaph

DATE 1004/1596

DYNASTY Qutb Shahi sultans of Golconda, reign of
Muhammad Quli (1580-1611)

SCRIPT overlapping Thulth and square Kufi

SIZE 21x87 cm

PUBLISHED *EIM* 1915-16, pl. VIII(a) (List No. 20)

This unusual inscription, combining the stately cursive rhythms of Thulth with the rigid geometry of square Kufi, adorns the top of the cenotaph of the prince (*mirza*) Muhammad Amin (d. 1595)—sixth son of the late King of Golconda, Ibrahim Qutb Shah; and younger brother of the reigning monarch, Muhammad Quli. The square Kufi panel at the head end of the sarchophogus is the only example of the script known at Golconda, and one of the very few examples from any Indian monument. Despite its archaic appearance, square Kufi was the most recent variety of Kufi to have evolved. Considering its widespread use in Iran from the 14th century on (particularly in mosaic tile inscriptions), it is puzzling that Indian calligraphers largely ignored it.

The effect of visual unity created by the square format and uniform letters is appropriately matched to the powerful and profound content of the Koranic passage inscribed, which consists of the entire Sura "The Unity" (112. 1-4):

In the name of God the Merciful, the Compassionate.

Say: He is the One God, the Eternal God; He begetteth not, nor is He begotten—And there is none like unto him.

Inscribed in cursive Thulth letters at the left is a Koranic passage (3.18) communicating essentially the same idea of God's unity:

God witnesseth that there is no god but him; and His angels also, and those endued with knowledge, who firmly adhere to justice. There is no god but Him, the Almighty, the Wise. 1004 (=1596).

49.

SITE	Hyderabad (Andhra Pradesh)
MONUMENT	Jami' Masjid, Persian metrical inscription over entrance doorway, recording construction by the noble Amin al-Mulk
DATE	1006/1597
DYNASTY	Qutb Shahi sultans of Golconda, reign of Muhammad Quli (1580-1611)
SCRIPT	Nasta'liq
CALLIGRAPHER	Baba Khan
SIZE	53x189 cm
PUBLISHED	*EIM* 1917-18, pl. XVII(a) (List No. 25)

After founding Hyderabad as his new capital, the sultan Muhammad Quli endowed a congregational mosque near the famed Char Minar gateway, also built by him. As we learn from the inscription over the entrance, this important project was supervised by the vizier Amin al-Mulk—who was himself the patron of other architectural monuments in the city.

As was customary, skilled calligraphers were commissioned to design panels inside and outside the mosque. Around the interior *mihrab* niche is a large framing arch with Koranic inscriptions executed in Thulth script by a great Persian master, Jamal al-Din Husain (whose design was emulated more than seventy-five years later in the Great Mosque at Golconda; see No. 64). By contrast, the dedication panel over the entrance, which consists of seven effusive Persian couplets inscribed in fourteen cartouches arranged in three rows (the fifteenth cartouche contains the colophon), is executed—in a somewhat dense hand of Nasta'liq—by the otherwise unknown calligrapher Baba Khan:

(1) The keeper of the World, the King of Kings,
In whose reign Virtue itself benefited through his example;

(2) The heart is consoled and the soul is refreshed
When speech emanates from the ruby of his lips;

(3) His perfect disposition has made this earth the envy of Paradise,
And his beautiful face has become the rose-garden of Iram;

(4) By his own exalted order, he has constructed a mosque,
Beneath whose lofty roof, the revolving heavens seem like a mere ball;

(5) And within whose precinct, Paradise itself, hopeful of admission,
Is continuously engaged in sweeping the courtyard.

(6) Of this I may boast with pride:
The preeminence of Islam is well substantiated within

(7) Should anyone enquire about its date, say:
"How excellent is this lofty edifice of bounty" (=1006/1597)

Completed by the efforts of Malik Amin al-Mulk. Written by Baba Khan.

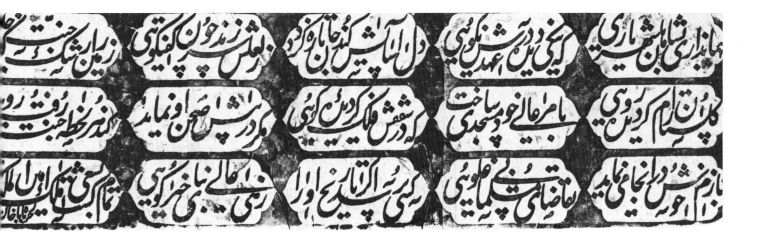

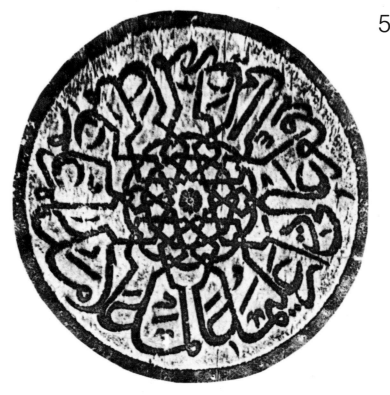

51.

SITE	Paithan (Maharashtra)
MONUMENT	detached gravestone, with Arabic and Persian epitaph of Bustan 'Ali Beg
DATE	1010/1601-02
DYNASTY	Nizam Shahi sultans of Ahmadnagar, reign of Murtaza II (1600-1610); contemporaneous with Mughal emperor Akbar (1556-1605)
SCRIPT	Thulth and Nasta'liq
CALLIGRAPHER	Khalaf al-Tabrizi
SIZE	140x50 cm
PUBLISHED	*EIAPS* 1949-50, pl. VII(b) (List No. 117)

50.

SITE	Bijapur (Karnataka)
MONUMENT	detached medallion with Arabic inscription (now in Archaelogical Museum, Bijapur), possibly from a Sufi shrine or seminary
DATE	undated, ca. 1010/1601 (?)
DYNASTY	'Adil Shahi sultans of Bijapur, reign of Ibrahim II (1580-1627)
SCRIPT	ornamental Thulth
SIZE	39 cm (diameter)
PUBLISHED	*EIAPS* 1955-56, pl. XXIII (List No. 148)

The decorative potential of the Thulth script is especially evident in this medallion, in which the extended vertical tops of the letters combine perfectly with the geometric star pattern in the center. Although decorative medallions occur in great profusion in the architecture of Bijapur, most do not have calligraphic inscriptions. It is not possible to date this medallion precisely, but it bears some resemblance to those inside the tomb of Ibrahim II at Bijapur, which was completed in 1626.

Judging from the inscription's allusions to learning, it very likely was originally attached to the tomb—shrine of some scholar saint, or else perhaps a seminary (*madrasa*)—serving as a kind of a formulaic prayer:

(O God!) The Knower, the Learned, the Most Learned! Keep aloft the standard of the knowledge of a learned man!

During the turbulent period at the end of the 16th century, much of the northern Deccan was occupied by invading Mughal armies, including Ahmadnagar, the capital of the Nizam Shahi sultans. The real power behind the Nizam Shahi throne was the Abyssinian general Malik 'Ambar, who first installed, then deposed the ruler Murtaza II. Several inscribed gravestones discovered at Paithan date to this period, and attest to the death in battle of noblemen such as Burhan 'Ali Beg (who is otherwise unknown to history).

The overall geometric design of the gravestone is bold and logical. By organizing into separate compartments the two types of scripts used—Nasta'liq in the cartouche border and Thulth in the middle zones— the calligrapher clearly demonstrates his understanding of their differing functions and aesthetic qualities. The six middle rows of dense, overlapping Thulth quote the well-known "Throne Verse" (2.255; for translation. see No. 12); while the pointed arch and upper medallion contain the following:

He is the Lord, the Everlasting, never to die!

All that is on earth will perish. But there will abide forever the Face of thy Lord—full of majesty, bounty and honor! (55. 26-27).

The eight cartouches in the border contain the following four Persian verses written in Nasta'liq:

(1) O Lord! By Thy Self without any equal.
 By those desirous of beholding the Sun of Thy Beauty;

(2) By the light of devotion of the recluses,
 By the humble prayers of the righteous;

(3) With the faith Thou hast Thyself bestowed,
 Take us to the plain of Resurrection

(4) May Thy Guidance be the companion of our path,
 And let Muhammad intercede on our behalf.

A fifth verse is inscribed in smaller Nasta'liq script across the bottom, but the value of the chronogram does not seem to match the date written at the end:

(5) Wisdom said to me: *"Bustan 'Ali Beg
 Has verily achieved great and sacred martyrdom"*; Year 1010 (=1601-02)

Instead of being placed at the bottom, the calligrapher's signature is inscribed in two small vertical compartments placed within the last row of the central Koranic passage: "Written by the sinful Khalaf al-Tabrizi."

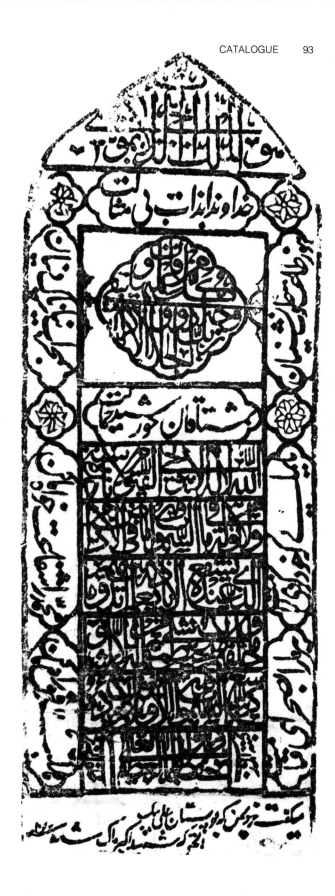

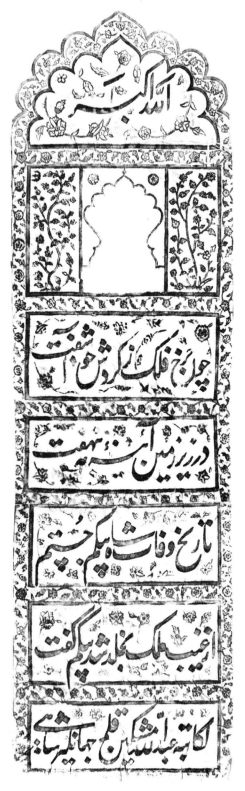

52.

SITE	Allahabad (Uttar Pradesh)
MONUMENT	Khusrau Bagh, Persian epitaph on grave-stone of Shah Begam, wife of Prince Salim
DATE	1012/1604 (completed after 1605)
DYNASTY	Mughal, reign of Akbar (1556-1605)
SCRIPT	Nasta'liq
CALLIGRAPHER	Mir 'Abd Allah, titled *Mushkin Qalam*
SIZE	190x559 cm
PUBLISHED	*EIAPS* 1961, pl. XXI(b) (List No. 172)

The calligrapher Mir 'Abd Allah was one of the greatest Indian masters of Nasta'liq at the end of the 16th and beginning of the 17th-century. Awarded the title *Mushkin Qalam* ("Musky Pen") sometime after 1595, Mir 'Abd Allah entered the service of Prince Salim, when he rebelled against his father and set up a rival court at Allahabad. In 1011/1602, Mir 'Abd Allah transcribed a *Diwan* manuscript for Salim at Allahabad, at the end of which one of the painters in the prince's atelier painted a remarkable portrait of the calligrapher at work (reproduced on p. 7. of this Catalogue). While several portraits of Mughal calligraphers are extant, this is the only one of a calligrapher who designed architectural inscriptions in addition to copying manuscripts.

Mir 'Abd Allah's skillful and elegant design for the present inscription—a verse epitaph for Salim's wife, Shah Begam—was probably prepared shortly after her tragic death in 1604; but the actual slab was not set up until sometime after November 1605, when Salim succeeded his father and assumed the royal title Jahangir. Daughter of the Hindu noble Raja Bhagwan Das, the princess Shah Begam had become distracted following her son Khusrau's falling out with his father, and subsequently committed suicide. The full text of the epitaph, which is set up inside her tomb in the Khusrau Bagh at Allahabad (where her son is also buried), is as follows:

God is Great!

When the spheres of the Heavens became distracted from their revolving,

They concealed the mirror of the moon underneath the earth;

When I sought the date of Shah Begam's death,

An angel from the Unseen World replied: "The Begam went to Heaven" (=1012/1604).

Composed by its writer, 'Abd Allah *Mushkin Qalam*, Jahangir Shahi.

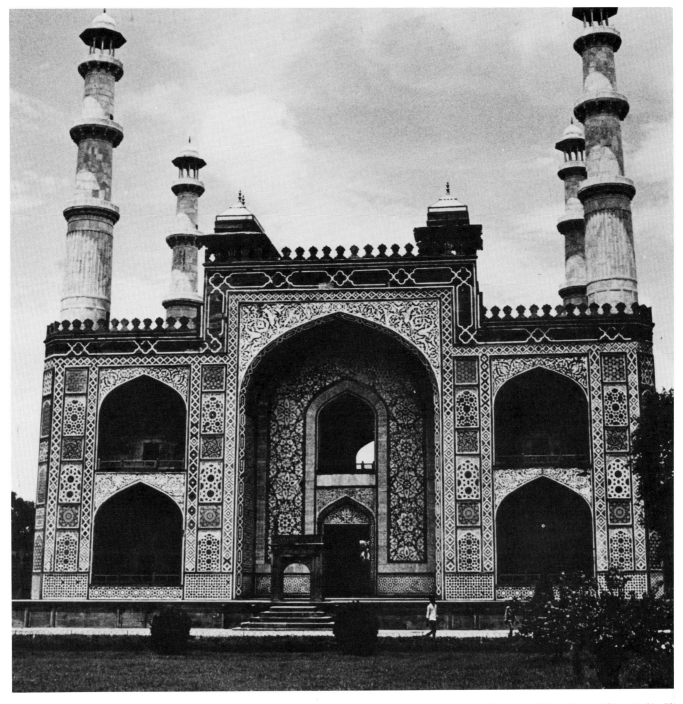

Gateway to Akbar's Tomb at Sikandra (No. 53)

53.

SITE	Sikandra (Uttar Pradesh)
MONUMENT	Tomb of Akbar, detail of Persian dedication eulogy and verses inscribed on south facade of main gateway
DATE	1022/1613
DYNASTY	Mughal, reign of Jahangir (1605-1627)
SCRIPT	overlapping Thulth
CALLIGRAPHER	'Abd al-Haqq of Shiraz (later titled Amanat Khan)
SIZE	approx. 122x244 cm (exhibited portion)
PUBLISHED	W.E. Begley, "Amanat Khan and the Calligraphy on theTaj Mahal," *Kunst des Orients* 12 (1978-79): 5-60

This detail forms part of a very long dedication inscription band in white marble, which frames the inner recessed arch of the main gateway of Akbar's tomb at Sikandra (near Agra). The designer of the inscription, and probably the author of the Persian text of the dedication itself, was the great calligrapher 'Abd al-Haqq of Shiraz, who immigrated to India around 1608, three years after the death of the emperor Akbar. At about this time, Akbar's son and successor Jahangir decided to make some modifications in the design of his father's tomb, and apparently appointed 'Abd al-Haqq to be chief calligrapher for the project.

As presumed author of the Persian dedication inscription, 'Abd al-Haqq composed a flowery eulogy celebrating both the deceased emperor and the emperor Jahingir, the patron of the monument. Most of the eulogy is in prose, but the bottom marble panel, above the geometric patterned dado, contains three poetic couplets, exalting the magnificence of the tomb structure itself (the present detail shows only the third couplet). The verses shed a great deal of light on the poetic hyperbole of the

time and also help us to understand some of the religious symbolism underlying garden tomb architecture during the Mughal period. The translation of all three couplets is as follows:

(1) Hail, blessed space happier than the garden of Paradise!
Hail, lofty building higher than the Divine Throne!

(2) A Paradise, the garden of which has thousands of Rizwans (gatekeepers of Paradise) as its servants,
The garden of which has thousands of celestial Paradises for its land.

(3) The pen of the Divine Decree has written on its threshold:
"These are the gardens of Eden, enter them to live forever."

While the rest of the verses are in Persian, the last line is in Arabic, and calls to mind various Koranic verses that allude to God's divine invitation to the faithful to enter the heavenly Paradise. Thus the present inscription provides a clue to the symbolic meaning of the vast garden tomb complex as a metaphorical replica of the heavenly Paradise, which the faithful shall enter on the Day of Judgement.

At various places on the inscribed gateway at Sikandra, the calligrapher 'Abd al-Haqq signs his name a total of three times, including once in the present inscription. The signature is found in the small vertical letters at the left end of the panel, which read: "Written by 'Abd al-Haqq of Shiraz, in 1022" (which corresponds to 1613, the date of the completion of the entire tomb complex). The style of the raised marble calligraphy is a very bold Thulth script, in which order and coherence are given to the overlapping design by means of the rythmic and stately repetition of vertical letters. The strong geometric composition is a typical feature of 'Abd al-Haqq's style, as we know from other monuments designed by him later in his career.

Some twenty years after Akbar's tomb was completed, 'Abd al-Haqq was appointed chief calligrapher of the famed Taj Mahal, the tomb built by the emperor Shah Jahan for his beloved wife Mumtaz Mahal (see No. 59). As a reward for his brilliant designs for the Taj Mahal, 'Abd al-Haqq was appointed at that time to a relatively high position in the Mughal nobility and also awarded the title Amanat Khan.

Marble inscription on
Serai Nur Mahal

54.

SITE Nurmahal (Punjab)

MONUMENT Serai Nur Mahal, Persian verses inscribed on west gateway, recording construction by the queen Nur Mahal

DATE 1030/1620-21

DYNASTY Mughal, reign of Jahangir (1605-1627)

SCRIPT Nasta'liq

SIZE 57x210 cm

PUBLISHED *Archaeological Survey of India Reports* 14 (1878-79), 64-65; *ARIE* 1977-78, No. D-99; W.E. Begley, "Four Mughal Caravanserais Built during the Reigns of Jahangir and Shah Jahan," *Muqarnas* 1(1983): 167-179

Although the emperor Jahangir had numerous wives, undoubtedly the most powerful in her own right was his queen Nur Jahan. She eventually usurped so much imperial authority that she even issued coins in her own name—in addition to constructing impressive caravanserais like the one at Nurmahal, situated on the old Mughal highway connecting Delhi and Lahore. Endowing serais for the benefit of travelers was considered an act of Muslim charity, but it was also a royal prerogative, and the frequently imposing monuments served as effective symbols of the political power of their builders. In his 1626 report to the East India Company, the Dutch agent Pelsaert wrote from Agra: "Meanwhile she (Nur Jahan) erects very expensive buildings in all directions—serais, or halting-places for travelers and merchants—intending thereby to establish an enduring reputation."

West gateway to Serai Nur Mahal

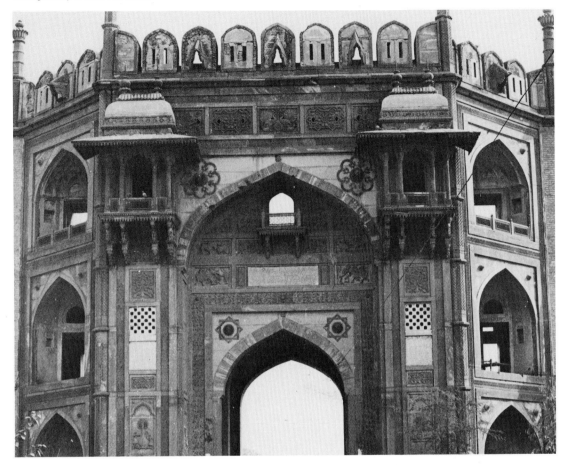

Like most state caravanserais, the one at Nur-mahal was a huge affair, capable of holding more than 3,000 travelers within its vast quadrangular enclosure walls. Two enormous gateways are situated in the west and east walls, through which the highway actually passed. The west gateway, bearing the present inscription on a fairly small marble slab above the arched opening, is clearly modelled on the vast Buland Darwaza at Fathpur Sikri (see No. 41)—even to the point of using the same red sandstone building materials, which had to be transported at great expense from distant quarries. If Nur Jahan's purpose was to symbolize her own imperial destiny, she could hardly have chosen a more effective prototype than Akbar's magnificent gateway.

Though unsigned, the delicate verses written in Nasta'liq script obviously came from the hand of a master calligrapher—perhaps one of those employed in the imperial ateliers. There are altogether four couplets inscribed in eight cartouches and arranged in two rows. Here also, the artistic qualities of the calligraphy are far superior to those of the poetry; for essentially, the verses were merely a vehicle to convey two ingeniously worded chronograms giving the date of the serai. One of the most important tasks performed by a court poet was to devise appropriate chronograms to commemorate important occasions like births, marriages and deaths—as well as the completion of architectural projects. For original and ingenious creations, poets were lavishly rewarded, frequently with the equivalent of small fortunes in gold or jewels.

Here the poet, who was probably also the calligrapher, shows his cleverness by slightly varying the Persian wording of the two chronograms (which translate exactly the same in English), thereby conveying the two-year difference between the dates of commencement and completion:

(1) During the just rule of Jahangir Shah, son of Akbar Shah—
 Whose like neither heaven nor earth remembers—

(2) The Nur Serai was founded in the district of Phillaur,
 By command fo the angel-natured Nur Jahan Begum.

(3) The date of its foundation the poet happily pronounced:
 "This Sarai was founded by Nur Jahan Begum."
 (1028)

(4) When it was completed, Wisdom uttered its date:
 "This Sarai was founded by Nur Jahan Begum."
 (1030)

55.

SITE	Raichur (Karnataka)
MONUMENT	Reading Hall inside Kati gate, Arabic and Persian inscription recording construction by the governor 'Abd al-Muhammad
DATE	1032/1622-23
DYNASTY	'Adil Shahi sultans of Bijapur, reign of Ibrahim II (1580-1627)
SCRIPT	monumental Thulth/Tughra
SIZE	81x64 cm
PUBLISHED	*EIAPS* 1963, pl. XXIII(b) (List No. 182)

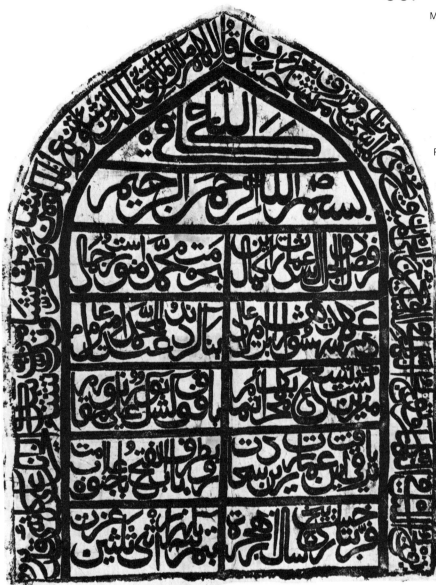

may have been composed by the calligrapher.

The outer border contains the following Koranic passage (3.25-26):

Say: "O God! Lord of Power, Thou givest power to whom Thou wilt, and strippest power from whom Thou wilt; Thou exaltest whom Thou wilt, and bringest low whom Thou wilt, In thy Hand is all good; verily Thou hast power over all things. Thou causest the night to pass into day, and the day into night; Thou bringest forth the living from the the dead, and the dead from the living. And Thou givest sustenance without measure to whom Thou wilt."

Whoever may have selected this passage, it seems clearly intended to serve as a sober reminder of the transitoriness of power to those who read it—in this case the governor and others who wielded the power of the state. As we know from literary sources, the Raichur governor 'Abd al-Muhammad eventually met his death leading an attack on the fort at Kurnool.

The Persian verses in the middle portion of the inscription (inscribed in five rows below the *Bismillah* invocation at the top) read as follows:

(1) Through the grace of the Lord of Glory, this building reached perfection;
By the sanctity of the Prophet Muhammad, its beauty became resplandant.

(2) In the reign of the valiant Ibrahim the Just (Ibrahim 'Adil Shah II),
It was founded by the governor 'Abd al-Muhammad.

(3) The nine arches within were completely decorated;
With its pavilion on top, it became like a place with "light upon light."

(4) This building attained ascendence because of this happy fortune,
That it is oriented toward the Gate of Victory facing south.

(5) Its auspicious date according to the Hijri year,
Has the dignity and honor of being one thousand and thirty-two (=1622-23).

Because of the resemblance of its shape to that of a prayer-niche, the present boldly written inscriptions at first glance might be mistaken as pertaining to a religious endowment. However, although a Koranic passage is inscribed on the outer border and the apex of the arch contain the words "God is Sufficient" and the usual *Bismillah* invocation, the epigraph's purpose is to record the construction by the governor 'Abd al-Muhammad of a palatial building in the fortification walls of the citadel, near the Gate of Victory (*Bab al-Fath*)—probably to serve various official functions such as the reception of ambassadors or other dignitaries.

Due to the uniform thickness of many letters, the effect of the calligraphy here is somewhat coarse and unsophisticated, despite the skill shown in the convoluted Tughra patterns of overlapping and the overall forcefulness of the design. A general lack of sophistication is also evident in the five Persian verses, which are mediocre in quality and perhaps

56.

SITE	Hyderabad (Andhra Pradesh)
MONUMENT	Husaini mosque, Arabic inscription framing the *mihrab*, quoting Shiite Prayer and recording construction by Haji Husaini
DATE	1045/1635-36
DYNASTY	Qutb Shahi sultans of Golconda, reign of 'Abd Allah (1626-1672)
SCRIPT	overlapping Thulth
CALLIGRAPHER	Mir 'Ali (son of Mir 'Ali Jan Mashhadi)
SIZE	213x98 cm
PUBLISHED	*EIAPS* 1966, pl. IX (List No. 199)

Though the Husaini mosque itself is of modest significance, the calligraphy signed by Mir 'Ali on the black basalt *mihrab* niche is of excellent quality. Through the evidence of other works signed by him, we may conclude that he was active at Hyderabad over a period of ten years or so. That he was of Iranian background is clear from his father's name, as given in another inscription designed by him in this same mosque. The style throughout is boldly written Thulth; noteworthy is the use of a greatly extended letter on the top and both sides of the arch frame, to divide the writing into two zones and provide a dynamic rhythmic sweep carrying the viewer's eye around the entire composition.

The content of the larger part of the inscription reveals the Shiite affiliation of the patron of the mosque as well as the calligrapher. The two cartouches across the top contain a well-known Tradition *(hadith)* of the Prophet, urging prayer and repentance while there is still time: "Hasten with prayer before its expiry and hasten with repentance before death (overtake)."

The continuous panel framing the arch contains the full Shiite formula prayer *(Durud)*:

O God! Bestow blessings on Muhammad the chosen, and 'Ali the approved, and the righteous Fatima, the two offspring Hasan and Husain; and bestow blessings on Zain al-'Abidin, and on Muhammad al-Baqir, and Ja'far al-Sadiq, and Musa al-Kazim and 'Ali al-Riza, and Muhammad al-Taqi, and 'Ali al-Naqi and the pious Hasan al-'Askari; and bestow blessings on the abiding proof, the righteous successor, the magnamimous Imam, expected to return, the Victorious Muhammad al-Mahdi, Lord of Time and final proof and Vicegerent of the Compassionate and the chief of men and genii—may the blessings and peace of God be upon them!

Verily the mosque is auspicious, and so be Haji Husaini.

Written by the humble creature Mir 'Ali in 1045 (=1635-36)

57.

SITE	Golconda (Andhra Pradesh)
MONUMENT	Shaikhpet mosque, Persian and Arabic inscription inside central *mihrab*, recording construction by sultan 'Abd Allah
DATE	1043/1633-34
DYNASTY	Qutb Shahi sultans of Golconda, reign of 'Abd Allah (1626-1672)
SCRIPT	Nasta'liq and Thulth
CALLIGRAPHER	Lutf Allah al-Husaini al-Tabrizi
SIZE	42x422 cm
PUBLISHED	*EIM* 1935-36, pl. XIII (List No. 81)

Though the Shaikhpet mosque is small in scale (and today in an extreme state of disrepair), its band of calligraphy, carved on fine-grained basalt slabs and set into the *mihrab* recess, is of extraordinarily high quality. Like many other artisans who worked for royal patrons in the Deccan kingdoms, the calligrapher Lutf Allah may have been a recent immigrant from Iran—in this case from the city of Tabriz, since this is the place-name he includes in his signature. In any event, his handling of Nasta'liq script superimposed against a floral arabesque background reveals his complete mastery of both writing and ornamentation.

Due to the pentagonal structure of the recessed prayer-niche, the format of the inscription includes five ornamental cartouches, one for each of the five sides (for a photograph of a similar recessed *mihràb*, see No. 65). Like many Indian dedicatory inscriptions, the text of the present one was devised by the poet/calligrapher to convey the date of the mosque in the most elegant and ingenious manner possible. Usually this was achieved by a chronogram forming part of a poem. In this instance, the calligrapher has instead selected a Koranic verse

(72.18), inscribed in Thulth script on the middle cartouche, the numerical value of whose letters gives the total 1042 (=1632-33). But since a different date, 1043, is given on the fifth cartouche, it appears that the mosque was begun in 1042 and finished one year later in 1043.

The following is a translation of the inscriptions on all five cartouches, beginning with the one at the right:

(1) For its date, from the Word of God,

(2) Wisdom was inspired with this verse:

(3) *"And verily, the mosques are for God alone, hence invoke not anyone else with God."* 1042

(4) The King, Refuge of the World, 'Abd Allah,

(5) Constructed a mosque of heavenly foundation. Written by Lutf Alllah al-Husaini al-Tabrizi, year 1043 (=1633-34).

Not shown here is a smaller colophon panel, to the left of the fifth cartouche, giving the date 1044; but this probably indicates the final date for the installation of all the inscribed panels, rather than the date of their original design by the calligrapher (for a similar instance of more than one date on the same inscribed prayer-niche, see No. 58).

58.

SITE	Agra (Uttar Pradesh)
MONUMENT	Madrasa Shahi mosque, Koranic inscription around central *mihrab*, followed by prayer and calligrapher's colophon
DATE	1045-1046/1636
DYNASTY	Mughal, reign of Shah Jahan (1628-1658)
SCRIPT	monumental overlapping Thulth
CALLIGRAPHER	'Abd al-Haqq, titled Amanat Khan
SIZE	285x232 cm
PUBLISHED	W.E. Begley, "Amanat Khan and the Calligraphy on the Taj Mahal," *Kunst des Orients* 12(1978-79); 5-55; *ARIE* 1975-76, Nos. D-203-205

The great Persian calligrapher 'Abd al-Haqq, who had designed the inscriptions for Akbar's tomb at Sikandra (see No. 53) was appointed chief calligrapher of the Taj Mahal toward the end of 1631. For more than twenty years before this, the calligrapher had held an official position in the royal library, first under Jahangir, and later, after Shah Jahan's accession in 1628, under the new emperor as well. 'Abd al-Haqq's brother Afzal Khan soon became prime minister *(Diwan-i-Kull)* of the empire, and the scholar-calligrapher himself was entrusted with various diplomatic tasks.

In 1632, 'Abd al-Haqq was elevated to the nobility and awarded the title Amanat Khan—which title he

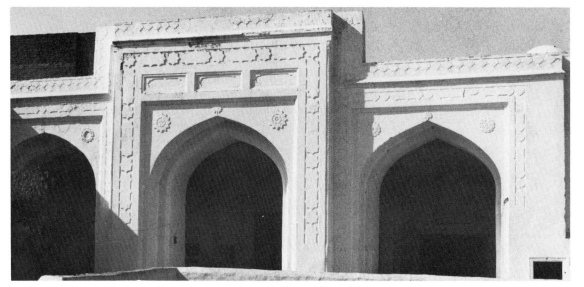

Madrasa Shahi Mosque at Agra

uses here for the first time on an architectural monument, in signing his masterful calligraphic designs for the central *mihrab*. Like the calligraphy on Akbar's tomb (but unlike that on the Taj Mahal), the letters are carved in raised relief on the white marble slabs fixed to the *mihrab*. As with all such relief calligraphy, the inked estampage gives a better idea of the original design prepared by the calligrapher in black ink on white paper—which was to serve as a model for the stonecutter.

Unfortunately, we do not know who built the small Madrasa Shahi mosque, but as its name implies, it seems to have once been attached to a seminary school *(madrasa)*. The calligrapher's main assignment of these years was of course the vast Taj Mahal mausoleum—whose exterior calligraphy appears to have been completed shortly after the present modest project.

In view of the small size of the mosque, it is curious that the calligrapher signs his name three times, just as he had done earlier on the gateway of Akbar's tomb. Two of the signatures are located on the central *mihrab*, in small rectangular cartouches at the bottom left side. The larger of these, on the outer framing arch, reads as follows: "Written by 'Abd al-Haqq, entitled Amanat Khan, year 1045" (=1635-36). The smaller panel is immediately adjacent, at the end of the narrow inner framing arch.

The signature is the same, but the date is one year later, 1046—which probably indicates that the entire project was being worked on toward the end of one Hijri year and the beginning of another (that is, around May-June 1636).

The content of the Koranic passages inscribed on the *mihrab* seem appropriate to their situation and may very well have been chosen by the scholar-calligrapher himself (who incidentally was a staunch Sunni in his religious practice, while his brother Afzal Khan was Shiite). The first passage (62.9-11) inscribed on the outer frame, enjoins the faithful to assemble for prayer on the day of assembly, and not to be distracted by the temptations of the outside world; while the second passage (48.27-29), inscribed on the top panel and around the inner frame, evokes the image of the Sacred Mosque at Mecca and the victoriousness of Islam against the unbelievers:

O ye who believe! When the call is proclaimed on the day of assembly, hasten earnestly to the remembrance of God, and leave off your trading; that is better for you if ye did but know. And when the prayer is finished, then may ye disperse through the land, and seek the bounty of God; and celebrate the praises of God often, that ye may prosper. But when they see some merchandise or some amusement, they disperse headlong to it, and leave thee standing. Say: "That which God hath is better than amusement and merchandise, and God is the best of providers."

The exalted God has spoken the truth and so has his Prophet, the noble Messeneger. And we are among the witnesses to this, and praise be to God, the nourisher of the worlds.
Written by 'Abd al-Haqq, entitled Amanat Khan, year 1045.

Truly hath God fulfilled the vision He vouchsafed to His Messenger: "Ye shall enter the Sacred Mosque, if God will, in full security, having your heads shaved, your hair cut short, and without fear—for He knoweth what ye know not, and hath appointed beforehand a speedy Victory.

It is He who hath sent His Messenger with guidance and the religion of Truth, that He may uplift it above every religion—and God sufficeth as a witness. Muhammad is the Messenger of God; and those who are with him are vehement against the unbelievers, but compassionate toward one another. Thou mayest see them bowing down, prostrate, seeking bounty from God and His Good Pleasure. The mark of them is upon their foreheads, the traces of their prostration; that is their similitude in the Torah. And in the Gospel, their similitude is: Like a seed which sendeth forth its shoot, then strengthens it; and it groweth thick and riseth straight upon its stalk, delighting the sowers—that the unbelievers may swell with indignation at them. And to such of them as believe and do deeds of righteousness, hath God promised Forgiveness and immense Reward.

Written by 'Abd al-Haqq, entitled Amanat Khan, 1046.

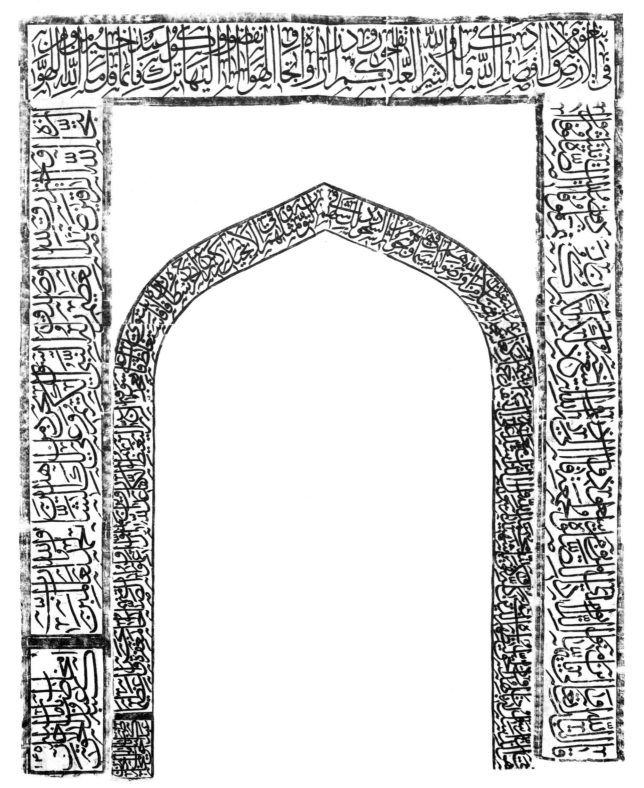

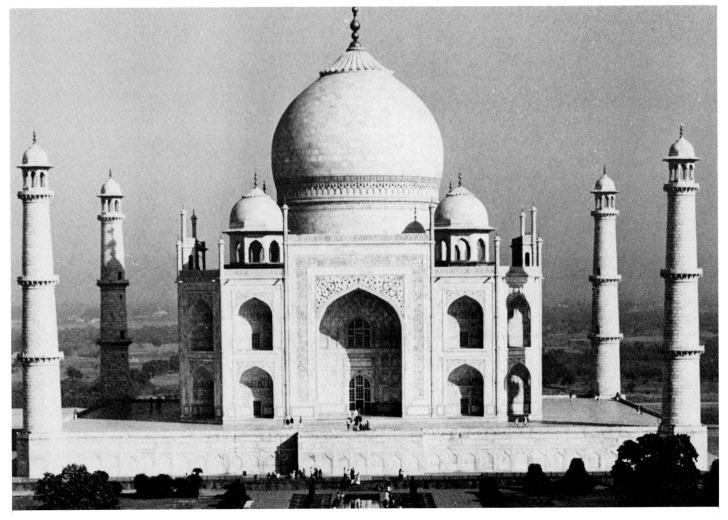

Taj Mahal at Agra

59.

SITE	Agra (Uttar Pradesh)
MONUMENT	Taj Mahal, southern facade, part of Koranic inscription at lower left of arch
DATE	1046/1636-37 (completion of exterior calligraphy)
DYNASTY	Mughal, reign of Shah Jahan (1628-1658)
SCRIPT	monumental overlapping Thulth
CALLIGRAPHER	Amanat Khan (title of 'Abd al-Haqq of Shiraz)
SIZE	approx. 360x180 cm (exhibited portion)
PUBLISHED	W.E. Begley, "Amanat Khan and the Calligraphy on the Taj Mahal," *Kunst des Orients* 12(1978-79); 5-55

The famed Taj Mahal was built by Shah Jahan as a tomb for his wife Mumtaz Mahal, with work beginning about six months after her death on 17 June 1631. Some twenty years earlier, the great Persian calligrapher 'Abd al-Haqq of Shiraz had designed the inscriptions on the tomb of Shah Jahan's grandfather Akbar (see No. 53); hence he was the logical choice for this important new commission. Moreover, 'Abd al-Haqq also had the good fortune of being the brother of Shah Jahan's prime minister Afzal Khan, which undoubtedly enhanced his prestige in the eyes of the emperor. In any event, shortly after construction of the vast Taj complex began, the emperor paid a signal honor to the calligrapher by raising him to the ranks of nobility and awarding him the title Amanat Khan—thus making him perhaps the most highly honored calligrapher in India's history.

The beauty and majesty of the calligraphy on the Taj demonstrate that Amanat Khan's renown as an artist was well deserved. The grand linear sweep of the inlaid calligraphy dramatically articulates the gleaming surfaces of white marble, framing the recessed arches like vast heraldic banners. The formal organization is highly abstract, as we can see in the design of the Koranic passages inscribed on the framing panel of the southern facade. The entire panel contains the opening verses of the profound *Ya Sin* chapter (36.1-21), whose solemn grandeur and majestic rhetoric have caused it to be considered the "heart" of the entire Koran. Because of its content, the chapter is also traditionally recited at the time of death, since it powerfully affirms the vision of the final reward in the Hereafter. (for translation of 36.1-14, see above, No. 15). The exhibited detail shows the bottom portion of the left side of the enormous framing arch, containing only a single verse (36.21):

"Obey) those who ask no reward of you, and who are themselves rightly guided."

Even in this one detail, Amanat Khan's skill and brilliance as a calligrapher is supremely evident. The grouped verticals impart a stately geometric coherence to the design, while the overlapping curved letters and sprinkled ornamental strokes create an overall aura of dramatic intensity. Perhaps the most inspired calligraphic device is the arrangement of the letters *lam-alif* of the word *la* (meaning "no") into a flared, right-angled "V"-shape

Detail of *Ya Sin* Sura inscribed on south facade (36.16-21)

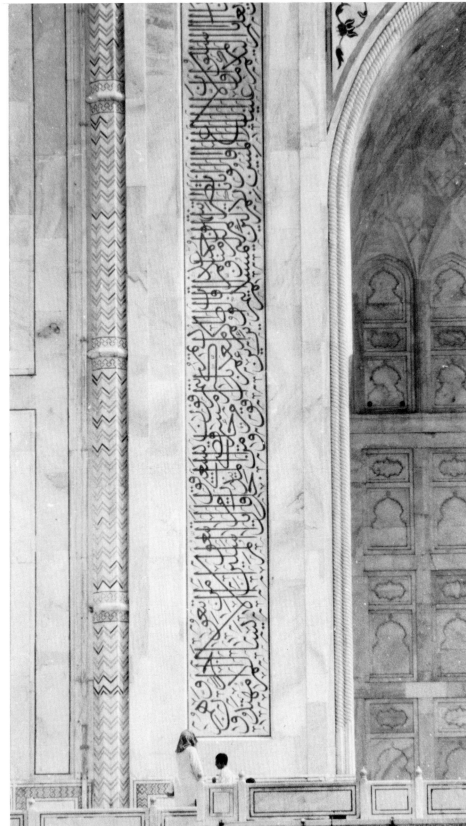

Verse from *Ya Sin* Sura (36.21) inscribed on south facade of Taj Mahal (No. 59)

linking the two clusters of verticals, and at the same time revealing the abstract geometric grid underlying the entire design.

But Amanat Khan was more than a master of the abstract principles of calligraphy. He was also a learned scholar, who apparently was personally responsible for the selection of the entire program of Koranic passages inscribed on the Taj, through which he sought to communicate the meaning of the monument on both the functional and symbolic levels. Like the Persian verses he apparently composed for the tomb of Akbar, the Koranic passages on the Taj also seem to have been selected to suggest that the tomb and its garden are to be understood as a kind of symbolic prefiguration of the celestial Paradise and its ultimate reward.

In the case of the Taj Mahal, it is apparent that in giving shape to the meaning of the entire architectural program, the role of the calligrapher was just as crucial—perhaps more so—as that of the architect. Proof of the high regard in which calligraphers were held in Mughal India is also furnished by the prominent signature of Amanat Khan inside the Taj Mahal. Although he calls himself a "humble *faqir*," the large size and distinctive flourish of the signature reveals a supremely self-confident artist. Comparison of the signature inside the Taj with one of his three signatures found on the gateway of Akbar's tomb at Sikandra reveals a strong stylistic continuity over a period more than twenty-five years. Both signatures create a checkerboard pattern by crossing vertical letters with greatly extended horizontals. The names are of course different; on the earlier monuments, he writes his real name 'Abd al-Haqq of Shiraz, while on the Taj he signs only the title Amanat Khan. It is noteworthy that, except for the deceased queen Mumtaz Mahal, whose name occurs both on her cenotaph and grave, Amanat Khan is the only other person whose name was originally inscribed on this most beautiful of all Indian Islamic monuments.

Calligrapher's signature on gateway of Akbar's Tomb at Sikandra: "Written by 'Abd al-Haqq of Shiraz, in 1022" (=1613)

Calligrapher's signature inside Taj Mahal:

"Finished with His help. Written by the humble *faqir* Amanat Khan of Shiraz, in the year one-thousand-and-forty-eight Hijri, corresponding to the twelfth year of the auspicious accession (of Shah Jahan)" (=1638-39)

60.

SITE	Ahmadabad (Gujarat)
MONUMENT	Serai of A'zam Khan, Persian couplets inscribed inside gateway, recording construction by the Mughal governor
DATE	1047/1637-38
DYNASTY	Mughal, reign of Shah Jahan (1628-1658)
SCRIPT	Nasta'liq
SIZE	210x109 cm (as mounted)
PUBLISHED	M.A. Chaghtai, *Muslim Monuments of Ahmadabad through their Inscriptions* (Poona, 1942), 86-87, No. XLIII; *ARIE* 1967-68, No. D 90

The ten Persian couplets displayed here are actually inscribed in a continuous narrow band more than twelve meters in length, situated in the recessed gateway arch of the imposing caravanserai built by the Mughal governor of Gujarat, A'zam Khan. With their bulbous and cusped ends, the twenty consecutive cartouches and intervening medallions create a rich ornamental design; but it is the consummate mastery of the difficult Nasta'liq script that deserves the highest praise. Unlike examples of Nasta'liq placed against a foliate background, here the cartouches contain only calligraphy of unsurpassed beauty and elegance—calligraphy that perfectly expresses the exquisitely refined taste of Mughal patronage during the reign of Shah Jahan.

The extended letters are particularly well executed and constitute a repeating rhythm that links—like a recurring musical theme—otherwise separated elements of the composition. Particularly brilliant is the extended curve in the writing of the name of the serai's patron, A'zam Khan (first cartouche of fifth couplet). The letters of the word *A'zam* (meaning "Great") normally have no extended element;

the curved extension here in the middle of the word both repeats the theme running through all the cartouches and also gives flattering rhetorical emphasis to the patron's title.

The governor's real name was Mir Muhammad Baqir, and earlier he had held the title Iradat Khan. Though he built many impressive buildings during his six years as governor of Gujarat (1636-1642), his administration was highly unpopular, and he was ultimately removed from office by the emperor Shah Jahan. Seven years later, he died at Jaunpur at the age of seventy-six. As was usual, the dedication starts off with praise of the emperor and recitation of his titles, before turning to a eulogy of A'zam Khan and his charitable endowment. The full translation of the ten couplets is as follows:

(1) During the reign of the just king,
 Refuge of the people of the world, the Shadow of God,

(2) Lord of the Auspicious Conjunction (Sahib Qiran), the second Timur,
 Bright star of the Faith (Shihab al-Din) Muhammad, King of Kings,

(3) Emperor of the World, the greatest Khaqan (Khaqan Akbar),
 Of Auspicious rank (Humayun Jah), Sultan, son of a Sultan,

(4) One of his most devoted servants,
 Who from heart and soul obeys his order,

(5) The spring of justice, A'zam Khan, champion of the faith,
 Whose sword provides life to the kingdom,

(6) Laid the foundation of a serai in Gujarat,
 The likes of which the eye of Time has never seen.

(7) How unsurpassed is its magnificence!
 In loftiness, the step of its rank has surpassed Saturn;

(8) In beauty and elegance, it is like Paradise,
 For its gatekeeping, Rizwan the Keeper of Paradise would be most appropriate.

(9) The Sarai and the market of imperial dignity (qaisariya) reached completion
 By order of the just Khan who is the jewel among men;

(10) When I sought its date from the Angel of the Unseen,
 A voice said: "The house of bounty and beneficence!" (=1047/1637-38)

61.

SITE	Vinukonda (Andhra Pradesh)
MONUMENT	Jami' Masjid, Arabic and Persian inscription on Central *mihrab*, recording construction by the noble 'Ali Riza Khan
DATE	1050/1640-41
DYNASTY	Qutb Shahi sultans of Golconda, reign of 'Abd Allah (1626-1672)
SCRIPT	Thulth and Nasta'liq
SIZE	130x64 cm
PUBLISHED	*EIAPS* 1953-54, pl. IX (List No. 130)

The region of Vinukonda had been in the hands of the Golconda sultans from about 1580 onwards, but the somewhat coarse Thulth calligraphy of this inscription has a definite provincial quality (cf. the Raichur inscription of 1032/1622-23, Cat. No. 55). Obviously many of the territories under Golconda control lacked the cosmopolitan sophistication of the capital, even though they were frequently governed by important nobles like 'Ali Riza Khan, whose title was 'Ain al-Mulk ("Eye of the Kingdom")—and who apparently had been deputed to ensure the safety of the highways through the province.

The present inscription occupies the central part of the recessed *mihrab* of the Vinukonda mosque, which is Shiite in its affiliation. The outer border contains the Shiite *Durud*, or formulaic prayer (with minor variations, it is the same as that translated in No. 51). Inside the border at the top, there are inscribed the names "Allah, Muhammad, and 'Ali," followed by the *Bismillah* invocation and the well-known "Throne Verse" (2.255; for translation see Cat. No. 12). Below the "Throne Verse" there is a special prayer to 'Ali, called the *Nad-i-'Ali*;

Beckon 'Ali, the manifestation of wonders; you will find him a great help in your difficulties, and all grief and cares will disappear—through thy status of being Friend of God, O 'Ali, O 'Ali, O 'Ali!

At the very bottom of the inscription panel, the dedication proper is inscribed in small Nasta'liq letters:

During the reign of the king of Jamshid-like dignity, the sultan 'Abd Allah Qutb Shah—may God perpetuate his kingdom—the humble servant 'Ali Riza Khan, titled 'Ain al-Mulk, having brought to book the robbers on the highways to the coastal ports, and having managed the expedition of Tangeta, erected a mosque for the promulgation of Faith, during the Hijri year 1050." (=1640-41).

62.

SITE	Ajmer (Rajasthan)
MONUMENT	Shrine of Sufi saint Mu'in al-Din Chishti, Arabic and Persian dedication inscription on gateway built by Shah Jahan
DATE	1065/1655
DYNASTY	Mughal, reign of Shah Jahan (1628-1658)
SCRIPT	Thulth and Nasta'liq
SIZE	48x247 cm
PUBLISHED	*EIAPS* 1957-58, pl. XVIII(a) (List No. 157)

By the Mughal period, the tomb complex of the medieval saint Khwaja Mu'in al-Din at Ajmer had become the most celebrated Sufi shrine in North India—to which the emperors Akbar, Jahangir and Shah Jahan all made pilgrimages and added various architectural embellishments. The present inscription comes from the gateway Shah Jahan ordered to be erected on the occasion of his pilgrimage there in November 1654, his third such visit after his accession. At the same time the emperor set out for Ajmer, he had also dispatched his prime minister Sa'd Allah Khan to demolish the bastions of the Rajput fortress at Chitor, and it seems likely that the gateway at Ajmer specifically commemorates the success of that expedition.

This conclusion is based on the content of the inscription, which consists of two parts. The large central cartouche contains the *Kalima* or Muslim "Profession of Faith" and also the date: *There is no god but God, Muhammad is the Prophet of God* 1065 (=1655). At either end are two quatrefoil medallions containing two lines of a single Persian verse:

During the reign of Shah Jahan, the religion-cherishing king,
The sun of Faith has wiped away the darkness of infidelity completely. Year 29 (of Shah Jahan)

Since the Hindu ruler Rana Raj Singh had disobeyed Shah Jahan's orders by erecting the fortifications at Chitor, his speedy submission was apparently viewed by those at Ajmer as yet another Muslim triumph over the unbelievers.

The calligraphy of both the central cartouche, written in Thulth, and the two medallions, in Nasta'liq, is quite handsome and functions well with the dignified architectural simplicity of the gateway—which is variously known as the Kalima Darwaza, on account of the central inscribed panel; or the Shah Jahani Darwaza, after its builder. Since the inscription is dated in both the Hijri year 1065 and the 29th regnal year of Shah Jahan, we can pinpoint its completion to the months April-October 1655.

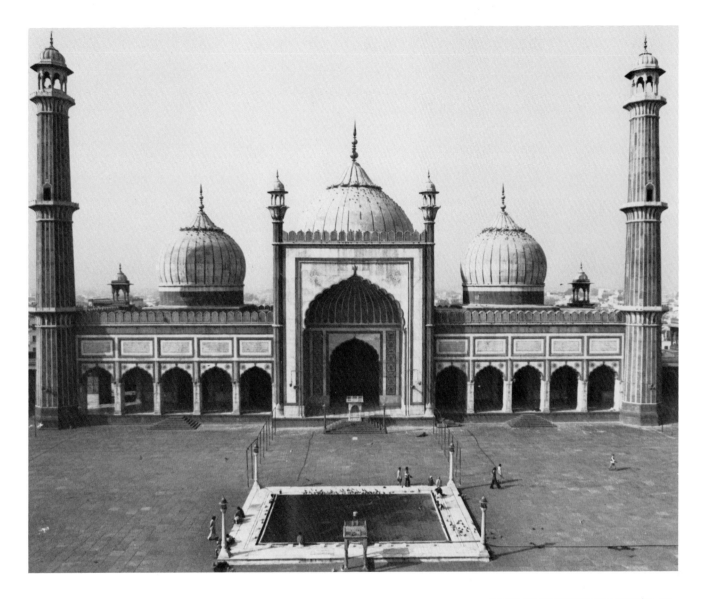

Jami Masjid at Shahjahanabad, Delhi (No. 63)

63.

SITE	Shahjahanabad (Delhi)
MONUMENT	Jami' Masjid, built by emperor Shah Jahan, Koranic inscriptions above central *mihrab*
DATE	1066/1656
DYNASTY	Mughal, reign of Shah Jahan (1628-1658)
SCRIPT	monumental Thulth
CALLIGRAPHER	Nur Allah, son of Ahmad
SIZE	approx. 244x366 cm (exhibited portion)
PUBLISHED	W.E. Begley, "The Symbolic Role of Calligraphy on Three Imperial Mosques of Shah Jahan," in J. Williams, ed., *Kaladarsana: American Studies in the Art of India* (New Delhi, 1981), 7-18

The vast congregational mosque built by Shah Jahan in his new capital Shahjahanabad at Delhi was the last great monument of his reign. Begun in October 1650 (two years after the completion of the Red Fort), the mosque took six years to complete but cost only about one-fifth the amount spent on the Taj Mahal. This information is contained in the official court history of Shah Jahan's reign and is also inscribed on the facade of the mosque, in a lengthy Persian inscription designed by the calligrapher Nur Allah, son of Ahmad. The calligrapher's father was apparently the great Mughal architect Ustad Ahmad, designer of both the Taj Mahal and the Red Fort; since the father died before work commenced on the great Jami Masjid, it is possible that his son Nur Allah may have assumed some architectural responsibilities for the project, in addition to designing the calligraphic inscriptions.

In view of the unusual length of the dedicatory inscription on the mosque's facade, the Koranic inscriptions on the interior are surprisingly brief—consisting of only two verses inscribed at the top of the *mihrab* arch, one within a rectangular cartouche (39.53), and the other divided into two sections on either side (9.108). Preceded by the *Bismillah* invocation *In the Name of God the Merciful, the Compassionate*, the verse within the cartouche translates:

Say: "O my servants who have transgressed against their soul, despair not of the mercy of God! For God forgives all sins and He is All-Forgiving and All-Merciful!"

Frequently inscribed on both mosques and tombs, this short verse has acquired a special sanctity within the Islamic tradition, being recited as a kind of ritual prayer for divine mercy.

By contrast, the second verse has an obvious relevance to its architectural context:

There is a mosque whose foundation was laid from the first day on piety; it is worthier that thou stand forth therein to pray. Within it are men who strive to be purified—for God loves those who make themselves pure.

In effect this verse conveys the suggestion that Shah Jahan's mosque should also be regarded as one founded in piety—despite the imperial pretensiousness of the text of the Persian eulogy inscribed across the facade.

Beneath the two Koranic verses are two circular medallions on the spandrels of the *mihrab* arch, each with an eight-pointed star in the center, formed by the interlaced verticals of the words *Ya Ghaffar*, "O Forgiver", repeated eight times. In these and the other inscribed panels, the crisp linearity of the calligraphy perfectly augments the effect of dignified elegance aspired to in all the architectural works of Shah Jahan.

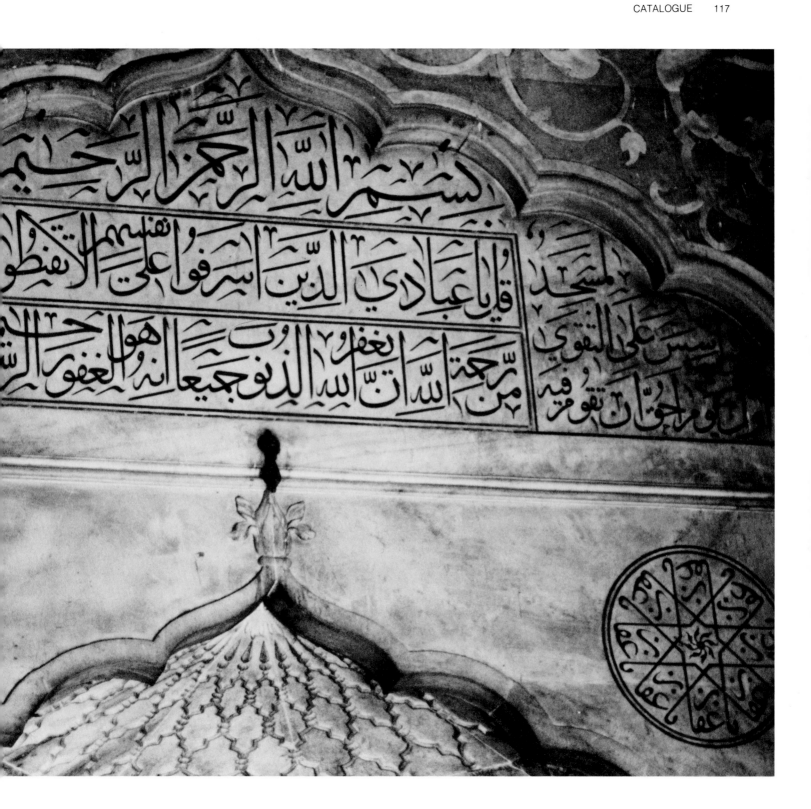

64.

SITE	Golconda (Andhra Pradesh)
MONUMENT	Great Mosque adjoining tomb of Hayat Bakhsh Begum, Koranic inscriptions framing the central *mihrab*
DATE	1077/1667
DYNASTY	Qutb Shahi sultans of Golconda, reign of Abu'l-Hasan (1672-1687)
SCRIPT	monumental overlapping Thulth
CALLIGRAPHER	Taqi al-Din Muhammad, son of Shaikh Salih of Bahrain
SIZE	288x230 cm
PUBLISHED	*EIM* 1915-16, pl. XI (List No. 20)

The dowager queen Hayat Bakhsh Begum, daughter of the sultan Muhammad Qutb Shah, had been married in 1607 to her cousin, the future sultan Muhammad Qutb Shah (r.1611-1626). The next sultan was her son, 'Abd Allah (r.1626-1672); and following his mother's death in 1667, he caused both an imposing tomb and large adjoining mosque to be erected in her honor, according to the long-standing custom of the royal dynasty.

Known as the Great Mosque, the building's most impressive feature is the large central *mihrab* with its inscribed rectangular framing arch. Like many of the artists and artisans who worked for the Qutb Shahi rulers, who were Shiite in their religious belief, the calligrapher apparently immigrated to South India from Iran—or rather from Bahrain. Persian masters of the monumental overlapping Thulth style of calligraphy had been in demand throughout India for almost one hundred years, in both North and South. Judging from the examples of this style included in the present exhibition, the calligraphers who prac-

ticed it tended over time to increase its complexity and expressionistic qualities. Thus the design of Taqi al-Din Muhammad at Golconda appears much more crowded than the earlier designs of Amanat Khan for the Taj Mahal. While sacrificing a certain amount of clarity and elegance, however, the Qutb Shahi calligrapher creates a rather more forceful design—although his small signature at the bottom left of the panel is in this instance much more modest than that of Amanat Khan (but compare his signature in the next entry, No. 65).

Like so many mosque inscriptions already discussed, the choice of Koranic verses to be inscribed around the *mihrab* was clearly intentional rather than haphazard. In this case, the Koranic passage (2.142-143) alludes to the controversy that arose when Muhammad reversed the direction of prayer *(qibla)* from toward Jerusalem to toward Mecca. Not only is the passage therefore appropriate with respect to its location on the prayer-niche of the mosque, but it also contains an eloquent

affirmation of the universality of God, to whom "belong both East and West"; while the believers are strongly enjoined to be "witnesses over all the nations". (The Koranic passage is preceded by the short formulaic prayer: "I take refuge in God from the accursed Satan"):

The fools among the people will say: "What hath turned them from the Qibla to which they were accustomed?" Say: To God belong both East and West, He guideth whom he will in a Way that is straight. Thus have we made of you a community justly balanced, that ye might be witnesses over all the nations, and the Apostle a witness over yourselves. And we appointed the Qibla to which thou wert accustomed, only to separate those who followed the Apostle from those who would turn on their heels. Indeed it was a hard test, except for those guided by God. But it was not God's purpose that your faith should be in vain, for God is full of pity, Merciful to all people.

Written by Taqi al-Din Muhammad, son of Shaikh Salih of Bahrain, in 1077 (=1667).

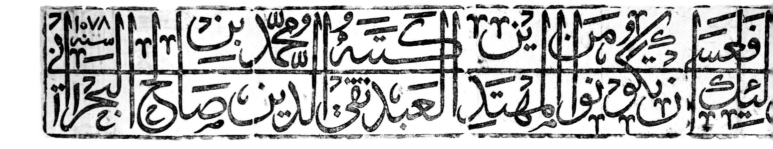

65.

SITE	Golconda (Andhra Pradesh)
MONUMENT	Hira Masjid inside Golconda Fort, Koranic passage inscribed in *mihrab* niche
DATE	1078/1677-78
DYNASTY	Qutb Shahi sultans of Golconda, reign of Abu'l-Hasan (1672-1687)
SCRIPT	monumental overlapping Thulth
CALLIGRAPHER	Taqi al-Din Muhammad, son of Shaikh Salih of Bahrain
SIZE	41x470 cm
PUBLISHED	*EIM* 1913-14, pl. XIX(c) (List No. 16)

As we know from another inscription on this mosque, it was built by a Sultan Muhammad, at the order of the last Qutb Shahi ruler Abu'l-Hasan, who was eventually deposed by the Mughal emperor Aurangzeb in 1687. Before marrying into the royal Qutb Shahi family, Abu'l Hasan had lived the life of a Sufi devotee, and several religious endowments at Golconda attest to his architectural patronage after his accession. The mosque is situated within a large enclosure containing rooms for students and travelers. The architectural style of this and various other Qutb Shahi mosques embodies numerous eclectric features, many borrowed from Hindu architectural forms of the later medieval period in South India. The *mihrab* arch fronts a deeply recessed polygonal chamber, and it is on the seven faceted dado slabs that the Koranic passage exhibited here is inscribed, following the designs of the calligrapher Taqi al-Din Muhammad (the same as in the preceding entry).

Though the present mosque is more modest than the Great Mosque, the calligraphic design is equally monumental in effect, particularly since the spacing of the boldly written letters is more open. With more space available, the calligrapher has signed his name in a much more prominent manner; in fact, almost one-fourth of the entire inscribed band is given over to his name—though admittedly both the beginning and end portions of the inscription are partly hidden from view by the projecting pilasters supporting the *mihrab* arch. As with most Koranic inscriptions written in the Thulth script, the words alternate back and forth between a lower and upper zone, here divided by the greatly elongated letter *ya* of the place name "Bahrani"—which runs from beginning to end of the entire panel.

The Koranic passage inscribed consists of a single verse (9.18), which occurs fairly frequently on Indian mosques (compare entry Nos. 5, 19). The implication is clearly that mosques are for the exclusive use of believers:

The mosques of God shall be visited and maintained by such as believe in God and the Last Day, establish regular prayers, and practice regular charity, and fear none except God. It is they only who can be considered among the rightly guided.

Written by the servant Taqi al-Din Muhammad, son of Shaikh Salih of Bahrain, year 1078 (=1667-68)

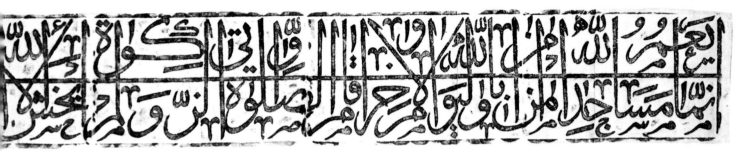

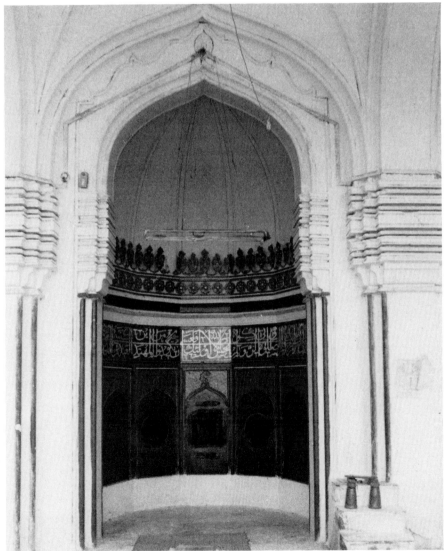

Mihrab niche inside Hira Mosque

66.

SITE	Bijapur (Karnataka)	
MONUMENT	detached Persian inscription (now in Bijapur Museum), recording construction of a tank, probably inside a mosque	
DATE	1082/1671-72	
DYNASTY	'Adil Shahi sultans of Bijapur, reign of 'Ali II (1656-1672); contemporaneous with Mughal emperor Aurangzeb(1658-1707)	
SCRIPT	Nasta'liq against floriated background	
SIZE	41x62 cm	
PUBLISHED	*EIAPS* 1955-56, pl. XX(b) (List No. 148)	

In this beautiful inscription, the calligrapher has combined the linear elegance of Nasta'liq script with an intricate floral arabesque, in an attempt to create visual equivalents for the subtlety and nuance of Persian poetry. Script and background merge together into a perfectly integrated design, in which letters and foliage display the same graceful rhythms. So unified is the concept, that the rhomboid dots of four of the letters can also be read as blossoming flowers.

This kind of visual ambiguity seems appropriate in view of the ambiguous literary imagery of the inscription, which is yet another example of an ingenious Persian chronogram giving the date of the construction of the monument. The three inscribed words are *chashma az Kawthar* which mean *"A spring from the Kawthar."* The numerical value of the Persian letters totals 1082, which date is also given in figures at the lower left.

The literary associations of this short phrase are fairly complex. The word Kawthar indicates the celestial tank of abundance, beside which, according to Muslim belief, the prophet Muhammad will stand to intercede for the faithful on the Day of Judgment. Thus the chronogram metaphorically suggests that the tank being dedicated is a kind of replica—in both beauty and sancity—of a prototype in Paradise. The floral arabesque in the inscription also seems intended to evoke the beauty of Paradise, but in a much more "literal" way than the abstract perfection of the calligraphy.

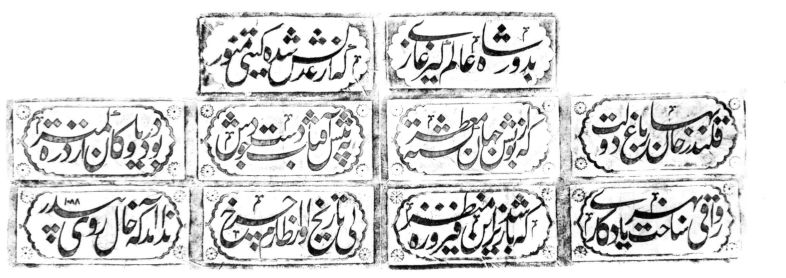

67.

SITE Bidar (Karnataka)

MONUMENT detached Persian inscription recording construction of a bacony by the noble Qalandar Khan

DATE 1088/1677

DYNASTY Mughal, reign of Aurangzeb (1658-1707)

SCRIPT Nasta'liq

SIZE 67x198 cm

PUBLISHED *EIM* 1927-28, pl. XVI (List No. 54)

The formerly independent kingdom of Bidar had been absorbed by the rulers of Bijapur in 1619, and subsequently annexed to the Mughal empire in 1656. The noble Qalandar Khan, who built the balcony mentioned in the inscription, was the fifth Mughal governor of Bidar—serving under the emperor Aurangzeb. Where the balcony was situated is unknown, but it was common practice for governors to undertake extensive repairs and additions to the forts under their command, and to commission a poet/calligrapher to compose suitable verses for the dedication.

By the middle of the 17th century, Persian poetry was almost always inscribed in the elegant Nasta'liq script, with the two halves of each couplet frequently occupying separate cartouches. The variety of Nasta'liq created by the present calligrapher appears bolder than usual, as a result of the large dots and denser juxtapositioning of the letters. This degree of crowding decreases the legibility of the inscription somewhat, but increases the strength and formal cohesiveness of each panel as an abstract composition.

The text of the verses contains the usual flattering eulogy of both building and builder, written in the effusive Persian style that had long been in fashion in Mughal India (the final verse records the date in the form of a poetically worded chronogram):

(1) During the reign of the World-seizing and Valiant King (Aurangzeb),
Through whose justice the world has been illumined,

(2) Qalandar Khan—the bloom of the garden of the state,
Whose sweet odor has perfumed the country;

(3) Before the sun of whose hand of generosity,
The treasures under the sea and earth pale into insignificance—

(4) Built a balcony as a memorial
To be seen beneath the azure Heavens;

(5) To record its date, from the fourth Heaven
Came this voice: *"The beauty-mark on the face of Bidar"* 1088(=1677)

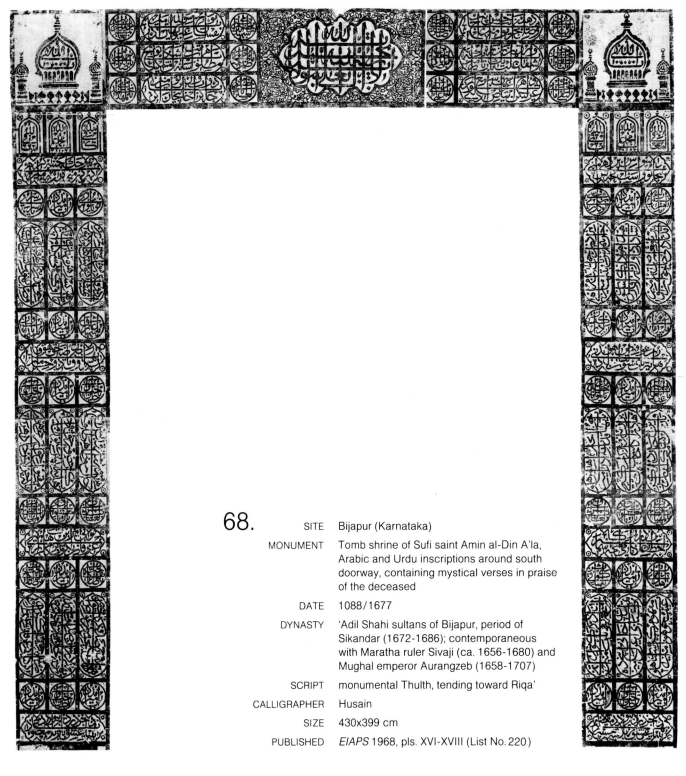

68.

SITE	Bijapur (Karnataka)
MONUMENT	Tomb shrine of Sufi saint Amin al-Din A'la, Arabic and Urdu inscriptions around south doorway, containing mystical verses in praise of the deceased
DATE	1088/1677
DYNASTY	'Adil Shahi sultans of Bijapur, period of Sikandar (1672-1686); contemporaneous with Maratha ruler Sivaji (ca. 1656-1680) and Mughal emperor Aurangzeb (1658-1707)
SCRIPT	monumental Thulth, tending toward Riqa'
CALLIGRAPHER	Husain
SIZE	430x399 cm
PUBLISHED	*EIAPS* 1968, pls. XVI-XVIII (List No. 220)

Amin Dargah at Bijapur

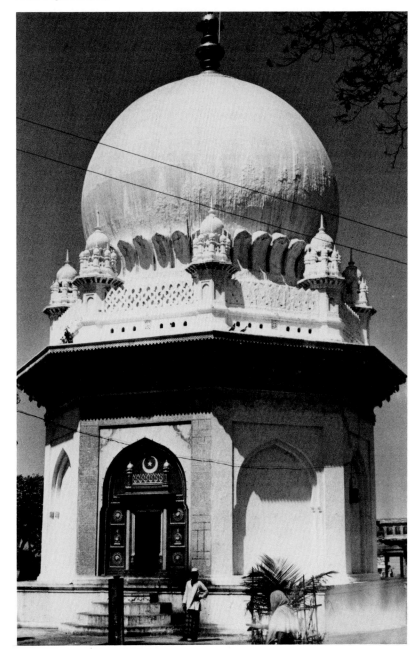

From the middle of the 17th-century the fortunes of the sultans of Bijapur began to deteriorate rapidly, due not only to invasions by the Mughals, but also to insurrections by the Marathas and other former vassal states. With the death of the Maratha general Sivaji in 1680, the field was left open for Aurangzeb, who deposed the last Bijapur ruler in 1686 and annexed the kingdom to his own empire.

In the midst of this turbulent period, the great Sufi saint Amin al-Din A'la died in 1675 and was buried in an impressive octagonal tomb shrine on the Shahpur hill at Bijapur. A member of the Chishti order of Sufis, Amin came from Illustrious line of mystics resident in Bijapur since the middle of the 15th century. After preaching the technique of spiritual ecstasy as a means of union with God, Amin attracted numerous followers who made him an object of worship, much to the disapproval of the religious orthodoxy in the city. The content of the mystical poems in praise of Amin that are inscribed on the doorway to this tomb convey the intensity of this devotion by his followers.

The inscription is remarkable for its large size and complexity of design, which utilizes a grid-like pattern of circular and oval cartouches to inscribe a series of pious invocations and verses addressed to the saint. Some such geometric division was essential in order to organize the text of the inscriptions coherently. In addition, the tops of the two vertical sides of the arch are crowned by replicas of the bulbous dome of the tomb itself, flanked by smaller domed finials—probably inspired by those placed along the tomb's parapet, above the overhanging cornice. The script employed is Thulth with some elements of the freer cursive style called Riqa'. There is extensive overlapping, which reinforces the grid-like pattern of the design, and throughout the letters are executed with skill and boldness (this is especially noticable in the large cartouche in the center of the horizontal panel forming the top of the arch).

Detailed analysis of this lengthy inscription is not feasible here, but a clue to the overall tone of the religious content is provided by the words inscribed in the four small circles on the top panel, adjoining the large central cartouche reciting the Muslim profession of a faith. Read consecutively, these inscribed circles quote a prophetic Tradition (hadith) about the Prophet's mystical night-journey when he was transported from Mecca to the very presence of God. This journey, known as the Mir'aj, had long served Sufis as a model of their own fervent longing for direct knowledge of, and mystical union with, God. Perhaps even more radical in their mystical implications are the words "Verily, I am God," inscribed on the two large domes atop the right and left panels. While these words derive from a Koranic passage (28.30), they also evoke the ambiguous utterances of earlier Muslim mystics like al-Hallaj, whom critics accused of heresy, and suggest a degree of veneration of the deceased saint that

orthodox Muslims would regard as unacceptable.

In the following translation, the text proceeds from the bottom right side, upwards across the top, and down the left part of the frame. The numbers pertain to the fifteen verses of a mystical Urdu *ghazal* (one of the few early examples of an architectural inscription composed in the Urdu language). Unfortunately unattributed to any author, the verses are interspersed in the inscription with various invocations addressed to Amin, the names of the twelve Shiite Imams, and other short formulaic expressions in Arabic:

RIGHT PANEL:

He laid the foundation of the game of love;
The aim was nothing else but pain!

O Amin, help! O fulfiller of needs! O Amin, help!

(1) O Amin! You must dive deep into the sea of Heart and find the shell of Soul,
If you want to obtain the precious pearl of the Secret of Life.

(2) O Amin! Revere your religious preceptor *(pir)* and break the shell;

O performer of miracles! O Amin, help! O performer of miracles!

So that you may obtain the beautiful pearl, keep knowledge of God always in mind.

O Shams al-'Ushaq ("Sun of Lovers")! O divine beloved! O sun and moon!

(3) O Amin! You look beautifully respendent like light:
When you obtain knowledge of God, you can present yourself as a suitable gift to Him.

(4) O Amin! As you are the favorite of God, where else can you go now?

O fulfiller of needs! O Amin, help! O fulfiller of needs!

Submissive to His pleasure, sacrifice yourself for Him, there can now be no other desire.

O Ashiq Shahbaz ("Lover Falcon")! O Amin, help! O Buland Parwaz ("High Soaring")!

(5) O Amin! How and with what tongue can I speak of the hidden meaning illustrating this desire?
None has the capacity, nor is there anyone able to say it.

(6) O Amin! Many are the ways of reaching God, but attempting to name them cuts our tongue;

O Light of my light! O Amin, help! O Secret of my secret!

His most pure and refined essence throws us into wonder every moment.

God is sufficient! God, Muhammad, 'Ali! God is the Healer!
O God! "Verily, I am God" (28.30) O God!

TOP PANEL:

Imam 'Ali al-Murtaza! Imam Muhammad al-Baqir! Imam Muhammad al-Taqi!

(7) O Amin! Since the sea is stormy and raging, only with a spiritual guide *(murshid)* can one reach God.
Otherwise, the path is narrow and dark, and every risk of despair and disappointment in the attempt.

(8) O Amin! Listen to me with the ears of your heart, O Swimmer;

Imam Hasan al-Mujtaba, the patient! Imam Ja'far al-Sadiq! Imam 'Ali al-Naqi!

There is no god but God, Muhammad is the Prophet of God, exalted be His Glory!

The Prophet of God... has said—may God's blessings and peace be upon him, his descendants and his companions—"When He caused me to ascend during the night toward the heavens, He guided me to the Divine Throne."

Imam Husain al-Shahid at Karbala! Imam Musa al-Kazim! Imam Hasan al-'Askari!

Do not be afraid of the waves of carnal desire which are other than God.

(9) O Amin! Thus can you easily achieve the goal, since the only obstacle is yourself;
Hence do not hestitate to dive into (the ocean of) love and cross to the other side.

Imam Zain al-'Abidin! Imam Musa al-Riza! Imam Muhammad al-Mahdi!

LEFT PANEL:

O God! "Verily, I am God!" (28.30) O God!
God is my forgiver! God, Muhammad, 'Ali! God is everlasting!

(10) O Amin! These confusing ideas are out of place, like curtains obstructing your aim;

I am from the light of God! O Amin, help! And everything is from my light!

Men of truth are those whose hearts are filled only with Love.

O Banda Nawaz ("Cherisher of Slaves")! O Amin, help! O Gaisu Daraz ("Long-Haired")!

(11) O Amin! Be a witness with both your body and soul;
To attain God, seek help from your teacher and guide, who is wise and brave.

(12) O Amin! Through the bounty of (your father) Burhan, you have dived deep to seek Him;

O asylum of lovers! O Amin, help! O crown of monotheists!

Now live in tranquility since you have found the pearl that befits you.

(13) O Amin! On the dust of the shrine of (your father) Burhan, son of Miran,
You have sacrificed your body, nay soul and mind as well.

(14) O Amin! I have received the deed of servitude of that shrine *(dargah)*;

O path-finding guide! Amin, help! O cup-bearer of the celestial Kawthar tank!

I have renounced the universe to gain you!

(15) O Amin! I have completed this *ghazal* in fifteen couplets;
Accept it, overlooking its shortcomings and not finding fault.

O Amin, help! O fulfiller of needs! O Amin, help!

He laid the foundation of the game of love;
The aim was nothing else but pain!
This was written by Husain, 1088 (=1677)

69.

SITE	Burhanpur (Madhya Pradesh)
MONUMENT	gravestone with Arabic and Persian epitaph, recording the death of Maryam, daughter of the noble Muftakhar Khan and wife of Abu'l-Fazl Khan
DATE	12 Jumada I 1130/ 2 April 1718
DYNASTY	Mughal, reign of Farrukhsiyar (1713-1719)
SCRIPT	monumental Thulth
CALLIGRAPHER	Abu'l-Fazl Khan, husband of the deceased (?)
SIZE	174x89 cm
PUBLISHED	*EIAPS* 1962, pl. XXV(b) (List No. 177)

The calligraphy for this elegant epitaph for a noble lady was apparently designed by her husband, who was in any event the author of its touching tribute to her religious piety and learning. Nothing is known about the husband Abu'l-Fazl Khan beyond the information given in the epitaph, but the deceased lady may be the Maryam who served as tutor to princess Zeb al-Nisa, daughter of the emperor Aurangzeb. Her father's name is given in the inscription as Muftakhar Khan, and a noble by that title is known to have served twice as governor of the strategic city of Burhanpur, before Aurangzeb's death in 1707.

The inscribed marble slab, which resembles the arched shape of a *mihrab*, forms a flat tablet-like surface on top of the cenotaph, as was usual for the graves of women (the cenotaphs of men were frequently surmounted by an arched projection resembling a pen-box, or *qalam-dan*). The skill and delicacy of the writing resemble that of the best calligraphy under the earlier Mughal rulers Jahangir and Shah Jahan.

As is obvious from the content of the epitaph, the deceased and her family were Shiite, not surprising in view of their ancestral origins in Iran. Maryam is described in the inscription as one who had memorized the entire Koran; she also had performed the Haj and had visited the tombs of the Shiite Imams. The epitaph proper is inscribed on the outer border, beginning at the top:

There has occurred the death of one who is the elevated, the forgiven, the pardoned, the skilled reciter (*qariyya*) of the glorious Koran, the visitor of the Holy House of God (at Mecca), where she stayed for two years, performing two pilgrimages and visiting the tombs of her ancestor, the chief of the prophets (Muhammad), of her ancestress, the chief of all the women of the world (Fatima), and of the remaining holy Imams—may the blessings of God be upon them in their sacred tombs—one who bears the same name as the mother of Jesus—may peace be upon him and the Prophet Muhammed—that is to say, Maryam, daughter of the late highly respected noble Muhammad, son of 'Ali Musa al-Husaini al-Mazandarani, entitled Muftakhar Khan, on Thursday, the 12th of the month of Jumada I, the year 1130 Hijri (=2 April 1718).

This is written by her husband, who is also the son of the son of her father's sister, the humble creature, the depressed, the sorrowful, the separated, the deprived, Abu'l-Fazl Khan, son of Ghiyath al-Din Mansur, al-Hasani al-Husaini al-Inju'i.

The middle portion of the panel contains the Shiite *Durud*, or formulaic prayer, and three Persian couplets; both are preceded by two short Koranic phrases located in the corner above the top of the cusped arch:

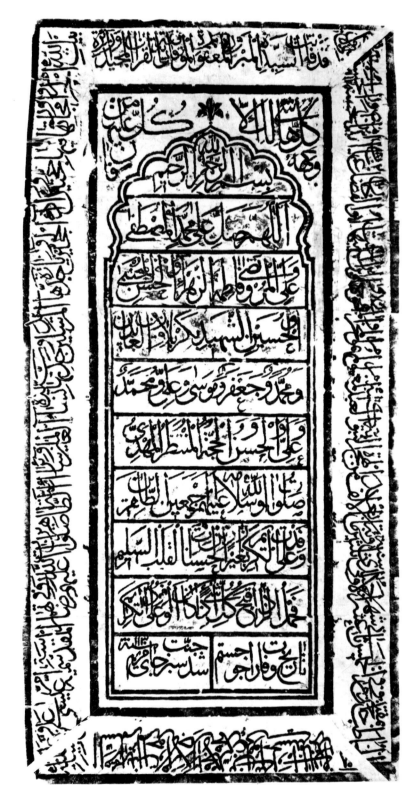

70.

SITE	Kurnool (Andhra Pradesh)
MONUMENT	detached Persian inscription found at Kallur, recording construction of a garden by the noble Bahadur Khan
DATE	1139/1726-27
DYNASTY	independent Nawabs of Kurnool; contemporaneous with Nizam of Hyderabad, Asaf Jah (1713-1748)
SCRIPT	Nasta'liq
SIZE	107x83 cm
PUBLISHED	*EIAPS* 1951-52, pl. XXVII(a) (List No. 126)

Throughout most of the 17th century, the region around Kurnool formed part of the Bijapur kingdom until its takeover by the Mughal armies in 1686. A few years after the death of Aurangzeb in 1707, the Kurnool governors assumed the title of Nawab, and maintained a fair degree of independence, notwithstanding the pressures exerted by their much stronger neighbors in adjoining Mysore and the territories ruled over by the Nizams of Hyderabad.

The present inscription records the construction of a no longer extant garden in the vicinity of Kurnool (the slab was found at the village of Kallur), by the noble Bahadur Khan, who is flatteringly characterized in the Persian verses as "the cloud of liberality and generosity, through whom the garden of munificence has come to flourish." The script is a very elegant variety of Nasta'liq, with wide spacing and very attenuated letters. The letters of The *Bismillah* invocation at the top are particularly fine, and appear to float above the rest of the panel:

In the Name of God, the Merciful, the Compassionate

(1) A garden was constructed by the grace of God—
 He whose name is glorified and Who is Most High

(2) By the cloud of liberality and generosity, Bahadur Khan,
 Through whom the garden of munificence has come to flourish.

(3) May the fruit of his desire remain always fresh and flourishing;
 May the tree of his reputation bedeck the world!

(4) I composed the year of the date in the form of a prayer:
 "*May the Praiseworthy Garden* (Bagh-i-Muhammadi) *remain most excellent!*" (1139=1726-27)

"*Everything is mortal except His face*" (28.88 part); "*Everything on it* (the earth) *will perish*" (55.26 part).

In the Name of God, the Merciful, the Compassionate.

O God! Bestow blessings on Muhammad the chosen one, and 'Ali the approved, and Fatima the radiant, and Hasan the elect, and Husain the martyr at Karbala, and Zain al-'Abidin, and Muhammad, and Ja'far, and Sadiq, and Musa, and 'Ali and Muhammad, and 'Ali and Hasan, and the expected proof, the Mahdi—may God's blessings and peace be upon them, the pure one's all.

(1) I went to the presence of the Most Beneficient, Without provisions of good deeds and faultless heart;

(2) For carrying provisions is the worst of all things, When one happens to go to a generous person.

(3) When I sought the date of her death:
 "*The evergreen Paradise became the abode of Maryam,*" year 1130(=1718).

71.

SITE
Siddhavatam (Andhra Pradesh)

MONUMENT
detached Arabic and Persian inscription apparently serving as epitaph for a Sufi saint, Shah Bismillah

DATE
1186/1772

DYNASTY
semi-independent Nawabs of Cuddapah, vassals of Haidar 'Ali of Mysore after 1765; contemporaneous with Nizam of Hyderabad, 'Ali Khan (1761-1803)

SCRIPT
overlapping Thulth and Nasta'liq

SIZE
70x134 cm

PUBLISHED
EIM 1939-42, pl. XVIII(b) (List No. 113)

The late 18th century saw turbulent times throughout India. The great Muslim empires of both North and South had now fallen or were about to fall, due to the steady advances of the British, who assumed direct political control over some kingdoms, while allowing others to continue as semi-independent vassal statec. Like so many other small states in the subcontinent, the territories of both Kurnool and Cuddapah, located in present-day Andhra Pradesh, lost their independent status completely by the end of the century—passing ultimately into the hands of the British in 1800 (the last Nawab was deposed in 1839). Without stable patronage, monumental Islamic calligraphy in India entered upon a phase of precipitous decline.

It is tempting to see the eclectic artistic character of the present inscription as somehow reflecting this chaotic political and cultural situation (which coincides almost exactly with the period of political unrest in the American colonies that led to the Declaration of Independence). But it is more likely that the somewhat strange juxtaposition of calligraphic and decorative elements seen here reflects instead Muslim India's longstanding preoccupation with Sufi mysticism, particularly in the largely Shiite south.

The circular medallion is skillfully executed; and although the overlapping letters of the *Bismillah* invocation and Profession of Faith create a rather dense pattern, the design is still coherent and legible:

In the Name of God, the Merciful, the Compassionate. There is no God but God, Muhammad is the Prophet of God.

At the bottom of the circle, in smaller letters, there is inscribed the name of the otherwise unknown Sufi saint whose epitaph this is: "Shah Bismillah, Solver of Difficulties *(Mushkil Kusha)*, 1186." The epithet *Mushkil Kusha,* which is associated with the Prophet's son-in-law 'Ali, also occurs in the two star medallions on either side at the top of the panel—the right one reading "Shah Bismillah Mushkil Kusha" and the left reading "Muhammad, 'Ali, Shah Mushkil Kusha."

By comparison with the majestic design inside the large circle, all of the other ornament and lettering appears somewhat awkwardly placed, especially the two highly heretical, mystical verses inscribed diagonally on either side. Like the inscriptions on the shrines of other Sufi saints discussed earlier, these verses stress the ecstatic total union with God that was the mystic's ultimate goal. The author of these verses—who was perhaps also the patron of the inscribed grave of the saint—gives his name as Halim (an individual of the same name also endowed a mosque at the locality of Siddhavatam).

(1) Pole-star *(qutb)* of the Age and adept in the mystery of union with God,
The Essence of Truth became his truth through repudiation of all save God!

(2) Halim, you should consider his body to be the shadow of the everlasting emanation;
The Angel from the Unseen gave the date: *"He was the Self of God."*

The Persian words of the chronogram, *u bud zat Allah,* give the numerical total 1186. This is the same date as that inscribed at the bottom left of the large circle, and in the lowermost words on the right and left sides: "Completed 1186" (=1772).

APPENDIX I:

List of Articles Published in
Epigraphia Indo-Moslemica and *Epigraphia Indica,*
Arabic and Persian Supplement

Epigraphia Indo-Moslemica (EIM)
1907-08

1. T.W. Haig, "Inscriptions in Gulbarga," 1-10.

2. _____, "Some Inscriptions in Berar," 10-21.

3. _____, "An Inscription in the Fort of Daulatabad," 21-23.

4. _____, "Inscriptions in Hyderabad and Golconda," 23-29.

1909-10

5. G. Yazdani, "The Inscription on the Tomb of 'Abdullah Shah Changal at Dhar," 1-5.

6. Zafar Hasan, "The Inscriptions of Dhar and Mandu," 6-29.

7. J. Horovitz, "A list of the Published Mohamedan Inscriptions of India," 30-144.

1911-12

8. Muhammed Shu'aib, "Inscriptions from Palwal," 1-4.

9. G. Yazdani, "A New Inscription of Sultan Nusrat Shah of Bengal (at Gaur)," 5-7.

10. _____ "Remarks on the Inscriptions of Dhar and Mandu," 8-11.

11. J. Horovitz, "The Inscriptions of Muhammad ibn Sam, Qutbuddin Aibeg, and Iltutmish," 12-34.

1913-14

12. Zafar Hasan, "Inscription Found in the Adchini Village, Now Preserved in the Delhi Museum of Archaeology," 1-4.

13. Jivanji Jamshedji Modi, "A Copper Plate Inscription of Khandesh," 5-10.

14. Zafar Hasan, "Inscription Originally on the Khass Mahall and Now Preserved in the Delhi Museum of Archaeology," 11-12.

15. G. Yazdani, "The Inscriptions of the Turk Sultans of Delhi — Mu'izzu-d-Din Bahram, 'Ala'u-d-Din Mas'ud, Nasiru-d-Din Mahmud, Ghiyathu-d-Din Balban and Mu'izzu-d-Din Kaiqubad," 13-46.

16. _____, "Inscriptions in Golconda Fort," 47-59.

1915-16

17. H. Beveridge, "Mahdi Khwaja," 1-9.

18. G. Yazdani, "Two Inscriptions of King Husain Shah of Bengal from Tribeni," 10-14.

19. _____, "Inscriptions of the Tomb of Baba Arjun Shah, Petlad (Baroda State)," 15-18.

20. _____, "Inscriptions in the Golconda Tombs," 19-40.

21. _____, "Remarks on the Date of a Copper Plate Inscription of Khandesh," 41-42.

1917-18

22. G. Yazdani, "Inscriptions of the Bijapur Kings, 'Ali 'Adil Shah I and Ibrahim 'Adil Shah II, from Naldrug, Nizam's Dominions," 1-3.

23. _____, "Inscription of Khafi Khan from Narsapur (Hyderabad State)," 4-7.

24. _____, "Inscriptions of the Khalji Sultans of Delhi and Their Contemporaries in Bengal," 8-42.

25. _____, "Inscriptions of the Qutb Shahi Kings in Hyderabad City and Suburbs," 43-56.

1919-20

26. Zafar Hasan, "Inscriptions of Sikandar Shah Lodi in Delhi," 1-11.

27. G. Yazdani, "Inscriptions of Nizam Shahi Kings from Antur Fort, Aurangabad District," 12-15.

28. _____, "Inscriptions at Bodham, Nizamabad District," 16-19.

29. _____, "Inscriptions in the Fort at Qandhar, Nanded District, H.E.H. the Nizam's Dominions," 20-26.

30. _____, "Inscriptions at Elgandal," 27-29.

1921-22

31. Muhammad Hamid, "A Kufic Inscription from Hund," 1.

32. Ch. Mohammad Ismail, "Two Inscriptions from the Rauza of Malik Sha'ban in Rakhyal near Ahmadabad," 2-5.

33. G. Yazdani, "An Inscription from the Parenda Fort," 6-7.

34. _____, "Inscriptions from Gudur and Siruguppa," 8-12.

35. _____, "Inscriptions from the Bid (Bhir) District," 13-30.

1923-24

36. L. Bogdanov, "The Tomb of the Emperor Babur Near Kabul," 1-12.

37. G. Yazdani, "Inscription of Ghiyathu'd Din Tughlaq from Rajahmundry," 13-14.

38. _____, "Some Unpublished Inscriptions from the Jaipur State," 15-25.

39. M. Hamid Quraishi, "Inscriptions of Sher Shah and Islam Shah," 26-30.

40. G. Yazdani, "A New Inscription from Golconda," 31-32.

1925-26

41. Muhammad Hamid Kuraishi, "Some Persian, Arabic and Sanskrit Inscriptions from Asirgarh in Nimar District, Central Provinces," 1-8.

42. Maulawi Ashfaq 'Ali, "Inscription Originally on the Old 'Idgah of Aligarh Which Is Now Ruined," 8-9.

43. C.R. Singhal , "An Arabic Inscription of Ba'i Harir from Ahmedabad," 9-10.

44. _____ , "Two Persian Inscriptions from Surat," 10-13.

45. Ram Singh Saksena, "Moslem Epigraphy in the Gwalior State," 14-17.

46. Khwaja Muhammad Ahmad , "Two Inscriptions from Bidar," 17-19.

47. _____ , "An Inscription of Mahmud Shah I of Gujarat Found at Dohad," 20-21.

48. Ram Singh Saksena, "An Inscription of the Reign of Hoshang Shah," 21-22.

49. G. Yazdani , "Inscription of Ibrahim Qutb Shah from the Pangal Tank, Nalgonda District," 23-25.

50. _____ , "Two Qutb Shahi Inscriptions from Hyderabad," 25-27.

51. Muhammad Hamid Kuraishi, "A Kufic Sarada Inscription from the Peshawar Museum," 27-28.

1927-28

52. Muhammad Hamid Kuraishi, "Multan — Its Brief History and Persian and Arabic Inscriptions," 1-16.

53. G. Yazdani , "An Inscription of 'Ala'u-d-Din Khalji from Rakkasgi in the Bijapur District," 16-17.

54. _____ , "The Inscriptions of Bidar," 18-38.

1929-30

55. G. Yazdani, "Inscriptions of Yadgir, Gulbarga District," 1-3.

56. Muhammad Nazim, "Two Arabic Inscriptions at Champanir," 3-5.

57. C.R. Singhal, "A Persian Inscription of Dastur Khan," 5-6.

58. R.G. Gyani, "The Delhi Gate Inscription of Nasik," 6-7.

59. Ram Singh Saksena, "Moslem Epigraphy in the Gwalior State," 7-9.

60. G. Yazdani , "Some Inscriptions of the Muslaman Kings of Bengal," 9-13.

61. _____ , "Six New Inscriptions from Koppal, Raichur District," 14-18.

62. Khwaja Muhammad Ahmad, "Inscriptions from Udgir, Bidar District," 18-31.

1931-32

63. G. Yazdani , "Inscriptions of Shahpur, Gogi and Sagar, Gulbarga District," 1-25.

64. _____ , "An Inscription from Dornhalli, Shahpur Taluqa, Gulbarga District," 25-26.

65. _____ , "Seven New Inscriptions from Bidar, Hyderabad State," 26-31.

66. _____ , "Two Inscriptions from the Warangal Fort," 31-32.

1933-34

67. Maulawi Shamsuddin Ahmad, "Some Unpublished Inscriptions of Bengal," 1-9.

68. Muhammad Nazim, "An Inscription from Dabhol," 9-12.

69. R.G. Gyani, "An Inscription from the Jami' Masjid at Dabhol, (Ratnagiri District)," 12-13.

70. Ram Singh Saksena, "Inscriptions from Kaliadeh and Antri in Gwalior State," 13-17.

71. Zafar Hasan, "Three Inscriptions of Humayun," 17-20.

72. G. Yazdani , "Inscription in Margalla Pass, Rawalpindi District," 21-22.

73. _____ , "An Inscription from the New Fort at Palamau in the Chota Nagpur Division, Bihar," 22-23.

74. _____ , "An Inscription of Sultan Husain Shah of Bengal from the Village Margam, Police Station Khargram, District Murshidabad," 23-24.

75. _____ , "An Inscription from Raisen Fort in the Bhopal State," 24-27.

76. Shamsuddin Ahmad, "Some Persian Inscriptions of the Period of the Lodi and Mughal Sultans of Delhi," 27-33.

Supplement

77. Muhammad Nazim, "Inscriptions from the Bombay Presidency," 1-61.

1935-36

78. G. Yazdani , "Inscriptions from Kalyani," 1-14.

79. _____ , "Inscriptions from Mudgal," 14-19.

80. _____ , "Inscriptions from the Taltam Fort," 20-21.

81. _____ , "Some New Inscriptions from Golconda and Hyderabad," 21-33.

82. _____ , "Two Mughal Inscriptions from Anad Near the Ajanta Ghat, Hyderabad State," 33-34.

83. _____ , "Two New Inscriptions from the Bidar District, Hyderabad State," 35-36.

84. _____ , "Some Unpublished Inscriptions from the Bombay Presidency," 36-47.

85. _____ , "The Bilingual Inscription of Qutbu'd-Din Khalji from Rasul Khanji Museum, Junagarh," 48-49.

86. _____ , "Inscription of Mubarak Shah Khalji from Jalor, Jodhpur State," 49-50.

87. _____ , "An Old Urdu Inscription of Ahmad Shah II of Gujarat," 50-51.

88. Ram Singh Saksena, "Some Moslem Inscriptions from Gwalior State," 52-57.

89. Shamsuddin Ahmad, "Three Inscriptions of Bengal," 59-60.

90. G. Yazdani, "A Qutb Shahi Inscription from Patancheru, Medak District, Hyderabad State," 60-62.

1937-38

91. G. Yazdani , "Five New Inscriptions from the Bidar District," 1-4.

92. _____ , "Inscription of Sultan Balban from Bayana, Bharatpur State," 5-6.

93. _____ , "Inscription of Ghiyathu'd-Din Tughluq from Asrawa Khurd Near Allahabad," 6-7.

94. Q.M. Moneer , "Three Persian Inscriptions of Allah Vardi Khan Turkman from the Ancient Hill Forts in the Nasik District," 7-13.

95. _____ , "A Persian Inscription from the Jami' Masjid at Champaner," 13-17.

96. Shamsuddin Ahmad, "Two Inscriptions from Sherpur, Bogra District, Bengal," 17-22.

97. Ram Singh Saksena, "Muslim Inscriptions from Bhonrasa, Gwalior State," 22-34.

98. G. Yazdani, "Two Persian Inscriptions from Dhamoni, Saugor District, C.P.," 34-37.

99. Shamsuddin Ahmad, "The Navagram Inscription of Sultan Nusrat Shah of Bengal," 37-38.

100. G. Yazdani, "Five Inscriptions from the Provincial Museum, Lucknow," 38-41.

101. Fazal Ahmad, "Three Inscriptions from Gingee," 42-45.

102. _____ , "Three Inscriptions from the Indi Taluka, Bijapur District," 45-47.

103. Muhammad Ahmad, "Some New Inscriptions from the Golconda Fort," 47-52.

104. G. Yazdani, "Some Muslim Inscriptions from the Madras Presidency and Orissa," 52-59.

105. Zafar Hasan, "An Inscription of 'Alau'd-Din Khalji Recently Discovered at Muttra," 59-61.

1939-40

106. G. Yazdani, "Seven New Inscriptions from Baroda State," 1-7.

107. Shamsuddin Ahmad, "A Rare Unpublished Inscription of Ilyas Shah of Bengal," 7-9.

108. Muhammad Ahmad, "Inscriptions of Raichur in the Hyderabad Museum," 10-23.

109. Q.M. Moneer, "Two Unpublished Inscriptions of the Time of Sultan Muhammad bin Tughluq," 23-26.

110. Shamsuddin Ahmad, "Inscriptions in the Provincial Museum, Lucknow," 26-29.

111. C.H. Shaikh, "Some Unpublished Inscriptions from Ahmadnagar," 30-33.

112. Shamsuddin Ahmad , "Five Inscriptions from Bijapur District," 33-37.

113. _____ , "Inscriptions from Siddhavatam, Cuddapah District, Madras," 37-43.

114. _____ , "Inscriptions from Gwalior State," 43-47.

115. G. Yazdani, "The Bilingual Inscription of Qutb'd-Din from Rasulkhanji Museum, Junagarh," 47.

116. C.H. Shaikh, "Identification of Two Historical Personages Mentioned in the Muslim Inscriptions of Ahmadnagar," 47-49.

1949-50

117. Syed Yusuf, "Muslim Inscriptions from Paithan," 1-14.

118. Q.M. Moneer, "Two Arabic Inscriptions of the Khalji Period from Baroda State," 15-18.

119. M.A. Chaghtai, "Some Inscriptions from Jodhpur State, Rajputana," 18-53.

Epigraphia Indica, Arabic and Persian Supplement (EIAPS)

1951-1952

120. Mohd. Ashraf Husain, "Arabic and Persian Inscriptions in the Agra Fort," 1-12.

121. Yusuf Kamal Bukhari, "Inscriptions from Maner," 13-24.

122. A.K. Bhattacharya, "Two Unpublished Arabic Inscriptions of Nusrat Shah from Santoshpur, District Hooghly, Bengal," 24-27.

123. Y.K. Bukhari , "Inscription in the Shaikonwali Masjid at Agra," 27-29.

124. _____ , "Some New Inscriptions from South India," 29-34.

125. M. Idrisullah, "Two Persian Inscriptions carved on the Gate of Bibi Ka Maqbara, Aurangabad-Dn," 34-35.

126. Z.A. Desai, "Some Unpublished Inscriptions from Kurnool," 35-60.

1953-1954

127. M. Wahid Mirza, "Some Arabic and Persian Inscriptions from the East Punjab," 1-11.

128. Y.K. Bukhari , "Inscriptions of the Tughluq Period from the Village of Etamda in Bharatpur District," 11-18.

129 _____ , "Four Unpublished Arabic Inscriptions of Sultan Barbak Shah of Bengal," 18-23.

130. Z.A. Desai, "Qutb Shahi Inscriptions from Andhra State," 23-33.

131. Y.K. Bukhari, "Some Inscriptions from Kalpi and Jatara," 34-41.

132. Z.A. Desai, "A Persian Inscription of Adil Shahi Period from Siraguppa," 41-44.

133. Y.K. Bukhari, "Two Persian Inscriptions of the Reign of Shah Jahan from Sarai Ekdil, District Etawa," 44-46.

134. Z.A. Desai, "An Inscription of Shah Jahan from Hajo in Assam," 46-49.

135. _____ , "Inscriptions of the Sultans of Gujarat from Saurashtra," 49-77.

1955-1956

136. Z.A. Desai, "Arabic and Persian Inscriptions from the Indian Museum, Calcutta," 1-32.

137. _____ , "Inscription from the Assam Provincial Museum, Gauhati," 33-34.

138. Y.K. Bukhari, "Inscriptions from the Gomti Gate Museum, Gaur," 35-36.

139. M. Ishaque, "Arabic and Persian Inscriptions from the B.R. Sen Museum, Malda, West Bengal," 37-42.

140. Y.K. Bukhari , "Inscriptions from the State Museum, Lucknow," 43-48.

141. _____ , "Inscription from the Curzon Museum, Mathura," 49-50.

142. Z.A. Desai, "Inscription from the Rajputana Museum, Ajmer," 51-52.

143. _____ , "Inscriptions from the State Museum, Alwar," 53-56.

144. Y.K. Bukhari , "Inscriptions from the Archaeological Museum, Amber," 57-60.

145. _____ , "Inscription from the State Museum Bharatpur," 61-62.

146. M. Ishaque, "Inscriptions from the Sardar Museum, Jodhpur," 63-66.

147. Z.A. Desai, "Inscription from the Victoria Hall Museum, Udaipur," 67-70.

148. S.B. Samadi, "Inscriptions from the Archaeological Museum, Bijapur," 71-86.

149. Z.A. Desai, "Inscription in the Bharata Itihasa Samshodhaka Mandala, Poona," 87-88.

150. _____ , "Inscriptions from the Museum of Antiquities, Junagadh," 89-102.

151. _____ , "Two Inscriptions from the Government Museum, Madras." 103-106.

152. J.A. Omeri, "Note on an Unpublished Persian Inscription in the Provincial Museum, Orissa," 107-108.

153. B.D. Verma , "Inscriptions from the Central Museum, Nagpur," 109-118.

154. _____ , "Inscriptions from the Archaeological Museum, Gwalior," 119-126.

1957-1958

155. Z.A. Desai, "Inscriptions from the Prince of Wales Museum, Bombay," 1-29.

156. Mahdi Husain, "Six Inscriptions of Sultan Muhammad bin Tughluq Shah," 29-42.

157. Akbar Ali Tirmizi, "Persian Inscriptions at Ajmer," 43-70.

1959-1960

158. Y.K. Bukhari, "Inscriptions from the Archaeological Museum, Red Fort, Delhi" 1-22.

159. M. Khatun, "A Persian Inscription in the Indian Museum, Calcutta from Murshidabad," 23-26.

160. Z.A. Desai, "Inscriptions from the State Museum, Hyderabad," 27-37.

161. R.M. Joshi, "Sanskrit Version of the Bilingual Inscription from the State Museum, Hyderabad," 38-40.

162. Akbar Ali Tirmizi, "Persian Inscriptions at Ajmer," 41-56.

163. H.K. Sherwani, "A Qutb Shahi Inscription from Kodangal," 57-60.

164. Z.A. Desai , "Inscriptions from Cumbum in Andhra Pradesh," 61-68.

165. _____ , "Inscriptions of Alaud-Din Khalji from Chitorgadh," 69-74.

1961

166 Z.A. Desai , "Arabic Inscriptions of the Rajput Period from Gujarat," 1-24.

167. _____ , "Some Tughluq Inscriptions from Bihar," 25-34.

168. A.A. Kadiri, "Inscriptions of the Sultans of Bengal from Bihar," 35-44.

169. W.H. Siddiqi, "Two Inscriptions of Bengal Sultans from Uttar Pradesh," 45-48.

170. S.A. Rahim, "Inscriptions of the Faruqi Kings from Burhanpur," 49-58.

171. Z.A. Desai , "Three Inscriptions of the Auhadis," 59-63.

172. _____ , "Inscriptions from the Khusraw Bagh, Allahabad," 64-68.

173. W.H. Siddiqi, "Three Mughal inscriptions from Kesiari, West Bengal," 69-73.

1962

174. Z.A. Desai, "Khalji and Tughluq Inscriptions from Gujarat," 1-40.

175. W.H. Siddiqi, "Inscriptions of the Sharqis from Bihar and Uttar Pradesh," 41-52.

176. A.A. Kadiri, "Bahmani Inscriptions from Raichur District," 53-66.

177. S.A. Rahim, "Some More Inscriptions from Khandesh," 67-80.

178. B. Datta and C.L. Suri, "Sanskrit Portion of the Bidar Inscription in the Hyderabad Museum," 81-88.

1963

179. Qeyamud-Din Ahmad, "A New Inscription of Sikandar Shah of Bengal from Bihar?," 1-4.

180. Z.A. Desai, "Inscriptions of the Gujarat Sultans," 5-50.

181. S.A. Rahim, "Some Mughal Inscriptions from Vidarbha," 51-60.

182. A.A. Kadiri, " 'Adil Shahi Inscriptions from Raichur," 61-78.

1964

183. W.H. Siddiqi and Z.A. Desai, "Khalji and Tughluq Inscriptions from Uttar Pradesh," 1-20.

184. A.A. Kadiri, "Inscriptions of the Bahmanis of Deccan," 21-44.

185. S.A. Rahim and Z.A. Desai, "Inscriptions of the Sultans of Malwa," 45-78.

186. M.F. Khan, "Two Persian Inscriptions of Jahangir from Madhya Pradesh," 79-82.

1965

187. Z.A. Desai, "Kufi Epitaphs from Bhadreswar in Gujarat," 1-8.

188. _____ , "A Fourteenth Century Epitaph from Konkan," 9-10.

189. W.H. Siddiqi, "Inscriptions of the Sayyid Kings from Budaun," 11-18.

190. S.A. Rahim, "Inscriptions on the Kushk-Mahal at Chanderi," 19-22.

191. M.F. Khan, "Three New Inscriptions of 'Alau d-Din Husain Shah," 23-28.

192. S.A. Rahim, "Inscriptions of Sikandar Lodi from Narwar Fort," 29-38.

193. A.A. Kadiri, "Three Adil Shahi Inscriptions from Goa," 39-48.

194. M. Ashraf Husain, "Inscriptions of Emperor Babur," 49-66.

195. Z.A. Desai, "Inscriptions on the Bhadra Gateway, Ahmadabad," 67-71.

1966

196. Z.A. Desai , "Fragmentary Inscription of Queen Radiyya from Uttar Pradesh," 1-3.

197. _____ , "Inscriptions of the Mamluk Sultans of Delhi," 4-18.

198. _____ , "Two Inscriptions of Ghiyathu'd-Din Tughluq from Uttar Pradesh," 19-26.

199. M.K. Khan, "Inscriptions of the Qutb Shahi Kings," 27-34.

200. Q. Ahmad, "Inscriptions of Jahangir in the Patna District," 35-42.

201. S.A. Rahim, "Mughal Inscriptions from Panchgawhan," 43-54.

202. A.A. Kadiri, "Inscriptions of the Sidi Chiefs of Janjira," 55-76.

1967

203. Z.A. Desai, "Khalji and Tughluq Inscriptions from Rajasthan," 1-24.

204. W.H. Siddiqi, "Lodi and Sur Inscriptions from Bihar and Uttar Pradesh," 25-42.

205. A.A. Kadiri, "Nizam Shahi Inscriptions from Galna," 43-60.

206. M.F. Khan, "Two Epitaphs from Hyderabad City," 61-65.

207. S.A. Rahim, "Six Mughal Inscriptions from Vidarbha," 66-75.

1968

208. Z.A. Desai , "A New Inscription of Muhammad bin Sam," 1-3.

209. _____ , "The Chanderi Inscription of 'Alau'd-Din Khalji," 4-10.

210. Q. Ahmad, "Some Unpublished Pre-Mughal Inscriptions from Bihar," 11-16.

211. Z.A. Desai , "An Early Sultanate Record from Baroda," 17-20.

212. _____ , "An Early Fifteenth Century Inscription from Gujarat," 21-24.

213. _____ , "An Inscription of Husain Shah Sharqi from Bihar," 25-27.

214. _____ , "A Unique Inscription of Humayun from Bulandshahr," 28-32.

215. _____ , "A Sur Inscription from Central Rajasthan," 33-40.

216. A.A. Kadiri, " 'Adil Shahi Inscriptions from Bankapur," 41-50.

217. S.A. Rahim, "Inscriptions of Akbar and Jahangir from Madnya Pradesh," 51-66.

218. Satya Prakash, "A Bilingual Inscription from Jaipur District," 67-68.

219. M.F. Khan, "Three Grants of the Time of Aurangzeb from Kota District," 69-78.

220. M. Akbaruddin Siddiqi, "The Dakani Inscription on the Amin Dargah at Bijapur," 79-92.

1969

221. Qeyamud-Din Ahmed, "Some Inscription of Jahangir in Bihar," 1-14.

222. M.F. Khan, "Inscriptions of Shah Jahan from Madhya Pradesh," 15-28.

223. A.A. Kadiri, "Mughal Inscriptions from Maharashtra," 29-48.

224. S.A. Rahim, "Nine Inscriptions of Akbar from Rajasthan," 49-60.

225. W.H. Siddiqi and Z.A. Desai, "Inscriptions of Emperor Akbar from Uttar Pradesh," 61-86.

1970

226. S.A. Rahim, "A Unique Inscription of Sultan Ahmad of Malwa from Piranpur Near Chanderi," 1-8.

227. Z.A. Desai , "A Unique Inscription of Muhammad Shah Sur of Bihar," 9-12.

228. _____ , "An Early Fourteenth Century Epigraph from Gujarat," 13-15.

229. _____ , "Inscriptions of the Khanzadas of Nagaur," 16-44.

230. A.A. Kadiri, "Some More Direction-Stones of Nizam Shahi Dynasty," 45-62.

231. Z.A. Desai, "Some Mughal Inscriptions from Gujarat," 63-92.

1971

232. Z.A. Desai, "Some Fourteenth Century Epitaphs from Cambay in Gujarat," 1-58.

233. S.S. Hussain, "Two Mughal Inscriptions from Samana, Panjab," 59-63.

234. A.A. Kadiri, " 'Adil Shahi Inscriptions from Panhala," 64-80.

235. Marie H. Martin, "The Shuhur San: Date Equivalencies, Origins and Special Problems," 81-106.

1972

236. S.S. Hussain, "A New Inscription of Sultan Balban from the State Museum, Patiala, Panjab," 1-3.

237. Z.A. Desai , "A Unique Inscription of the Khalji Period from Allahabad Museum," 4-11.

238. _____ , "The Jalor 'Idgah Inscription of Qutbu'd-Din Mubarak Shah Khalji," 12-19.

239. _____ , "A Khalji and Tughluq Inscription Each from Rajasthan," 20-31.

240. _____ , "Two Fourteenth-Century Epitaphs from Central Rajasthan," 32-38.

241. Akbaru'd-Din Siddiqi, "Two Inscriptions of the Bahmani Period from Firozabad," 39-45.

242. S.A. Rahim, "A Unique Inscription of Malwa Prince Qadr Khan from Chanderi," 46-52.

243. A.A. Kadiri, "A Mahdar from Hukeri in Karnataka," 53-62.

1973

244. Z.A. Desai, "Epitaph of Khwaja Mubashshar, Attendant of Hadrat Nizamu'd-Din Auliya of Delhi," 1-9.

245. N.M. Ganam, "An Epitaph of Six Martyrs from Bari Khatu in Rajasthan," 10-13.

246. Z.A. Desai , "An Interesting Persian Inscription from Baroda in Gujarat," 14-18.

247. _____ , "An Inscription of Sultan Ahmad Shah I from Dhrangadhra," 19-25.

248. _____ , "Correct Attribution of Two So-Called Inscriptions of Nasiru'd-Din Mahmud Shah II of Bengal," 26-35.

249. _____ , "The So-Called Chunakhali Inscription of Nasiru'd-Din Mahmud Shah of Bengal," 36-43.

250. S.S. Hussain, "Two New Inscriptions of the Mughal Period from Ranthanbhor in Rajasthan," 44-51.

251. A.A. Kadiri, "Inscriptions from the Tomb of Sadr-i-Jahan at Pihani," 52-57.

252. Z.A. Desai and S.S. Hussain, "Two New Qutb Shahi Inscriptions from Golconda," 58-62.

1974

253. Z.A. Desai , "Inscriptions of the Sultans of Gujarat," 1-57.

254. _____ , "An Inscription Dated A.H. 969 from Patan (Gujarat)," 58-61.

1975

255. Z.A. Desai , "An Early Thirteenth Century Epitaph from Delhi," 1-5.

256. _____ , "An Early Thirteenth Century Inscription from West Bengal," 6-12.

257. _____ , "A Persian-Sanskrit Inscription of Karna Deva Vaghela of Gujarat," 13-20.

258. _____ , "Inscription from the Jaunpur Fort Mosque," 21-25.

259. _____ , "Dohad Inscription of Mahmud Begda," 26-30.

260. S.S. Hussain, "Some More New Inscriptions of Husain Shah from West Bengal," 31-38.

261. N.M. Ganam, "A New Epigraph of Malik Qutb-u'l-Mulk from Andhra Pradesh," 39-43.

262. M.I. Quddusi, "Some Mughal Inscriptions from Kannauj," 44-55.

263. M.Y. Quddusi, "Nawwabs of Ellichpur and their Inscriptions," 56-69.

APPENDIX II:

Arabic and *Persian* Texts of the Inscriptions

1. بسم الله الرحمن الرحيم
صلى الله على النبي محمد و آله ... [2:255]

2. (upper band)
... بما القائم بحجم..له الا اله...(؟)

(lower band)
...الا..لاة الله الا...(؟)

3. (1) أُدْخُلُوهَا بِسَلَمٍ أَمِنِينَ○ السلطان المعظم شاهنشاه
الاعظم مالك رقاب الامم شمس الدنيا و الدين غياث الاسلام

(2) و المسلمين اعدل الملوك و السلاطين ابو المظفر
ايلتمش السلطاني ناصر امير المومنين خلد الله ملكه في
شهور سنة عشرين و ستمائة

4. (1) بنى هذا الدرب المتين لحصن الحصين في عهد
سلطنة السلطان المعظم مالك رقاب الامم ...

(2) ذي الامان لاهل الايمان وارث ملك سليمان صاحب
التاج و الخاتم في ملك [العالم] ...

5. (left vertical band)
بسم الله الرحمن الرحيم
إِنَّمَا يَعْمُرُ مَسَجِدَ اللهِ مَنْ أَمَنَ بِاللهِ وَالْيَوْمِ الْأَخِرِ ...

(middle vertical band)
بسم الله الرحمن الرحيم
الرَّحْمَنُ○ عَلَّمَ الْقُرْآنَ○ خَلَقَ الْإِنْسَانَ○ عَلَّمَهُ الْبَيَانَ○
الشَّمْسُ وَالْقَمَرُ بِحُسْبَانٍ○ ...

(rectangular frame around arch)
...[وَ سَبِّحُوهُ] بُكْرَةً وَ أَصِيلًا○ هُوَ الَّذِي يُصَلِّي عَلَيْكُمْ وَ
مَلَئِكَتُهُ لِيُخْرِجَكُمْ مِنَ الظُّلُمَتِ إِلَى النُّورِ وَ كَانَ بِالْمُؤْمِنِينَ
رَحِيمًا○ تَحِيَّتُهُمْ يَوْمَ يَلْقَوْنَهُ سَلَمٌ وَ أَعَدَّ لَهُمْ أَجْرًا كَرِيمًا○

(horizontal panel above arch)
لا اله الا الله محمد رسول الله

(left side of pointed arch)
...[وَ الْمَلَئِكَةُ] وَ أُولُوا الْعِلْمِ قَائِمًا بِالْقِسْطِ لَا إِلَهَ الَّا هُوَ الْعَزِيزُ
الْحَكِيمُ○

6. (border)
شهد الله انه لا اله الا هو و الملئكة و اولوا العلم قائما
بالقسط لا اله الا هو العزيز الحكيم○ ان الدين عند الله
الاسلام○ و ما اختلف الذين اوتوا الكتب الا من بعد ما
جاءهم العلم بغيا بينهم و من يكفر بايت الله فان الله سريع الحساب

(center)
لا اله الا الله محمد رسول الله
هذا قبر العبد الغريب الراجي الى رحمة الله تعالى شيخ
المشايخ ارجن بن دمو الاخسي نور الله قبره بسعة مغفرته
قد توفي يوم الاثنين المنتصف من شهر رجب الاصم سنة
ثلث و ثلثين و ستمائة كاتبه ابوبكر بن محمود اسماعيل الجوهري

7. (1) امر ببنا هذه العمارة في ايام مملكة المجلس العالي
خان الاعظم خاقان...

(2) عز الحق و الدين غياث الاسلام و المسلمين مغيث الملوك
و السلاطين ابي الفتح طغرل

(3) السلطاني خلد الله ملكه العبد مبارك الغازي تقبل الله
منه في المحرم سنة اربعين و ستمائة

8. (1) امر ببنا هذه البقعة المباركة السلطان المعظم شمس
الدنيا و الدين ابي المظفر ايلتمش السلطان يمين
خليفة الله ناصر امير المومنين انار الله برهانه و نقل
بالحسنات صنيعة نه جدد العمارة في ايام دولت السلطان
الاعظم

(2) ناصر الدنيا و الدين ابي المظفر محمود شاه بن السلطان
ناصر امير المومنين خلد الله ملكه و سلطانه في نوبة
ايالت الملك المعظم جلال الحق و الدين ملك
ملوك الشرق مسعود شاه جاني برهان امير المومنين
خلد الله دولته في غرة محرم سنة سبع و اربعين و ستمائة

9. (border)
شهد الله انه لا اله الا هو و الملئكة و اولوا العلم قائما
بالقسط لا اله الا هو العزيز الحكيم○ ان الدين عند الله
[الاسلام] و ما اختلف الذين اوتوا الكتب الا من بعد ما
جاءهم العلم بغيا بينهم و من يكفر بايت الله فان الله سريع الحساب

(vertical panels)
(1) دل ماست
...مكان و لا مكان منزل ماست
موالید فلك
............... جملكی حامل ماست

(2) ما بهر نظام کاینات آمده ایم
با ذات قدیم در صفات آمده ایم
نور همه نور سایه سایه ماست
تو سایه مبین که ما بذات آمده ایم

(central rectangular panels)
(1) مقصد جان رو نمود جان بمیان کوبماش
دل چو همه حال کشت قال لسان کوبماش

(2) ای مدد صوت و حرف کشف شد اسرار غیب
کام و زبان کو بریز شرح و بیان کوبماش

(3) از صدف تن چو یافت جان کهر سرعشق
در همه جا از صدف نام و نشان کوبماش

(4) چون لب جان نوش کرد جرعة جام بقا
منزل دار فنا در ره جان کوبماش

(5) از سقر و جنتست خوف و امان همه
ما چو از ان فارغیم خوف و امان کوبماش

(6) مایه سود و زیان دنیا و عقباه تست
هر دو چو در باختی سود و زیان کوبماش

(7) روح چو از باغ عشق نو بر وحدت کرفت
ابر یقین کوبماد کشت کمان کوبماش

(8) چون که فرود آمدیم در حرم کبریا
شهپر روح الامین جلوه کنان کوبماش

(9) جمله صحرا و کوه نور تجلی کرفت
ما بتجلی خوشیم حور و جنان کوبماش

(10) زبده هر دو جهان کمل(؟) حیات همست
تنک در آغوش ماست هر دو جهان کوبماش



(11) ذات تو سالاريا روح مكانست و كون
دور و زمان كو مكرد كون و مكان كومباس

هذا قبر الصدر الكبير المرحوم سلطان المعتقين
زين الملة و الحق و الدين على بن سالار بن على اليزدى
توفى يوم الاحد الثالث عشرين ذوالحجه سنة خمسة و
ثمانين و سبعمايه

10. (border)

شهد الله انه لا اله الا هو و الملئكة و اولوا العلم قائما
بالقسط لا اله الا هو العزيز الحكيم ان الدين عند الله
الاسلام و ما اختلف الذين اوتوا الكتاب الا من بعد ما جاءهم
العلم بغيا بينهم و من يكفر بايت الله فان الله سريع الحساب

(center)

لا اله الا الله محمد رسول الله

كل نفس ذائقة الموت ...

هذا قبر العبد الضعيف المحتاج الى رحمة الله
تعالى شهاب الدين احمد ابن محمد ابن يحيى
الحاكم بكنبايه تغمده الله بغفرانه توفى
يوم الاربعا الخامس من شهر الله الاصب رجب
سنة ثمان و ثمنين و سبعمايه

11. الحمد لربى الحمد — بنيت هذه المدرسة المسماة
دار الخيرات في عهد سلطانة والى العبرة صاحب التاج
و الخاتم ظل الله في العالم الاكرم الاكرم العظم مالك
رقاب الامم شمس الدنيا و الدين المخصوص بعناية رب
العالمين وارث ملك سليمان ابى المظفر فيروز شاه
السلطان خلد الله سلطانه ...

12. (top of arch)

هو الله الذى لا اله الا هو علم الغيب و الشهادة و ماده الرحمن
الرحيم هو الله الذى لا اله الا هو الملك القدوس السلم
المؤمن المهيمن العزيز [الجبار المتكبر...]

(outer vertical, upper horizontal band)

الله لا اله الا هو الحى القيوم لا تأخذه سنة و لا نوم
له ما فى السموات و ما فى الارض من ذا الذى يشفع عنده
الا باذنه يعلم ما بين ايديهم و ما خلفهم و لا يحيطون بشى
من علمه الا بما شاء وسع كرسيه السموات و الارض و لا
يؤده حفظهما و هو العلى العظيم لا اكراه فى الدين
قد تبين الرشد من الغى فمن يكفر بالطاغوت و يؤمن بالله
فقد استمسك بالعروة الوثقى لا انفصام لها و الله سميع عليم
صرف الله

Middle column

(inner vertical band)

شهد الله انه لا اله الا هو و الملئكة و اولوا العلم قائما
بالقسط لا اله الا هو العزيز الحكيم ان الدين عند الله
الاسلام و ما اختلف الذين اوتوا الكتاب الا من بعد ما جاءهم
العلم بغيا بينهم و من يكفر بايت الله فان الله سريع الحساب
صدق الله العظيم و صدق رسوله

(center)

(1) لا اله الا الله محمد رسول الله

(2) بسم الله الرحمن الرحيم

(3-4) يبشرهم ربهم برحمة منه و رضوان و جنت لهم
فيها نعيم مقيم خلدين فيها ابدا ان الله عنده
اجر عظيم

(5) و قل رب انزلنى منزلا مباركا و انت خير المنزلين

(6-10) هذا القبر للامير الكبير المرحوم المغفر السعيد
الشهيد اختيار الدولة و الدين بجر بك معمورة كهنبايت
يشتهر اللئالى برد الله مضجعه و آنس مراقد مرحشته قد توفى
ليلة الثلثا سابع عشر من شهر جمادى الاخر سنه سادس
عشر و سبعمايه و صلى الله على خير خلقه محمد و آله

13. (1) بنا نمازكه متبركه در عهد دولت و نوبت مملكت سلطان
السلاطين فرمان رواى روى زمين ظل الله فى العالمين
سكندر الثانى ذو القرنين الزمان قطب الدنيا و الدين ابو
المظفر مبارك شاه السلطان ابن السلطان قسيم امير
المومنين خلد الله ملكه و سلطانه و اعلى امره و شانه كى
هواره در قواعد بادشاهى و انتظام امور شاهنشاهى سالها
ناتناهى باد و [] اولياى دولت منصور

(2) و اعداء حضرت مقهور بالنبى الامى و آله اجمعين
الطاهرين بانى اين مقام متبركه ملك الامرا تاج الدولة
و الدين پهلو زمان صفدر كيهان هوشنگ محمود محمد عمد
كابلى المعروف بالكرگ ادام الله تمكنه در غزاء [كا]
فران و نعمت سرمدى و باقى و پاينده داراد و
معمار و كار فرماى اين مقام متبرك بنده كتر نصرت رستم
محمود الغورى و كاتبه محمد لاجين القشرى الشمس الخامس
من المحرم سنة ثمان عشر و سبعمايه

14. (1) بسم الله الرحمن الرحيم
و ان المساجد لله فلا تدعوا مع الله احدا

و قال عليه السلام من بنا مسجدا لله و لو كمفحص قطاة
بنى الله له بيتا فى الجنة هذا ما وفق الله و اعاد بنى
هذا المسجد الجامع المبارك



(2) و عمارته بجميعه و كله من خالص ماله مما آتيه الله
من فضله و كرمه خالصا لله تعالى فى عهد السلطان
العالم العادل محمد شاه بن تغلقشاه السلطان خلد الله
ملكه و سلطانه العبد الضعيف الراجى الى رحمة الله
تعالى دولتشه محمد البوتهارى حصل الله مرامه و ذلك
فى الثامن عشر من المحرم سنه خمس و عشرين و سبعمايه

15. (outer border)

يس و القرآن الحكيم انك لمن المرسلين
على صراط مستقيم تنزيل العزيز الرحيم لتنذر
قوما ما انذر اباؤهم فهم غفلون لقد حق القول
على اكثرهم فهم لا يؤمنون انا جعلنا فى اعناقهم اغلل
فهى الى الاذقان فهم مقمحون و جعلنا من بين
ايديهم سدا و من خلفهم سدا فاغشينهم فهم لا
يبصرون و سواء عليهم أأنذرتهم ام لم تنذرهم لا
يؤمنون انما تنذر من اتبع الذكر و خشى الرحمن
بالغيب فبشره بمغفرة و اجر كريم انا نحن نحى
الموتى و نكتب ما قدموا و آثارهم و كل شى احصينه
فى امام مبين و اضرب لهم مثلا اصحب القرية
اذ جاءها المرسلون اذ ارسلنا اليهم اثنين فكذبوهما
فعززنا بثالث فقالوا انا اليكم مرسلون

(arch center)

اشهد ان لا اله الا الله وحده لا شريك له و اشهد
ان محمدا عبده و رسوله

(border around arch)

الله لا اله الا هو الحى القيوم لا تأخذه سنة و لا نوم
له ما فى السموات و ما فى الارض من ذا الذى يشفع عنده
الا باذنه يعلم ما بين ايديهم و ما خلفهم و لا يحيطون
بشى من علمه الا بما شاء وسع كرسيه السموات و الارض
و لا يؤده حفظهما و هو العلى العظيم

(bottom border of arch)

... هذا ما وعد الرحمن و صدق المرسلون
انا لله و انا اليه راجعون

(wide horizontal band)

بسم الله الرحمن الرحيم

(lower panel, vertical bands)

شهد الله انه لا اله الا هو و الملئكة و اولوا العلم قائما



بالقسط لَا إِلٰهَ إِلَّا هُوَ الْعَزِيزُ الْحَكِيمُ ۞ إِنَّ الدِّينَ عِنْدَ اللّٰهِ
الْإِسْلَامُ وَمَا اخْتَلَفَ الَّذِينَ أُوتُوا الْكِتَابَ إِلَّا مِنْ بَعْدِ مَا جَاءَ
هُمُ الْعِلْمُ بَغْيًا بَيْنَهُمْ وَ مَنْ يَكْفُرْ بِآيَاتِ اللّٰهِ فَإِنَّ اللّٰهَ سَرِيعُ الْحِسَابِ

(lower panel, horizontal bands)

وَلَا تَحْسَبَنَّ الَّذِينَ قُتِلُوا فِي سَبِيلِ اللّٰهِ أَمْوَاتًا بَلْ أَحْيَاءٌ
عِنْدَ رَبِّهِمْ يُرْزَقُونَ ۞ فَرِحِينَ بِمَا آتَاهُمُ اللّٰهُ مِنْ فَضْلِهِ
وَيَسْتَبْشِرُونَ بِالَّذِينَ لَمْ يَلْحَقُوا بِهِمْ مِنْ خَلْفِهِمْ أَلَّا خَوْفٌ
عَلَيْهِمْ وَلَا هُمْ يَحْزَنُونَ ۞ يَسْتَبْشِرُونَ بِنِعْمَةٍ مِنَ اللّٰهِ وَفَضْلٍ
وَأَنَّ اللّٰهَ لَا يُضِيعُ أَجْرَ الْمُؤْمِنِينَ ۞ هذا قبر العبد
الضعيف السعيد الشهيد المرحوم المغفور ملك ملوك
الشرق و الوزرا مشهور العرب و العجم زكى الدولة
و الدين عمر ابن احمد الكازرونى المخاطب ملك پرويز تغمده
تعالى بالرحمة و الغفران واسكنه فى دار الجنان
المتوفى الى رحمة الله تعالى فى يوم الاربعا التاسع من صفر
سنة اربع و ثلاثين و سبعماية

16.

(1) مجدد گشت اين ميمون عمارت
بعهد پادشاه عدل پرور

(2) شينشاه جهان فيروز شاه آنك
ازو آباد شد محراب و منبر

(3) بسمى و التماس بنت خاص
پريد خطه اندر دور داور

(4) ملك سيرت ملك كافى كفايت
فهيم نامور در هفت كشور

(5) گذشته هفصد از تاريخ هجرت
فزوده بود يك بر شست ديگر

(6) هميشه باد شه برتخت دولت
چو نام خويش فيروز و مظفر

17.

(1) [فى] روز شه كبنى مدار
الله

(2) وقت خانزاده سليمان الغ داود خان
افتخار اهل سيف و نمر هيجا اختيار

(3) [ا] ز براى كردگار

Column 2 (center)

الله
(4) رفته از تاريخ هجرت هفمد و پاشست وهفت
الله
باز از ماه محرم سى شمر ديكر شمار

18.

(1) بعهد همايون فيروز شاه
كه از فضل .حق باد دايم بكام

(2) ظفر خان اعظم بتوفيق حق
ز بهر عبادت بكرد اين مقام

(3) سنه اثنى و سبعين و سبعمايه
شد اين مسجد جنت آسا تمام

(left border)

كتب العبد عثمان كمال خطاط غفر الله له و لجميع
المسلمين و بكار فرمائى حسام عماد

19. (small upper band)

بِسْمِ اللّٰهِ الرَّحْمٰنِ الرَّحِيمِ ۞ الْحَمْدُ لِلّٰهِ رَبِّ الْعَالَمِينَ ۞
الرَّحْمٰنِ الرَّحِيمِ ۞ مَالِكِ يَوْمِ الدِّينِ ۞ إِيَّاكَ نَعْبُدُ وَإِيَّاكَ
نَسْتَعِينُ ۞ اهْدِنَا الصِّرَاطَ الْمُسْتَقِيمَ ۞ صِرَاطَ الَّذِينَ
أَنْعَمْتَ عَلَيْهِمْ غَيْرِ الْمَغْضُوبِ عَلَيْهِمْ وَلَا الضَّالِّينَ ۞

(main band)

قَالَ اللّٰهُ تَعَالَى —

إِنَّمَا يَعْمُرُ مَسَاجِدَ اللّٰهِ مَنْ آمَنَ بِاللّٰهِ وَالْيَوْمِ الْآخِرِ وَأَقَامَ
الصَّلَاةَ وَآتَى الزَّكَاةَ وَلَمْ يَخْشَ إِلَّا اللّٰهَ فَعَسَى أُولَٰئِكَ أَنْ
يَكُونُوا مِنَ الْمُهْتَدِينَ ۞ أَجَعَلْتُمْ سِقَايَةَ الْحَاجِّ وَعِمَارَةَ
الْمَسْجِدِ الْحَرَامِ كَمَنْ آمَنَ بِاللّٰهِ وَالْيَوْمِ الْآخِرِ وَجَاهَدَ فِي
سَبِيلِ اللّٰهِ لَا يَسْتَوُونَ عِنْدَ اللّٰهِ وَاللّٰهُ لَا يَهْدِي الْقَوْمَ
الظَّالِمِينَ ۞

20. (upper border)

يَا اللّٰهُ يَا اللّٰهُ يَا اللّٰهُ

قَالَ اللّٰهُ تَعَالَى —

إِنَّمَا يَعْمُرُ مَسَاجِدَ اللّٰهِ مَنْ آمَنَ بِاللّٰهِ وَالْيَوْمِ الْآخِرِ وَأَقَامَ
الصَّلَاةَ وَآتَى الزَّكَاةَ وَلَمْ يَخْشَ إِلَّا اللّٰهَ فَعَسَى أُولَٰئِكَ
[أَنْ يَكُونُوا مِنَ] الْمُهْتَدِينَ ۞

(center)

قَالَ اللّٰهُ تَعَالَى —

وَأَنَّ الْمَسَاجِدَ لِلّٰهِ فَلَا تَدْعُوا مَعَ اللّٰهِ أَحَدًا ۞

(side borders)

قال عليه السلام الدنيا ساعة فاجعلها طاعة
قال عليه السلام الدنيا داحة ليس فيها راحة



(lower border)

قال عليه السلام من بنى لله مسجدا بنى الله له فى
الجنة قصرا بنى كرد اين مسجد رحمت اتقى القضاة
صاحب الخير و الحسنات قاضى جلال قطب باسم سيد
السادات شيخ المشايخ قطب الاولياء جلال الحق و
الشرع و الدين در عهد سلطان الاعظم المعظم مالك
الجود و الكرم الواثق بتائيد الرحمن ابو المظفر فيروز
شاه سلطان خلد ملكه بتاريخ شهور سنه اربع و
ثمانين و سبعمايه كتب شيخ عمر ابن آدم

21.

(1) در عهد پادشاه جهانگير جم نشان
برهان روزكار براهيم در جهان

(2) نو كرد قطب احمد عارض بنا يقين
تاريخ سال هيمد بر و هفت در بيان

22. (1) بنى هذا البناء الرفيع والمسجد الوسيع العبد الراجى و
إلى ثنائى الملتجى إلى رحمة الله المنان غير مدعواه معه احد
ابدا لقوله تعالى وَأَنَّ الْمَسَاجِدَ لِلّٰهِ فَلَا تَدْعُوا مَعَ اللّٰهِ أَحَدًا ۞

(2) الواثق بالله المستعين ناصر الدنيا و الدين ابوالفتح احمد
شاه بن محمد شاه بن مظفر السلطان و كان تاريخ بنائه من
هجرة النبى صلى الله عليه و سلم الغره من صفر ختم الله
بالخير و الظفر سنه سبع و عشرين و ثمانماية

23. (main panel)

ايا سلطان علاء الدين دلت شاد

(vertical band)

مبارك باد اين ابن فرخنده بنياد

24. قال النبى عليه السلام من بنى مسجدا فى الدنيا بنى الله له
قصرا فى الجنة بنى ملك العادل محمود شاه السلطان بنا كرده
اين مسجد خانمعظم خرشيد خان سر نوبت غير محليان فى
العاشر من جمادى الاول سنه خمسين و ثمانماية

25. (right panel)

بِسْمِ اللّٰهِ الرَّحْمٰنِ الرَّحِيمِ قَالَ اللّٰهُ تَعَالَى —
[جَنَّاتُ عَدْنٍ يَدْخُلُونَهَا ...] [13.23-24]

(left panel)

[سَلَامٌ عَلَيْكُمْ بِمَا صَبَرْتُمْ فَنِعْمَ] عُقْبَى الدَّارِ ۞
كتبه الفقير المحتاج الى الله تعالى مغيث القارى
الشيرازي

26.

بسم الله الرحمن الرحيم

(1) الحمد لله ذي الآلاء والمنن
رب تنزه عن نوم وعن وسن

(2) ثم الصلوة على المختار من مضر
خير الانام النبي السيد المدني

(3) محمد خاتم الرسل الكرام ومن
لولاه سبل الهدى والحق لم تبن

(4) وآله معدن التقوى ومحبته
الطائعي لله في سر وفي علن

(5) وبعد اثني على جواد رحمة من
أزرى بجود السحاب الهاطل الهتن

(6) الشاه سلطان ركن الدنيا والدين
سلطاننا باربكشاه العلي الفطن

(7) ابن الذي شاع في الامصار بابه
سلطان محمود شاه العادل الحسن

(8) هل في العراقين سلطان له كرم
كباربكشاه وفي الشام واليمن

(9) كلا وما في بلاد الله قط له
في البذل مثل فهذا واحد الزمن

(10) وداره كالجنان رائق نزه
ويجلب للغنى ومذهب للشجن

(11) نهر جرى تحتها كالسلسبيل له
اجناء در قلت بالفقر والمحن

(12) وبابها راحة للروح ريحانا
لذي الحبيب وللاعداء كالدخن

(13) باب على نشيط مشرح اسمه
ميانه در وهي دخول خاص ابين [؟]

(14) احدى وسبعين والثمانمئة سنا
مبناه دار العيش والآمال والكنن

(15) فالله اساله تخليد دولته
ما غرد الطير في روض على القنن

(16) در دور سلطنت شاه جهانپناه ركن الدنيا
والدين ابو المظفر باربكشاه سلطان خلد الله
ملكه وسلطانه بناء ميانه در بسنة احدى وسبعين
وثمانمئة

27.

(1) قال الله تعالى ـ وان المساجد لله فلا تدعوا مع الله
احدا O وقال عليه السلام من بنى مسجدا في الدنيا بنى
الله له في الاخرة سبعين قصرا بنى المسجد في
عهد السلطان

(2) الزمان المويد بتاييد الديان خليفة الله بالحجة و
البرهان السلطان ابن سلطان ابن سلطان شمس الدنيا
و الدين ابو المظفر يوسف شاه السلطان ابن باربكشاه

(3) السلطان ابن محمود شاه السلطان خلد الله ملكه
و سلطانه بنى هذه المسجد المجلس المجالس مجلس معظم
و المكرم صاحب السيف و القلم بهلوى عصر و الزمان
الغ مجلس اعظم سلمه

(4) الله تعالى في الدارين مورخا في اليوم الرابع الغره
من شهر محرم سنه اثنى و ثمانين و ثمانمايه و تم
بالخير

28.

قال الله تعالى ـ
وان المساجد لله فلا تدعوا مع الله احدا O
و قال النبي صلى الله عليه و سلم من بنى مسجدا لله
بنى الله له قصرا مثله في الجنة بنى هذا المسجد
الجامع السلطان الاعظم الاعدل مالك الرقاب و الامم
السلطان بن السلطان بن السلطان شمس الدنيا و الدين
ابو المظفر يوسف شاه السلطان بن بار بكشاه السلطان بن
محمود شاه السلطان خلد الله ملكه و سلطانه و افاض على
العالمين بره و احسانه في سنة الهجريه اربع و ثمانين و
ثمان مايه

29.

قال النبي صلى الله عليه و سلم من بنى مسجدا في
الدنيا بنى الله تعالى في الجنة سبعين قصرا بنى المسجد
في زمن سلطان العادل الباذل اولاد سيد المرسلين
حسين شاه سلطان خلد الله ملكه و باني الخير مجلس
المجالس باربك مورخا[؟] في الرابع من شهر
جمادى الاخر سنة تسع تسعين و ثمانمائه

30.

بنا شد اين مسجد انور در عهد دولت خان اعظم
و خاقان معظم فيروز خا[ن] بتوفيق رحماني ددا
كيلا صلاحخاني برشه الثاني و الشر من شهر الرجب
رجب قدره سنة تسعمائة

31.

بسم الله الرحمن الرحيم قال الله تبارك و تعالى
وان المساجد لله فلا تدعوا مع الله احدا O
وقال النبي صلى الله عليه و سلم من بنا لله مسجدا و لو
كمفحص قطاة بنا الله له مثله في الجنة وقال النبي صلى الله عليه
و سلم من حفر كبد [بئرا؟] لم يشرب ما منه حرى من جن
و لا الانس ولا طاير حره الله يوم القيمة در عهد شهنشاه اعظم
الواثق بتائيد الرحمن ناصر الدنيا و الدين ابو ال(ا)لفتح محمود
شاه بن محمد شاه بن احمد شاه بن محمد شاه بن مظفر شاه
السلطان بنا كرده اين مسجد و باثين در شهر مكرم محماباد
عرف چانانير بنده مكرم ربانى(؟) حضرت ربانى(؟) ملك صندل ابن عود
سلطانى سنه خمس و تسعمائه

32.

(north end)

الموت جسر يوصل الحبيب الى الحبيب من مات فقد
قامت قيامته

(east side)

(1) قال سيد العرب و العجم صلى الله عليه و على آله
و سلم المؤمن حي في الدارين و قال عليه الصلوة و
السلام المؤمنون لايموتون بل ينتقلون من دار الى دار
و قال

(2) و قال عليه السلام و ونجبة و الاكرام من كان
آخر كلامه لا اله الا الله دخل الجنة و قال صلى الله
عليه و آله و لاحرمنا من جزيل نواله السخي قريب
من الله قريب من الجنة بعيد من النار

(south end)

له ملك ينادى كل يوم
لدوا للموت و ابنوا للخراب

(west side)

(1) قد اجاب وصى ربه و رضى بحبه من دار المحنة
و الغرور الى دار البهجة و السرور شهيد ذايقا الشهادة
نائلا درجة الشهيد الامير الكبير الكريم الذى قل بنمله
تبج الادوار ما دار الفلك الدوار من حاز كل قصبة
السبق في الجرى في مضمار الوجود

(2) وحيد الدهر و ناقد البرايا فريد العصر في بذل
العطايا الفايز برحمة الله الملك الوالى الولى [الا]مير
الاعظم المعظم شجاع الملة و الدولة و الدنيا [و]
الدين يار ع اسكنه الله تعالى في فراديس جنانه و افاض

علیه شایب رحمته و رضوانه فی الثامن و العشرین
من شهر ذی قعده سنه تسع و تسعمایه

33. (border)

در زمان بادشاه عادل سلطان محمود شاه بهمنی خلد
الله تعالی ملکه و سلطانه و در آوان وزارت و حکومت
عادلخان غازی خلد ایام دولته و بانبارت ملک سکندر
حیدری تهاندار ادام دولته تعمیر ابن حوض واقع شد

(center panel)

(1) اگر تو تاریخ حوض و عامراو
خواهی از بن طلب بوجه نکو

(2) باب حوضی بناله تاریخش
ملک اسکندر ست عامر او

34. (top arch)

لا اله الا الله محمد رسول الله علی ولی الله

(horizontal bands)

بنی هذا المقام الرفیع المسمی ببرج الفتح فی عهد
خلافة السلطان الاعظم شمس الدنیا و الدین محمود شاه
البهمنی و وزارة الخان الاکرم مجلس الرفیع عادل خان
بن العادلخان الغازی و حکومة الملک المکرم
نظام الدین احمد الکرمانی فی شهور سنه ست عشر
و تسعمایة

(cartouche, bottom left)

کتبه حسین بن یوسف الیزدی

35. (outer band)

بِسْمِ اللهِ الرَّحْمٰنِ الرَّحِيمِ
وَالشَّمْسِ وَضُحٰهَا ۰ وَالْقَمَرِ اِذَا تَلٰهَا ۰ وَالنَّهَارِ
اِذَا جَلّٰهَا ۰ وَالَّيْلِ اِذَا يَغْشٰهَا ۰ وَالسَّمَآءِ وَمَا
بَنٰهَا ۰ وَالْاَرْضِ وَمَا طَحٰهَا ۰ وَنَفْسٍ وَمَا سَوّٰهَا ۰
فَاَلْهَمَهَا فُجُورَهَا وَتَقْوٰهَا ۰ قَدْ اَفْلَحَ مَنْ زَكّٰهَا ۰
وَقَدْ خَابَ مَنْ دَسّٰهَا ۰ كَذَّبَتْ ثَمُودُ بِطَغْوٰهَا ۰
اِذِ انْبَعَثَ اَشْقٰهَا ۰ فَقَالَ لَهُمْ رَسُولُ اللهِ نَاقَةَ اللهِ وَ
سُقْيٰهَا ۰ فَكَذَّبُوهُ فَعَقَرُوهَا فَدَمْدَمَ عَلَيْهِمْ رَبُّهُمْ بِذَ
نْبِهِمْ فَسَوّٰهَا ۰ وَلَا يَخَافُ عُقْبٰهَا ۰

(inner band)

بِسْمِ اللهِ الرَّحْمٰنِ الرَّحِيمِ لا اله الاالاه محمد رسول الله
فی عهد الدولت نصیر الملت و المسلمین قاطع اهل (؟)
البدعه و محیی السنت المزید من السماء المظفر من

36. الملک لله

37. بسم الله الذی جعل کلمة توحیده حصنا حصینا و اصابنا
فتح ابوابه بالرحمة فمن دخله کان آمنا و الصلاة علی
المصطفی الذی تمت به حصون النبوة و شعابها و هو
مدینة العلم و علی با بها و علی آله التی ارتفعت بهم
برج الولایة و الامامة و اصحابه الخازنین لخصال الصدق
و السلامة و بعد فهذا درب الدرایة من حصون السعادة قد بنی
فی ایام خلافة اعظم السلاطین و اکرم الخواقین فرمان
الماء و الطین فاتح ابواب البرکة علی العالمین رافع
بناء شریعة سید المرسلین معمار الدولة و الدین ظل الله
فی الارضین سمی خلیل الله اعظم همایون قطب شاه
لازال حصون درلته محفوظة عن التنزل و برج خلافته مصطونة
عن آثار رصمة التغیر و التبدل بمساعی جمهاه رکن درلته
القاهره او عماد سلطنته الباهره جامع الکتب و مفرق
الکتایب الذی یزل حبا و نسبا الی مظاهر العجایب
المسمی فی الدین بکمال الدین حسین و المخاطب لعار
الشان بمصطفی خان شکر الله مساعیه و بسر دراعیه فی
شهور سنه ۹۲۷ ۰ کتبه محمد اصفهانی

38. لله

(1) بدران سلطان عالم پناه
سزاوار تخت و نگین قطب شاه

(2) زهجرت دربن کاخ زنگار ابن
ز نصف به هفتاد چون شد فزون

(3) ملک نائب ان صاحب و رو شان
پسندیده شاه رفعت مکان

(4) بنا کرد این مسجد با صفا
پی طاعت بنده کان خدا

(5) آبی برد تا جهان برقرار
برد عمر و هم درلتش پائدار

39. (1) در زمان ولی والی عهد
شاه اکبر شه بعق موصول

(2) خان مقبول دل حسین قلی
که نبا شد چو او و بحسن قبول

(3) مسجدی همچو کعبه کرد بنا
که بود قبله فروع و اصول

(4) منزل جمله پاک دینانت
همه پا کان در و کنند نزول

(5) جست تاریخ او وصالی گفت
بیت کل تقی حدیث رسول

مشقه العبد المذنب الراجی درویش محمد الحاجی
المشتهر بالترمزی

40. (1) فی زمان السلطان العادل جلال الدین محمد
اکبر بادشاه غازی

(2) زبن عمارة الشمسی و الحدیقة میرزا محمد ابن شاه ولی
حرره حسین خان سنه ۹۸۱

41. (vertical panel)

بِسْمِ اللهِ الرَّحْمٰنِ الرَّحِيمِ ۰
وَسِيقَ الَّذِينَ اتَّقَوْا رَبَّهُمْ [اِلَى الْجَنَّةِ زُمَرًا] ۰۰۰

(bottom cartouche)

کتب هذه الکتابة حسین ابن احمد الچشتی

42. (border)

لا اله الا الله محمد رسول الله علی ولی الله اللهم صل
علی محمد المصطفی و علی المرتضی و الحسن و الحسین
و العباد و الباقر و الصادق و الکاظم و موسی الرضا و
محمد النقی و علی النقی و العسکری و المهدی

(center panel)

بِسْمِ اللهِ الرَّحْمٰنِ الرَّحِيمِ ۰
وَاَنَّ الْمَسٰجِدَ لِلّٰهِ ۰ فَلَا تَدْعُوا مَعَ اللهِ اَحَدًا ۰
اِنَّا اَنْزَلْنٰهُ فِي لَيْلَةِ الْقَدْرِ ۰ وَمَا اَدْرٰكَ مَا لَيْلَةُ الْقَدْرِ ۰
لَيْلَةُ الْقَدْرِ خَيْرٌ مِنْ اَلْفِ شَهْرٍ ۰ تَنَزَّلُ الْمَلٰئِكَةُ وَالرُّوحُ
فِيهَا بِاِذْنِ رَبِّهِمْ مِنْ كُلِّ اَمْرٍ ۰ سَلٰمٌ هِيَ حَتّٰى مَطْلَعِ
الْفَجْرِ ۰ كُلُّ مَنْ عَلَيْهَا فَانٍ ۰ وَيَبْقٰى وَجْهُ رَبِّكَ
ذُو الْجَلٰلِ وَالْاِكْرَامِ ۰

(bottom)

در زمان دولت شاه عالمپناه جمجاه علی عادلشاه سنه ۹۸۵

من شهر جمادی الثانی]

الاعداء اسلیم شاه سلطان خلد الله ملکه و سلطانه و اعلا
امر و شانه سنه اثنی و خمسین و تسعمائة السابع
[من شهر جمادی الثانی]

43. (border)

اَللّٰهُ لَاۤ اِلٰهَ اِلَّا هُوَ الْحَىُّ الْقَيُّوْمُ لَا تَأْخُذُهٗ سِنَةٌ وَّلَا نَوْمٌ
لَهٗ مَا فِى السَّمٰوٰتِ وَمَا فِى الْاَرْضِ مَنْ ذَا الَّذِىْ يَشْفَعُ عِنْدَهٗۤ
اِلَّا بِاِذْنِهٖ يَعْلَمُ مَا بَيْنَ اَيْدِيْهِمْ وَمَا خَلْفَهُمْ وَلَا يُحِيْطُوْنَ
بِشَىْءٍ مِّنْ عِلْمِهٖۤ اِلَّا بِمَا شَاۤءَ وَسِعَ كُرْسِيُّهُ السَّمٰوٰتِ وَالْاَرْضَ
وَلَا يَـُٔوْدُهٗ حِفْظُهُمَا وَهُوَ الْعَلِىُّ الْعَظِيْمُ ۞

(horizontal bands)

(1) بدوران جلال الدين محمد اكبر غازى
كه عالم را مسخر كرد اقبال خدادادش

(2) شه پاكيزه سيرت شاه فخر الدين كه پيوسته
جهانى را باحسان بنده دارد طبع آزادش

(3) پى آسايش مردم سرائى ساخت زينگونه
كه خواند آسمان از محكميها حصن فولادش

(4) چو در وقت بنايش استعانت خواست از ايزد
خرد زان استعانت يافته تاريخ بنيادش ٩٨٢

(5) وگر تاريخ جونى از بے اتمام اين بقعه
بجو از بقعه خير و به بين دركار استادش ٩٨٦ ٩٨٦

44.

(1) ساعى كار خير عين الملك
ساخت مسجد بامر اكبر شاه

(2) مومنانرا ست سال تاريخش
فاسجدوا خالصا لوجه الله
سنه ٩٨٤

45. تاريخ عمارت گنبد مبارك ـ سنه اثنى تسعين تسعمائه

حبذا گنبدى عالى كه شد آسوده دراو
شاه فردوس مكان شاه على رهبر دين

سال تاريخ بتفتيش زخرد جستم و گفت
هاتف از غيب كه شد گنبد فردوس برين

46.

(1) سوى اين برج رفيع الشان بين
كه برفعت فلك مريخ است

(2) خردم از بى تاريخش گفت
برج خان نجفى تاريخ است

47. (upper panel)

(1) شيخ امير قافله حاجى حسين آنكه
بودش تمتعى زحج و عمره جاودان

(2) چون درصفا و مروه عمرش نماندسعى
رحمت كشيد جانب مقصد ورا عنان

(lower panel)

(3) سال و صالش اهل مناسك رقم زدند
بهرطواف كعبه مقصود شدبجان

48. (square panel at right)

بِسْمِ اللّٰهِ الرَّحْمٰنِ الرَّحِيْمِ

قُلْ هُوَ اللّٰهُ اَحَدٌ ۞ اَللّٰهُ الصَّمَدُ ۞ لَمْ يَلِدْ ەۙ وَلَمْ
يُوْلَدْ ۞ وَلَمْ يَكُنْ لَّهٗ كُفُوًا اَحَدٌ ۞

(rectangular panel)

شَهِدَ اللّٰهُ اَنَّهٗ لَاۤ اِلٰهَ اِلَّا هُوَ وَالْمَلٰٓئِكَةُ وَاُولُوا الْعِلْمِ قَاۤئِمًاۢ
بِالْقِسْطِ لَاۤ اِلٰهَ اِلَّا هُوَ الْعَزِيْزُ الْحَكِيْمُ فى ١٠٠٤

49.

(1) جهاندارى بشاهان شهر يارى
كه نيكبى ديده در عهدش نكوئى

(2) دل آسايش كند جان تازه گردد
زلعلش سر زند چون گفتگوئى

(3) زمين را رشك جنت كرده خلقى
گلستان ارم گرديده روئى

(4) بامر عالى خود مسجدى ساخت
كه در سقفش فلك گرديده گوئى

(5) مگر در پيش صحن او نمايد
كند هر لحظه جنت رفت روئى

(6) بنازم خوش در آنجا مى نمايد
تقاضاى مسلمانى غلوزوئى

(7) كسى پرسد اگر تاريخ ار را
زهى عالى بناى خـير گوئى

تمام گشت بسعى ملك امين الملك ـ حره بابا خان

50.

عالما عالما علاما علم علم
عالم را على الدوام عالى دار

51. (top arch)

هو الملك الحى الذى لا يموت

(cartouche border)

(1) خداوندا بذات بے مثالت
بمشتاقان خورشيد جمالت

(2) بنور طاعت خلوت نشينان
بمحراب نياز پاك دينان

(3) بايمانے كه خود كردى كرامت
ببر ما را بصحراے قيامت

(4) هدايت را رفيق راه ما كن
محمد را شفاعت خواه ما كن

(medallion in upper panel)

كُلُّ مَنْ عَلَيْهَا فَانٍ ۞ وَّيَبْقٰى وَجْهُ رَبِّكَ ذُو الْجَلٰلِ
وَالْاِكْرَامِ ۞

(lower horizontal bands)

اَللّٰهُ لَاۤ اِلٰهَ اِلَّا هُوَ الْحَىُّ الْقَيُّوْمُ لَا تَأْخُذُهٗ سِنَةٌ وَّلَا نَوْمٌ
لَهٗ مَا فِى السَّمٰوٰتِ وَمَا فِى الْاَرْضِ مَنْ ذَا الَّذِىْ يَشْفَعُ عِنْدَهٗۤ
اِلَّا بِاِذْنِهٖ يَعْلَمُ مَا بَيْنَ اَيْدِيْهِمْ وَمَا خَلْفَهُمْ وَلَا يُحِيْطُوْنَ
بِشَىْءٍ مِّنْ عِلْمِهٖۤ اِلَّا بِمَا شَاۤءَ وَسِعَ كُرْسِيُّهُ السَّمٰوٰتِ وَالْاَرْضَ
وَلَا يَـُٔوْدُهٗ حِفْظُهُمَا وَهُوَ الْعَلِىُّ الْعَظِيْمُ ۞

(small vertical bands)

كتبه المذنب خلف التبريزى

(bottom panel)

(5) ميگفت خرد بمن كه بوستان على بيك
الحق كه شهيد اكبر پاك شده سنه
١٠١٠

52.

الله اكبر

چون چرخ فلك ز گردش خود آشفت
در زير زمين آئينهٔ مه بنهفت

تاريخ وفات شاه بيكم جستم
از غيب ملك بخلد شد بيكم گفت

لكاتبه عبدالله مشكين قلم جهانگير شاهے

53.

كلك معمارقضا بنو شته بر درگاه او
هذه جنات عدن فادخلوها خالدين

(vertical colophon)

كتبه عبد الحق الشيرازى فى سنة ١٠٢٢

54.

(١) بدور عدل جهانگیر شاه اکبر شاه
که آسمان و زمین مثل او ندارد یاد

(٢) بنای نور سرا شد بخطه پهلور
بحکم نور جهان بیگم فرشته نهاد

(٣) برای سال بنایش سخنواری خوش گفت
که شد زنور جهان بیگم این سرا اباد
١٠٢٨

(٤) چوشد تمام خرد گفت بهر تاریخش
بشد زنورجهان بیگم این سرا اباد
١٠٣٠

55. (border)

قُلِ اللّٰهُمَّ مٰلِكَ الْمُلْكِ تُؤْتِی الْمُلْكَ مَنْ تَشَآءُ وَتَنْزِعُ الْمُلْكَ مِمَّنْ تَشَآءُ وَتُعِزُّ مَنْ تَشَآءُ وَتُذِلُّ مَنْ تَشَآءُ بِیَدِكَ الْخَیْرُ إِنَّكَ عَلٰی کُلِّ شَیْءٍ قَدِیْرٌ ۞ تُوْلِجُ الَّیْلَ فِی النَّهَارِ وَتُوْلِجُ النَّهَارَ فِی الَّیْلِ وَتُخْرِجُ الْحَیَّ مِنَ الْمَیِّتِ وَتُخْرِجُ الْمَیِّتَ مِنَ الْحَیِّ وَتَرْزُقُ مَنْ تَشَآءُ بِغَیْرِ حِسَابٍ ۞

(center)

اللّٰه کافی
بسم الله الرحمن الرحیم

(١) ز فضل ذو الجلال شد عمارت این کمال
بحرمت محمد منور است جمال

(٢) در عهد شهسوار ابراهیم عادل
بنا کردند عبد المحمد امیر عامل

(٣) مزین کشت تسم بجراباها تمام
با نوق کشک نور علی نور مقام

(٤) ترقی یافت این عمارت زین سعادت
رو بطرف باب الفتح با جنوب علامت

(٥) فرخست بتاریخ سال از هجرت
بمرتبه یکهزار اثنی ثلثین عزت

56. (top cartouches)

عجلوا با لصلوة قبل الفوت
عجلوا بالتوبت قبل الموت

(rectangular arch frame)

اللهم صل علی محمد المصطفی و علی المرتضی و البتول فاطمه و السبطین الحسن و الحسین و صل علی زین العباد و علی الباقر محمد و الصادق جعفر و

الکاظم موسی و الرضا علی و التقی محمد و النقی علی و الزکی العسکری حسن و صل علی الحجة القائمة الخلف الصالح الامام الهمام و المنتظر المظفر المهدی محمد صاحب الزمان و قاطع البرهان و خلیفة الرحمن و سید الانس و الجان صلوات الله و سلام لمسجد مبارک و حاجی حسینی – کتبه العبد میر علی فی ١٠٤٥

57. (right cartouches)

(١) بهر تاریخش از کلم خدای
(٢) کشت ملهم خرد باین آیه

(center cartouche)

(٣) وَأَنَّ الْمَسٰجِدَ لِلّٰهِ فَلَا تَدْعُوْا مَعَ اللّٰهِ أَحَدًا ۞
١٠٤٢

(left cartouches)

(٤) شاه گیتی پناه عبد الله
(٥) مسجدی ساخت آسمان پایه

کتبه لطف الله الحسیفی التبریزی سنه ١٠٤٣

58. (rectangular arch frame)

قال الله تبارک و تعالی –

یٰاَیُّهَا الَّذِیْنَ اٰمَنُوْا إِذَا نُوْدِیَ لِلصَّلٰوةِ مِنْ یَّوْمِ الْجُمُعَةِ فَاسْعَوْا إِلٰی ذِکْرِ اللّٰهِ وَذَرُوا الْبَیْعَ ذٰلِکُمْ خَیْرٌ لَّکُمْ إِنْ کُنْتُمْ تَعْلَمُوْنَ ۞ فَإِذَا قُضِیَتِ الصَّلٰوةُ فَانْتَشِرُوْا فِی الْأَرْضِ وَابْتَغُوْا مِنْ فَضْلِ اللّٰهِ وَاذْکُرُوا اللّٰهَ کَثِیْرًا لَّعَلَّکُمْ تُفْلِحُوْنَ ۞ وَإِذَا رَاَوْا تِجَارَةً أَوْ لَهْوًا انْفَضُّوْا إِلَیْهَا وَتَرَکُوْكَ قَآئِمًا قُلْ مَا عِنْدَ اللّٰهِ خَیْرٌ مِّنَ اللَّهْوِ وَمِنَ التِّجَارَةِ وَاللّٰهُ خَیْرُ الرّٰزِقِیْنَ ۞ صدق الله العظیم و صدق رسوله النبی الکریم نحن علی ذلک من الشاهدین و الحمد لله رب العالمین –

کتبه عبد الحق المخاطب بامانت خان - سنة ١٠٤٥

(horizontal panel above arch)

لَقَدْ صَدَقَ اللّٰهُ رَسُوْلَهُ الرُّءْیَا بِالْحَقِّ لَتَدْخُلُنَّ الْمَسْجِدَ الْحَرَامَ إِنْ شَآءَ اللّٰهُ اٰمِنِیْنَ مُحَلِّقِیْنَ رُءُوْسَکُمْ وَمُقَصِّرِیْنَ لَا تَخَافُوْنَ فَعَلِمَ مَا لَمْ تَعْلَمُوْا فَجَعَلَ مِنْ دُوْنِ ذٰلِكَ فَتْحًا قَرِیْبًا

(narrow arch band)

هُوَ الَّذِیْ أَرْسَلَ رَسُوْلَهُ بِالْهُدٰی وَدِیْنِ الْحَقِّ لِیُظْهِرَهُ عَلَی الدِّیْنِ کُلِّهِ وَکَفٰی بِاللّٰهِ شَهِیْدًا ۞ مُحَمَّدٌ رَّسُوْلُ اللّٰهِ وَالَّذِیْنَ مَعَهُ أَشِدَّآءُ عَلَی الْکُفَّارِ رُحَمَآءُ بَیْنَهُمْ تَرٰیهُمْ رُکَّعًا سُجَّدًا یَّبْتَغُوْنَ فَضْلًا

مِنَ اللّٰهِ وَرِضْوَانًا سِیْمَاهُمْ فِی وُجُوْهِهِمْ مِّنْ أَثَرِ السُّجُوْدِ ذٰلِكَ مَثَلُهُمْ فِی التَّوْرٰیةِ وَمَثَلُهُمْ فِی الْإِنْجِیْلِ کَزَرْعٍ أَخْرَجَ شَطْئَهُ فَاٰزَرَهُ فَاسْتَغْلَظَ فَاسْتَوٰی عَلٰی سُوْقِهِ یُعْجِبُ الزُّرَّاعَ لِیَغِیْظَ بِهِمُ الْکُفَّارَ وَعَدَ اللّٰهُ الَّذِیْنَ اٰمَنُوْا وَعَمِلُوا الصّٰلِحٰتِ مِنْهُمْ مَّغْفِرَةً وَّأَجْرًا عَظِیْمًا ۞

کتبه عبد الحق المخاطب بامانت خان - ١٠٤٦

59.

اتَّبِعُوْا مَنْ لَّا یَسْئَلُکُمْ أَجْرًا وَّهُمْ مُّهْتَدُوْنَ ۞

60.

(١) بدور بادشاه داد گستر
پناه خلق عالم ظل یزدان

(٢) شه صاحبقران تیمور ثانی
شهاب الدین محمد شاه شاهان

(٣) شهنشاه جهان خاقان اکبر
همایون جاه سلطان ابن سلطان

(٤) یکی صاحب پرست از بندگانش
که هست از جان و دل منقاد فرمان

(٥) بهار عدل اعظم خان غازی
که تیغش کشت جسم ملک را جان

(٦) سرای کرد در کجرات بنیاد
که مثلش را ندیده چشم دوران

(٧) زبی عالی بنا کز روی رفعت
گذشتم پایه قدرش ز کیوان

(٨) بخوبی و لطافت چون بهشت است
بدر بانی او شایسته رضوان

(٩) سرا و قیصریه یافت اتمام
بامر خان عادل نقد مردان

(١٠) ز هاتف سال تاریخش چو جستم
ندا آمد مکان خیر و احسان

61. (borders)

اللهم صل علی المصطفی محمد و المرتضی علی و البتول فاطمه (و) السبطین الحسن (و) الحسین و صل علی زین العباد علی و الباقر محمد و الصادق جعفر(و) الکاظم موسی و الرضا علی و التقی محمد و النقی علی و الزکی العسکری [١]الحسن

و صل الله على الحجة القايم الصالح الخلف الامام
[ا]لهمام المنتظر المظفر و المرضى محمد ابن [ا]لحسن
صاحب الزمان و قاطع البرهان و خليفة الرحمن و مظهر
الايمان سيد الانس و [ا]لجان صلوة الله و سلامه عليه
[و] عليهم اجمعين

(upper center panel)

الله محمد علي

بِسۡمِ اللهِ الرَّحۡمٰنِ الرَّحِيۡمِ اللهُ لَاۤ اِلٰهَ اِلَّا هُوَ ۚ اَلۡحَیُّ الۡقَیُّوۡمُ
لَا تَاۡخُذُهٗ سِنَةٌ وَّلَا نَوۡمٌ ؕ لَهٗ مَا فِی السَّمٰوٰتِ وَمَا فِی الۡاَرۡضِ ؕ مَنۡ
ذَا الَّذِیۡ یَشۡفَعُ عِنۡدَهٗۤ اِلَّا بِاِذۡنِهٖ ؕ یَعۡلَمُ مَا بَیۡنَ اَیۡدِیۡهِمۡ وَمَا
خَلۡفَهُمۡ ۚ وَلَا یُحِیۡطُوۡنَ بِشَیۡءٍ مِّنۡ عِلۡمِهٖۤ اِلَّا بِمَا شَآءَ ۚ وَسِعَ
كُرۡسِیُّهُ السَّمٰوٰتِ وَالۡاَرۡضَ ۚ وَلَا یَـُٔوۡدُهٗ حِفۡظُهُمَا ۚ وَهُوَ الۡعَلِیُّ
الۡعَظِیۡمُ

(middle band)

(1) ناد عليا مظهر [ا]لعجايب
تجده عونلك فنوايب (sic)

(2) كل هم و غم سينجلي
بولايت(sic) يا علي يا علي يا علي

(bottom panel)

در زمان شاه جم جاه سلطان عبد الله قطب شاه خلد الله
ملكه بنده على رضا خان عين الملك بدزدن راه نادر و
مهم بانكت بضبط در آورده از براى رواج دين بناى
مسجد نمود كه ز هجرت هزار و پنجاه سال بود

62. (center cartouche)

لا اله الا الله محمد رسول الله ١٠٦٥

(side medallions)

بعهد شاهجهان بادشاه دين پرور

ز دوده ظلامت كفر آفتاب دين يكسر سنه ٢٩

63. (top arch)

بِسۡمِ اللهِ الرَّحۡمٰنِ الرَّحِيۡمِ

(center rectangle)

قُلۡ یٰعِبَادِیَ الَّذِیۡنَ اَسۡرَفُوۡا عَلٰۤی اَنۡفُسِهِمۡ لَا تَقۡنَطُوۡا مِنۡ رَّحۡمَةِ
اللهِ ؕ اِنَّ اللهَ یَغۡفِرُ الذُّنُوۡبَ جَمِیۡعًا ؕ اِنَّهٗ هُوَ الۡغَفُوۡرُ الرَّحِیۡمُ

(right and left sides)

... لَمَسۡجِدٌ اُسِّسَ عَلَی التَّقۡوٰی مِنۡ اَوَّلِ یَوۡمٍ اَحَقُّ اَنۡ تَقُوۡمَ
فِیۡهِ ... فِیۡهِ رِجَالٌ یُّحِبُّوۡنَ اَنۡ یَّتَطَهَّرُوۡا ؕ وَاللهُ یُحِبُّ
الۡمُطَّهِّرِیۡنَ

(two circles)

ياغفار

64.
اعوذ بالله من الشيطان الرجيم —

سَیَقُوۡلُ السُّفَهَآءُ مِنَ النَّاسِ مَا وَلّٰهُمۡ عَنۡ قِبۡلَتِهِمُ الَّتِیۡ
كَانُوۡا عَلَیۡهَا ؕ قُلۡ لِّلّٰهِ الۡمَشۡرِقُ وَالۡمَغۡرِبُ ؕ یَهۡدِیۡ مَنۡ یَّشَآءُ اِلٰی
صِرَاطٍ مُّسۡتَقِیۡمٍ وَكَذٰلِكَ جَعَلۡنٰكُمۡ اُمَّةً وَّسَطًا لِّتَكُوۡنُوۡا شُهَدَآءَ

عَلَی النَّاسِ وَیَكُوۡنَ الرَّسُوۡلُ عَلَیۡكُمۡ شَهِیۡدًا ؕ وَمَا جَعَلۡنَا الۡقِبۡلَةَ
الَّتِیۡ كُنۡتَ عَلَیۡهَاۤ اِلَّا لِنَعۡلَمَ مَنۡ یَّتَّبِعُ الرَّسُوۡلَ مِمَّنۡ یَّنۡقَلِبُ
عَلٰی عَقِبَیۡهِ ؕ وَاِنۡ كَانَتۡ لَكَبِیۡرَةً اِلَّا عَلَی الَّذِیۡنَ هَدَی اللهُ ؕ وَ
مَا كَانَ اللهُ لِیُضِیۡعَ اِیۡمَانَكُمۡ ؕ اِنَّ اللهَ بِالنَّاسِ لَرَءُوۡفٌ رَّحِیۡمٌ

(small cartouche, bottom left)

كتبه تقي الدين محمد بن شيخ صالح البحراني ١٠٧٧

65. اِنَّمَا یَعۡمُرُ مَسٰجِدَ اللهِ مَنۡ اٰمَنَ بِاللهِ وَالۡیَوۡمِ الۡاٰخِرِ
وَاَقَامَ الصَّلٰوةَ وَاٰتَی الزَّكٰوةَ وَلَمۡ یَخۡشَ اِلَّا اللهَ ۫ فَعَسٰۤی
اُولٰٓئِكَ اَنۡ یَّكُوۡنُوۡا مِنَ الۡمُهۡتَدِیۡنَ

(كتبه العبد تقي الدين محمد بن صالح البحراني

سنة ١٠٧٨

66. چشمه از كوثر ١٠٨٢

67.
(1) بدر بدر شاه عالم گير غازي
كه از عدلش شده گيتي منور

(2) قلندر خان بهار باغ درلت
كه از بريش جهان گشته معطر

(3) به پيش آنتاب دست جودش
بود دريا ر كان از ذره كمتر

(4) رواقي ساخت بهر يادگاري
كه باشد زير اين فيروزه منظر

(5) پي تاريخ او از طارم چرخ
ندا آمد كه خال ردى بيدر

١٠٨٨

68. RIGHT PANEL
(bottom cartouche)

بنياد نهاد عشق بازے
جز درد بلا نبود مقصود

(circles)

يا امين مدد

يا حاجت روا

(three vertical cartouches)

(1) دل بحر مين غواص هو روح صد فكے كاجين امين

در نے بها تس صدف مں جان تون ساجين امين

(2) كركيان كي عرفان تون سنبهال سيانپے چير كر

(circles)

يا صاحب كرامات

يا امين مدد

(horizontal cartouche)

موتي مزين هات لے عرفان انگون پركار امين

(circles)

يا شمس العشاق

يا معشوق رباني

يا آفتاب المهتاب

(three vertical cartouches)

(3) سوهے منور نور تون تس حال جو ظاهر طلوع

كرنا حضور حق اوچت هديه اپس تب تون امين

(4) مقبول حق از حق هوا پاگه چراكس جا دهرے

(circles)

يا حاجت روا

يا امين مدد

(horizontal cartouches)

راضي رضا حق هو فدا نهان ذوق نا دوجا امين

(circles)

يا عاشق شهباز

يا امين مدد

يا بلند پرواز

(three vertical cartouches)

(5) اس ذوقكے تمثيل كون كس موكب سون ديا گركهون

ناهر كبے زهره تهان نا او كوئى سكيا امين

(6) حق وصل سون بهو بهانةهے تس بها كنے قتل اللسان

(circles)

يا نور نورے

يا امين مدد

يا سرسرے

(horizontal cartouche)

كهن كهن منزه روپه هے بهوجكت اچنبه كن امين

(parapet arches)

الله كافي – الله محمد علي – الله شافي

(domes)

يا الله

انا انا الله

TOP PANEL

امام علي المرتضي

امام محمد الباقر

امام محمد التقي

(three horizontal cartouches)

(7) وصل بحر امواج ميں هادے هدايت جس اپين

ورنه شفا اغلب تهان بازيك ره تاريك امين

(8) ليكن عروج ايتاهے سن غواص دلكے سمع لون

(circles)

امام حسن المجتبى صابر

امام جعفر الصادق

امام علي النقي

(center cartouche and four corner circles)

لا اله الا الله محمد رسول الله تعالي شانه

قال رسول الله و به ؟ الشفاه

صلى الله عليه و اله و صحبه و سلم

لما اسرى الى السماء الدنيا

ادل غی مكنون العرش

(circles)

امام حسين الشهيد كربلا

امام موسى الكاظم

امام حسن العسكرى

(three horizontal cartouches)

امواج نفسانے سوغیر الله تھین نادّر امین

(9) مطلوب ہے اسان آپ اشکال نه مشکیل توج

جا ذوب کدر اوپار جا بیجار توں کدر ناامین

(circles)

امام زين العابدين

امام موسى الرضا

امام محمد المهدے

LEFT PANEL
(domes)

يا الله

اے انا الله

(parapet arches)

الله معافے - الله محمد علي - الله باقے

(horizontal cartouche)

(10) بجا بود وسواس سب پرد! اے تجه اس منے

(circles)

انا من نوراالله

يا امين مدد

وكى سے من نورے

(three vertical cartouches)

مردان حق تن نام ہے جن پیم ایں پیٹها امین

(11) شاهید هو دل انگسوں دانا دلاور زور تر

پیرے معلم خاص تھی امداد لی حق سون امین

(circles)

يا بنده نواز

يا امين مدد

يا گیسو دراز

(horizontal cartouche)

(12) برهان کیرے فیض سون غوثا لیا ان دھوندھنے

(circles)

يا غیاث العاشقين

يا امين مدد

يا تاج الموحدين

(three vertical cartouches)

پایا جو تها تجه قدر در اب رہ اہمین هو امین

برهان بن میران کیرے درگه کے سب خاکی پر

قربان تن بل جان من دیکر کهان کیتا امین

(circles)

يا اقتاب المهتاب

يا معشوق ربانے

يا شمس العشاق

(horizontal cartouche)

(14) خط غلامی منجه سما آمیر اس دربار کا

(circles)

يا هادے رہبر

يا امين مدد

يا ساقی کوثر

(three vertical cartouches)

آزادگے کونین تھی مین منجه تھی پایا امین

(15) ابیات خالی پنج ده تمت کیا اے غزل مین

مفهوم کرستار هو نا عیب جو هونا امین

(circles)

يا امين مدد

يا حاجت روا

(bottom cartouche)

بنیاد نهاد عشقبازے

جز درد بلا نبود مقصود

كتبه حسين ١٠٨٨

69. (top corners)

كُلُّ شَیْءٍ هَالِكٌ اِلاَّ وَجْهَهُ ... كُلُّ مَنْ عَلَيْهَا فَانٍ ٥

(center panel)

بِسْمِ اللهِ الرَّحْمنِ الرَّحِيْمِ

اللهم صل على محمد المصطفى

و على المرتضى و فاطمة الزهراء و الحسن المجتبى

و الحسين الشهيد بكربلا و زين العابدين

و محمد و جعفر و موسى و على و محمد

و على و الحسن و الحجة المنتظر المهدى

صلوات الله و سلام عليهم اجمعين الظاهرين

(1) وفدت على الكريم بغير زاد

من الحسنات و القلب السليم

(2) فحل الزاد اقبح كل شىٔ

اذا كن الوفود على الكريم

(3) تاریخ وفات را جو جستم

شد جنت سبز جاى مریم سنه ١١٣٠

(border)

قد فاتت السيدة الـمبرورة المغفورة الموفقة قارئة
القرآن المجيد وزائرة بيت الله الحرام و مجاورتها
فيها حجتين و اداء الحجبن و زيارة جدها سيد المرسلين
و جدتها سيدة نساء العالمين و سائر ايمة الطاهرين
صلوات الله عليهم فى روضاتهم المقدسة سمية ام عيسى عليه
و على نبينا السلام مريم بنت المرحوم الاجل الامجد
محمد بن على موسى الحسينى المازندرانى المخاطب
بمفتخر خان فى يوم الخميس ثانى عشر شهر جمیدى
الاولى سنه ثلثين وماية بعد الالف من الهجرة النبوية
كتبه العبد المغموم المهموم المحزون الـمهجور زوجها
و ابن ابن اخت ابيها ابو الفضل خان بن غياث الدين
بن منصور الحسنى الحسينى الاتجونى

70. بِسْمِ اللهِ الرَّحْمنِ الرَّحِيْمِ

(1) کرد باغى بنا بفضل خدا

ما اعز اسمه و ما اعلى

(2) ابر جود و کرم بهادر خان

که از وگشت سبز باغ سخا

(3) نمر کام او تر و تازه

شجر نام او جهان آرا

(4) سال تاریخ با دعا گفتم

باد باغ محمدى طوبى

سنه ١١٣٩

71. (circle)

بِسْمِ اللهِ الرَّحْمنِ الرَّحِيْمِ

لا اله الا الله محمد رسول الله

متنکلکلکشا شاه بسم الله ١١٨٦

(upper medallions)

محمد علمى بسم الله

مشکلکشا مشکلکشا

شاه شاه

(sides)

(1) قطب زمان و ماهر از سرلى مع الله

... ت حق حق او از نفى ما ـ الله

(2) جسمش حلیم طل اعیان ثابته دان

تاریخ گفت هاتف او بود ذات الله

تمتم ١١٨٦

INDEX OF KORANIC PASSAGES